sona
BOOKS

First published in the UK 2021 by Sona Books
an imprint of Danann Media Publishing Ltd

Design of this book © Danann Media Publishing Limited 2021

Copy Editor for Danann Juliette O'Neill

CAT NO: **SON0513**
ISBN: **978-1-912918-78-2**

Made in EU.

The Big Book of the
OCEAN

Covering around 70 per cent of our planet's surface and home to more than 200,000 known species, the world's oceans are vital to life on Earth. However, despite producing around half the world's oxygen and helping to regulate our climate and weather patterns, human behaviour has put our incredible oceans and the amazing animals within them at risk.

In The Big Book of the Ocean, we go beneath the surface to explore the fascinating secrets of the sea and take an in-depth look at some of the planet's magnificent marine creatures, from killer whales and sea turtles to seahorses and starfish. We also explore what we can do to help protect these vital environments and discover ten of the most endangered ocean species.

CONTENTS

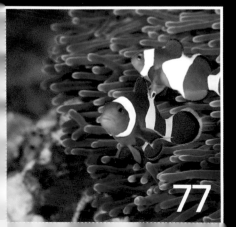

77

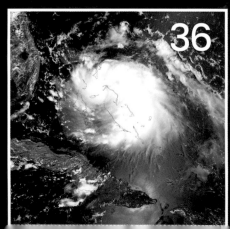

36

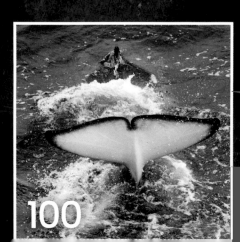

100

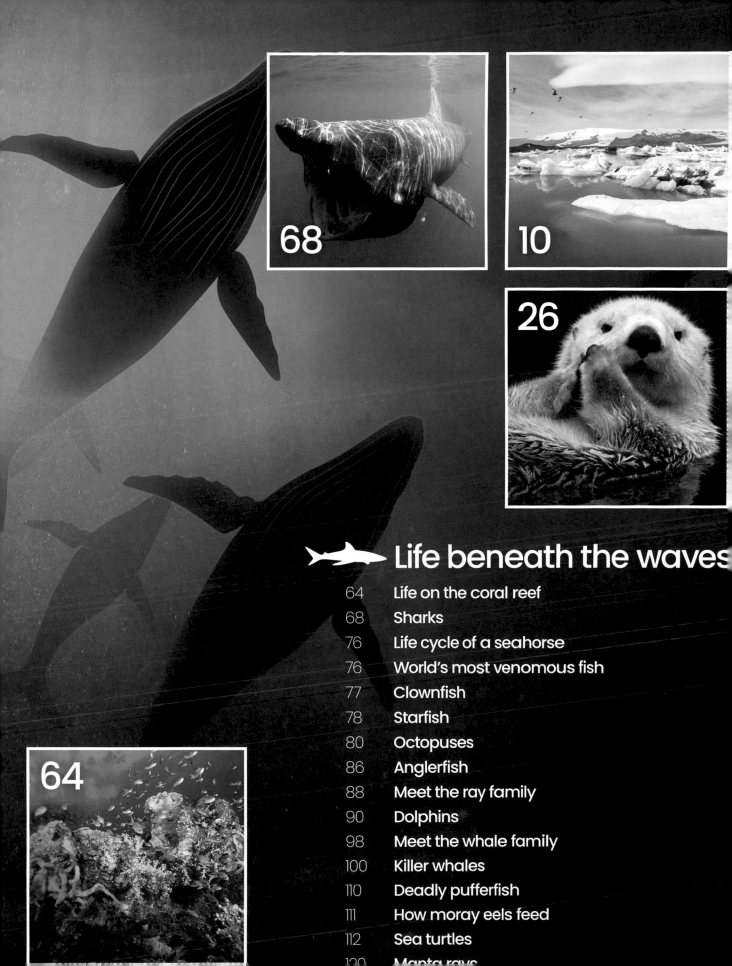

68

10

26

Life beneath the waves

64

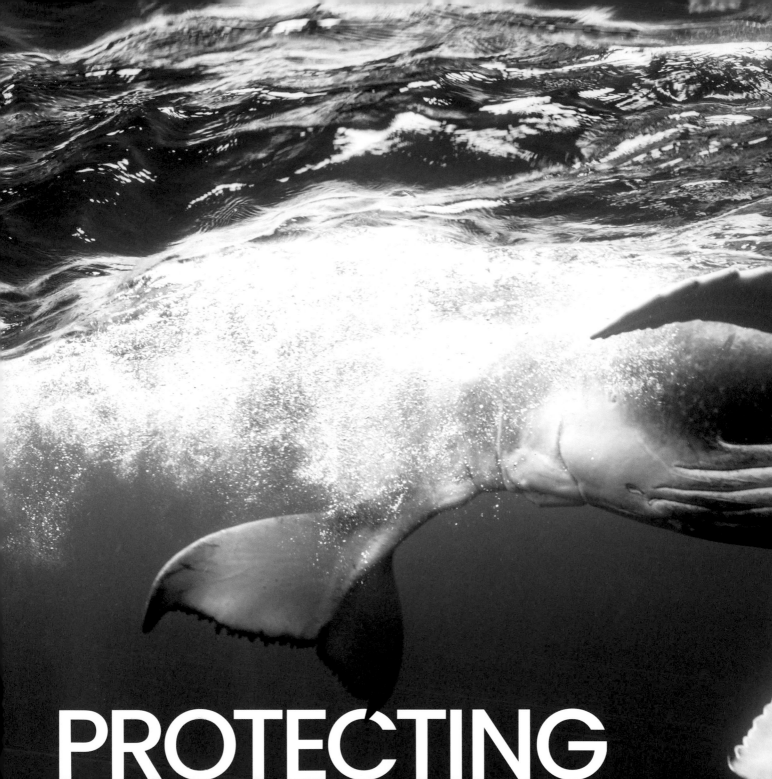

PROTECTING OUR OCEANS

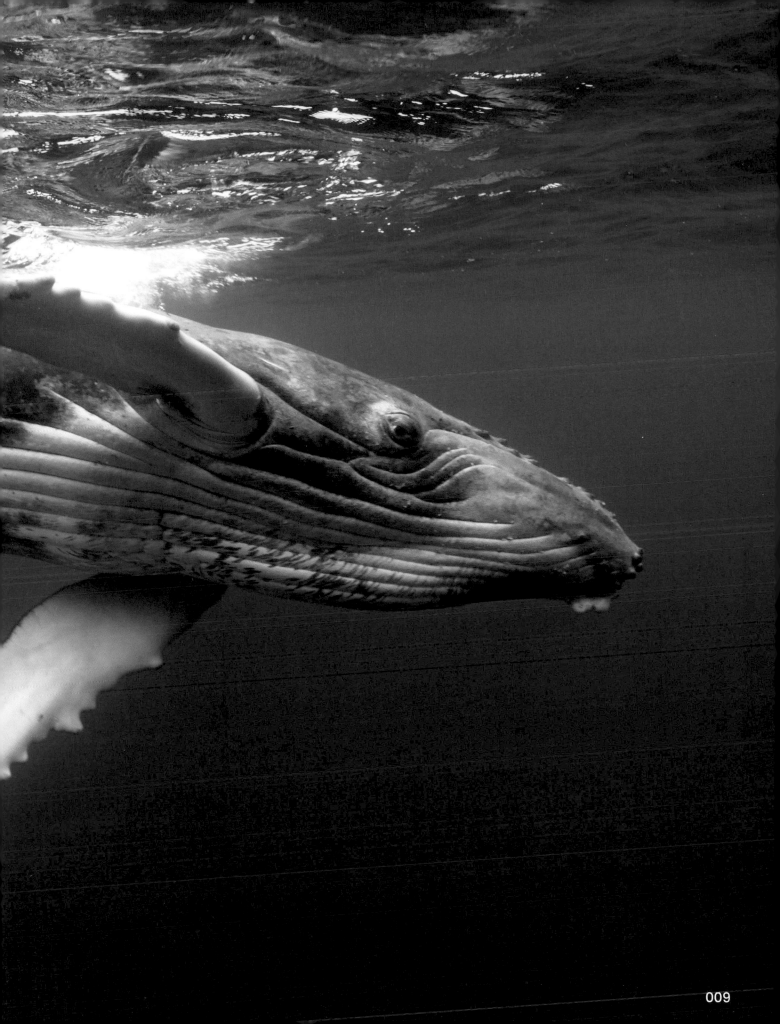

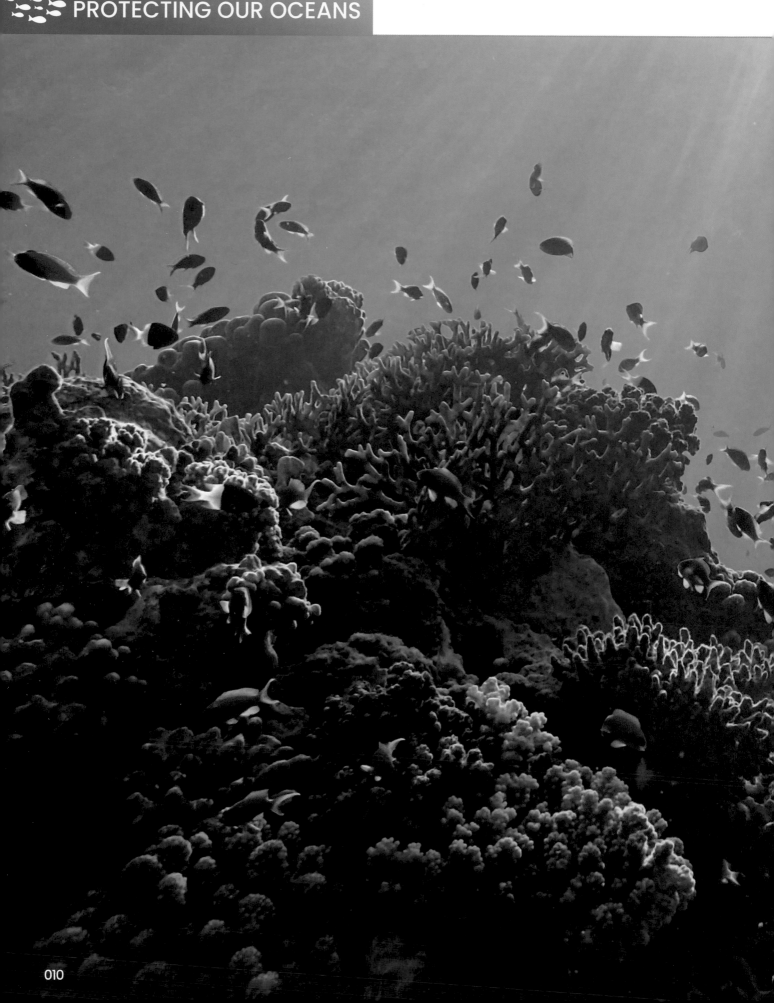

INTRODUCING THE
OCEAN

Dynamic, rich in resources and teeming with life, it is the Earth's most valuable environment

Words by **Michael Simpson**

It is ironic that we call our planet Earth as most of it is underwater. Approximately 71 per cent of the surface, or about 360 million square kilometres (139 million square miles), is covered by the vast expanse of the ocean.

We often refer to ocean and sea as if they are the same thing, but seas are technically smaller areas of saline water that are at least partially enclosed by land, such as the Mediterranean Sea and the Baltic Sea. In contrast, the ocean is a single continuous body of water that encircles the globe. As it would be difficult to navigate, study or describe an ocean of that extent, maps of the world show it subdivided into five ocean basins called the Pacific, Atlantic, Southern, Indian and Arctic Oceans.

Whether we talk about one ocean or several, however, we are referring to nature at its most epic. The ocean is home to an extraordinary diversity of marine organisms and is the driving force behind processes that enable life to flourish on land. Yet, we know very little about what is happening beneath the waves. Therefore, we may be putting ourselves at risk if we continue to overexploit and undervalue the resources the ocean provides.

THE GREAT FLOOD

The ocean contains over 1.3 billion cubic kilometres (312 million cubic miles) of saline water and about 97 per cent of all the water on Earth. What continues to puzzle scientists is where all that water came from. By comparing the detailed chemical composition of ocean water with that of water found elsewhere, though, experts have theorised that the ocean formed over aeons through two main processes.

Some of the first ocean water was probably trapped in the rocks that formed the Earth in the earliest periods of its history. When this water was

released, the intense heat of the mantle turned it to vapour. This vapour was subsequently ejected into the atmosphere by volcanoes. In the cooler atmosphere, this vapour condensed into water droplets that became rain. Because the plates forming the planet's early crust thickened over millions of years, the temperature of the surface steadily declined. Instead of evaporating again when it fell, the water in these primordial rain showers began to collect in basins and depressions.

Other water may have arrived from space after the Earth was formed. Ice on the surface of comets or trapped in meteorites that struck the Earth may have melted and added to the water that was accumulating from rain showers.

No one knows which of these processes was most important, but together they are thought to have formed the first ocean between approximately 4.2 billion and 3.5 billion years ago. About 2 billion years later, ocean waves were lapping at the shores of the first great supercontinent as the water became progressively deeper. Today, the deepest point in the ocean is believed to be in the Mariana Trench and you would have to go down to almost 11 kilometres (6.8 miles) to reach the bottom.

Although the ocean basins have filled up since prehistoric times, the amount of liquid water they contain has fluctuated according to changes in climate. We know this from fossils and human remains that show that people and animals once migrated across land bridges, such as the Bering Strait between Russia and North America. Land bridges form when a drop in global temperatures causes some ocean water to form icebergs, resulting in a drop in sea level. As temperatures rise again, the ice melts, refilling the ocean basins.

THE ATMOSPHERE'S ENGINE

The process of water cooling and warming is also a key driver of ocean currents that constantly circulate the globe. These currents distribute energy, along with nutrients and living things, in a continuous cycle that affects life everywhere.

Water in roughly the top 100 metres (328 feet) of the ocean is moved by winds from warmer tropical to colder polar regions of the planet. There, the water becomes denser and less saline as it cools and some turns to ice. This denser water sinks and is replaced at the surface

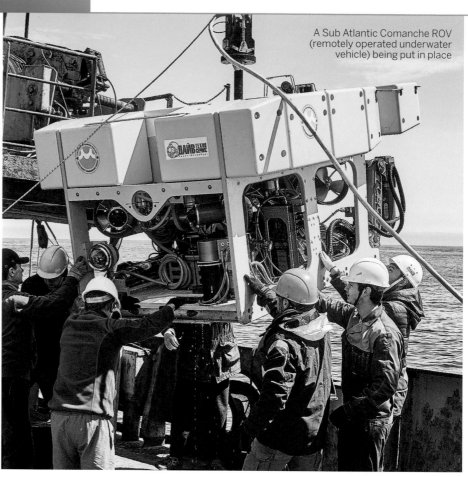

A Sub Atlantic Comanche ROV (remotely operated underwater vehicle) being put in place

Hydrothermal vents

Hydrothermal vents occur in the deep ocean, often where tectonic plates are colliding or moving apart. Seawater percolates through the crust to the magma below, and is heated to around 400 degrees Celsius (752 degrees Fahrenheit). The heat drives chemical reactions that remove oxygen and other chemicals from the water, and leach metals such as iron, copper and zinc from surrounding rocks. The water then rises back out of the fissures and encounters cold seawater, causing sulfides to precipitate out of the solution and form tubular towers. Hydrogen sulfide gas released by these processes is captured by oxidising bacteria and turned into chemical energy using a process called chemosynthesis. These bacteria are the primary source of energy for many other organisms, including tubeworms, shrimps, mussels, feather stars, fish and crabs. Unfortunately, rich deposits of silver, gold and other valuable minerals near hydrothermal vents put these fragile ecosystems at risk from commercial exploitation.

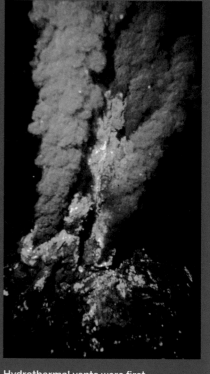

Hydrothermal vents were first discovered near the Galápagos Islands in the Pacific Ocean in 1977

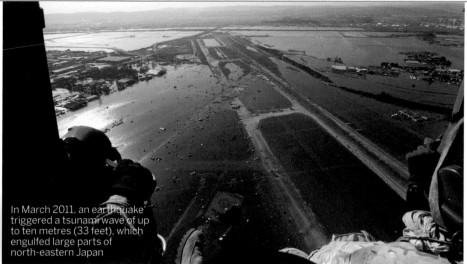

In March 2011, an earthquake triggered a tsunami wave of up to ten metres (33 feet), which engulfed large parts of north-eastern Japan

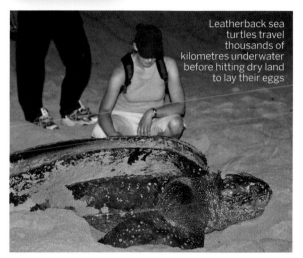

Leatherback sea turtles travel thousands of kilometres underwater before hitting dry land to lay their eggs

The comb jelly (Cydippida) uses groups of cilia (commonly referred to as 'combs') for swimming through the ocean

Oceans by the numbers

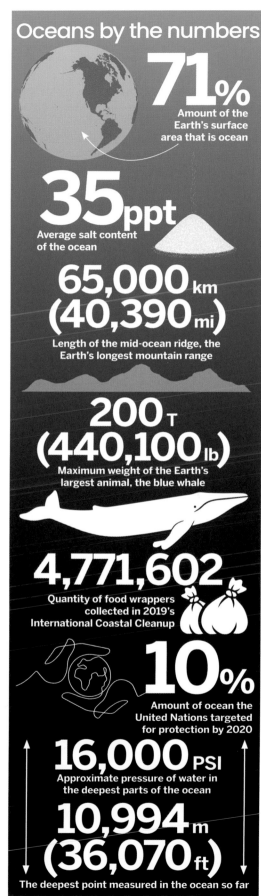

71%
Amount of the Earth's surface area that is ocean

35ppt
Average salt content of the ocean

65,000km (40,390mi)
Length of the mid-ocean ridge, the Earth's longest mountain range

200T (440,100lb)
Maximum weight of the Earth's largest animal, the blue whale

4,771,602
Quantity of food wrappers collected in 2019's International Coastal Cleanup

10%
Amount of ocean the United Nations targeted for protection by 2020

16,000PSI
Approximate pressure of water in the deepest parts of the ocean

10,994m (36,070ft)
The deepest point measured in the ocean so far

by less dense inflowing water. When that water also sinks, it pushes what is further down the column back towards the tropics, forming a current of deep water. This becomes less dense as its temperature increases and it accumulates salts. Eventually, the warmed water rises to the surface again and meets the winds that will drive it back towards the poles.

This process acts like a conveyor belt, moving water and heat around the Earth. However, it is not the only way in which the ocean influences temperatures and the distribution of water around the planet, as it works in tandem with the water cycle.

The water cycle functions much like the process that may have originally filled the ocean. Evaporation from ocean and land surfaces sends water vapour into the atmosphere, which is transported around the

"More than 2,500 scientists contributed data to the Census of Marine Life"

globe by air currents. At cooler latitudes and elevations, this vapour condenses to form clouds, and some of it falls back to earth as precipitation, usually rain or snow.

Evaporation captures latent heat from the atmosphere, which is released elsewhere by condensation. This process, together with the movement of heat by ocean currents, moderates temperatures in places where they might otherwise be inhospitably hot or cold. Without the ocean, therefore, life may not have adapted to some environments, and conditions everywhere would be very different indeed.

AWASH WITH LIFE
Inevitably, nowhere is more impacted by the dynamic nature of the ocean than areas within and near the ocean itself. Scientists have found rocks that may contain evidence

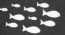

of bacteria living in the ocean more than four billion years ago. Now the ocean harbours examples of the smallest and largest organisms on Earth, while representatives of all the major taxa either live in or obtain resources from the ocean.

To get a better idea of the diversity, distribution and abundance of ocean life, more than 2,500 of the world's top marine scientists contributed data to the Census of Marine Life, an international effort to catalogue oceanic species and better understand what steps we need to take to conserve them. As of 2011, this effort had produced more than 30 million records that could potentially include more than 6,000 new marine species.

Yet, this just scratches the surface when it comes to ocean ecology, as we have only explored about five per cent of marine habitats. Large areas are currently hard to access, especially the deep-sea zones far down where there is no light and water pressures are enormous. Even so, studies of abyssal ecosystems, such as hydrothermal vents, have

"Atlantic bluefin tuna can travel at almost 80 kilometres an hour"

shown that even the ocean's extreme environments are far from lifeless.

Species diversity is generally much greater at zones near the ocean surface, but even there it is difficult to study, because much of it is microscopic. Countless species of plankton and krill are carried around the globe by ocean currents. One scientist working on the Census of Marine Life discovered more than 20,000 types of microbes in a single litre (1.8 pints) of ocean water.

Even though these microorganisms are tiny, they have a huge impact on other life. Ocean-living phytoplankton produce around half of the oxygen in the Earth's atmosphere. Krill, meanwhile, prop up much of the marine food chain and are eaten en masse by creatures much bigger than themselves, such as the largest animal to ever exist on Earth, the blue whale (Balaenoptera musculus).

It's not just the open ocean that's teeming with life. Tropical reefs are habitats for exotic

The Earth's ocean basins

How geographers have divided up the Earth's global ocean

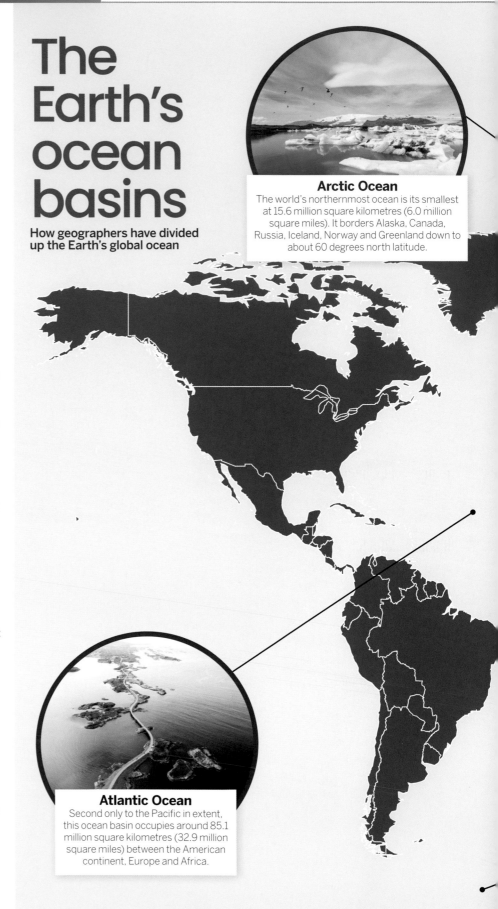

Arctic Ocean
The world's northernmost ocean is its smallest at 15.6 million square kilometres (6.0 million square miles). It borders Alaska, Canada, Russia, Iceland, Norway and Greenland down to about 60 degrees north latitude.

Atlantic Ocean
Second only to the Pacific in extent, this ocean basin occupies around 85.1 million square kilometres (32.9 million square miles) between the American continent, Europe and Africa.

Pacific Ocean
Earth's largest ocean basin borders on North and South America, Australia, Russia and Asia, covering about 168.7 million square kilometres (65.1 million square miles) from the Antarctic to the Arctic.

Atlantic bluefin tuna have been overfished to the point that some populations are now endangered

Indian Ocean
Bordering Africa, Asia, Australia and India, this ocean basin covers approximately 70.6 million square kilometres (27.3 million square miles), although exactly where it becomes the Atlantic and Pacific Oceans is unclear.

Southern Ocean
The world's newest ocean basin surrounds Antarctica up to 60 degrees south latitude and has an area of about 22.0 million square kilometres (8.5 million square miles).

Zones of the oceans

The layers we use to describe the ocean depths based on light

Mesopelagic Zone (Twilight Zone)
200m to 1,000m (656ft to 3,281ft)
Dimmer than the Sunlight Zone but not totally dark, this transition zone from warm upper waters to the cold depths supports highly varied species, including some that are bioluminescent.
SPECIES
Copepods (eg Oncaea spp.)
Midwater squid (Abralia veranyi)
Lantern fish (Myctophidae)
Bristlemouth fish (Gonostomatidae)
Sperm whale (Physeter macrocephalus)

Epipelagic Zone (Sunlight Zone)
0m to 200m (0ft to 656ft)
Due to abundant light, this is where phytoplankton and algae proliferate, generating oxygen through photosynthesis. It is also the most diverse zone for other species because of relatively warm water temperatures.
SPECIES
Zooplankton, such as Ctenophora (comb jellies)
Phytoplankton (algae and bacteria)
Atlantic bluefin tuna (Thunnus thynnus)
Leatherback sea turtle (Dermochelys coriacea)
Common bottlenose dolphin (Tursiops truncates)

Continental Shelf

Continental Slope

Continental Rise

Sperm Whale Maximum depth 3,300ft / 1,000m

Bathypelagic Zone (Midnight Zone)
1,000m to 4,000m (3,281ft to 13,123ft)
As the upper layer of the deep ocean, this zone provides habitat for some remarkable organisms that are either bioluminescent or otherwise adapted to cold and total darkness.
SPECIES
Amphipods (eg Cyclocaris guilelmi)
Giant squid (Architeuthis dux)
Deep-sea vent octopus (Vulcanoctopus hydrothermalis)
Deep-sea gulper eel (Eurypharynx pelecanoides)
Deep sea anglerfish (Melanocetus johnsonii)

Depth at which RMS Titanic rests 12,500ft / 3,800m

Ocean Basin

The height of Mount Everest 8,848m

Abyssopelagic Zone (The Abyss)
4,000m to 6,000m (13,123ft to 19,685ft)
High pressure and near-freezing temperatures make this a harsh environment for life and it gets more inhospitable as you go deeper. Only a few species have been identified here.
SPECIES
Sea pig (Scotoplanes globosa)
Tripod fish (Bathypterois grallator)
Deep-sea squid (Bathyteuthis abyssicola)
Brittle star (Ophiuroidea)
Sea spider (Class Pycnogonida)

Depth James Cameron reached 35,756ft / 10,898m

Hadopelagic Zone (Hadal Zone/The Trenches)
6,000m to 11,000m (19,685ft to 36,089ft)
As deep as it gets, this zone occurs only in ocean-bottom trenches and canyons. Yet, a few species can tolerate the incredible pressures and lack of resources.
SPECIES
Snailfish (eg Notoliparis antonbruuni)
Cusk-eel (Holcomycteronus profundissimus)
Giant tubeworm (Riftia pachyptila)
Giant amphipod (Hirondellea gigas)

fish and corals, while coastal mudflats support huge flocks of shorebirds drawn to the invertebrates that live in the mud. Also, the rising and falling tides, driven by the gravitational pull of the moon, have created unique ecosystems, such as mangroves, where organisms must be adapted to frequent changes in water level.

To discover more about life in the ocean, scientists are employing the latest technology, including research vessels that are capable of breaking through polar ice, as well as sophisticated submersibles and autonomous landing vehicles that can collect imagery and acoustic, chemical and optical measurements from great depths. Other sources of information include advanced computer software that can translate sonar readings into three-dimensional maps of the ocean floor, and thermal imaging satellites that provide graphical images of ocean currents, temperature variations and other processes that are constantly in flux.

Tagging is also being used to follow the movements of animals such as tuna, whales, seals, seabirds and turtles. It has helped biologists discover that Arctic terns (Sterna paradisaea) can migrate back and forth between the Arctic and Antarctic over distances of around 90,000 kilometres (55,923 miles), leatherback sea turtles (Dermochelys coriacea) travel thousands of kilometres underwater before hitting dry land to lay their eggs, and Atlantic bluefin tuna (Thunnus thynnus) can travel at speeds of 70 kilometres (43 miles) an hour. We might never have made these discoveries if scientists had not been able to build tracking devices capable of withstanding the demanding conditions these organisms encounter in or around the ocean.

AN OCEAN FOR THE FUTURE

One reason that scientists are studying Atlantic bluefin tuna is that there are relatively few of these magnificent fish left. Along with Pacific bluefins and other commercially valuable species, they have been overfished to the point that some populations are now endangered.

Sadly, it is not just the fish that trawlers mean to reel in that are being caught in excessive numbers. Active fishing nets also trap non-target fish, mammals, sea turtles and other marine animals. In addition, so-called 'ghost nets' – fishing nets that have been lost or simply dumped in the ocean – are entangling large numbers of fish, mammals, turtles and seabirds. Once ensnared, these unfortunate creatures drown or starve to death.

Moreover, fishing is only one of several human activities that are threatening ocean life. One of the most topical issues in marine conservation is the disposal of plastics and medical waste. Too much of both is already being carried with other garbage by ocean currents and collecting in places such as the Great Pacific Garbage Patch. Unfortunately, the COVID pandemic is likely to have made this problem worse, as it has resulted in the disposal of a huge number of face masks, many of which will end up in the ocean.

Other forms of pollution are also affecting the ocean, including sewage, fertiliser and detergent runoff. These discharges can cause a breakdown of oxygen in coastal waters and put excess nutrients into solution, leading to algal blooms. Coastlines are also being impacted by development that removes precious habitat or makes beaches inaccessible to animals such as the leatherback sea turtle. Ships can damage

"The biggest threat to the ocean is climate change"

important marine habitats, too, by leaking oil, dumping ballast water or dropping anchors on fragile coral reefs.

The biggest threat to the way the ocean works, though, is climate change. It has the potential to alter the temperature difference between the tropics and the poles, and thereby disrupt the currents that form the ocean's heat distribution conveyor belt. Furthermore, the ocean food chain relies heavily on the distribution of nutrients to warmer regions to fuel the growth of plankton. By changing precipitation patterns and causing icebergs to melt, climate change could also alter the water cycle and lead to a rise in sea level. This would flood some islands and shorelines. The results could be catastrophic for some marine species, and could devastate human communities that live in low-lying coastal areas.

OCEAN AWARE

Because many of us do not live near the ocean, it is easy for us to take it for granted and remain unaware of the vital role it has played throughout Earth's history in making and keeping the planet hospitable. Our image of the ocean, informed by literature, art and popular culture, is of a realm of wonder, mystery and drama. Tsunamis and hurricanes show its awesome power to destroy. But the more we learn about the ocean, the more it becomes clear that it is a surprisingly fragile environment that we need to respect and care for in the interests of all life on Earth.

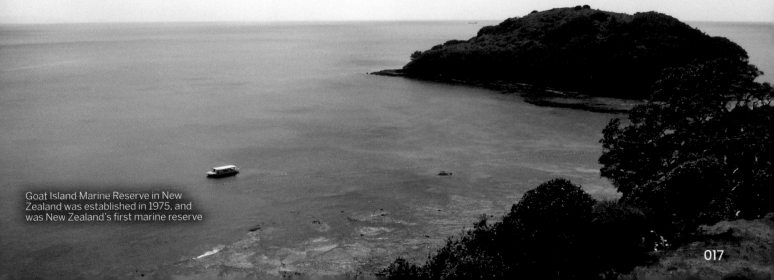

Goat Island Marine Reserve in New Zealand was established in 1975, and was New Zealand's first marine reserve

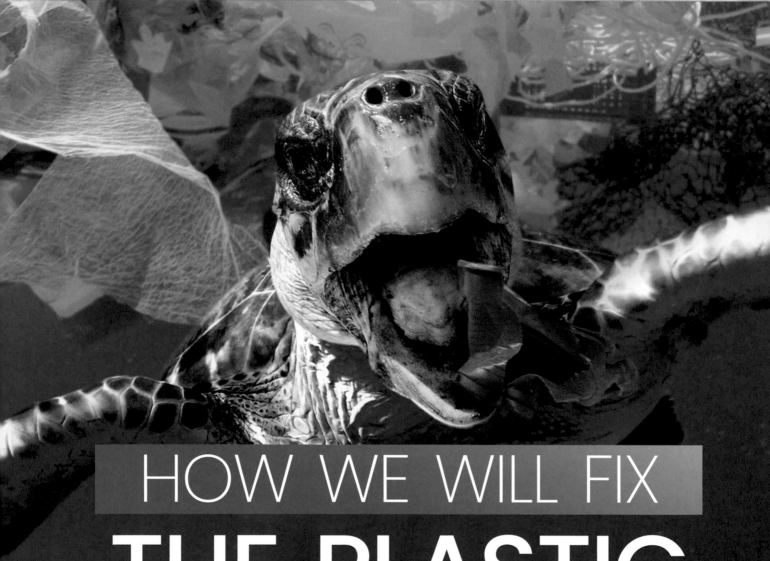

HOW WE WILL FIX

THE PLASTIC PROBLEM

Plastic waste is choking the planet. What can we do to clean the trash from the oceans?

Words by **Laura Mears**

Somewhere between Hawaii and California, a vast inflatable coastline sweeps through the sea. Beneath a 600-metre-long float, a three-metre deep skirt rakes the ocean. Forced along by wind and waves, it moves faster than the currents, bending as it travels to form a U-shaped net. Fish dive beneath to escape its advances, but as the system roams the water it gathers a strange catch. Braving gales and storms and resisting the corrosive effects of sea salt, System 001 sends signals to satellites overhead and boats close by to collect a haul unlike any other. This net is trawling the great Pacific Garbage Patch, and its job is to clean up the sea.

The Pacific Garbage Patch is a trash vortex; a swirling gyre of waste caught up in ocean currents. While not the literal island of rubbish sometimes described in the media, its waters are strewn with small chunks of floating debris. Churned by the action of the waves, the pieces bob up and down in the water column, circulating with the currents. Invasive species hitch a ride on the travelling plastics, making their way to waters nature never intended for their occupation. Sea birds, marine mammals and fish mistake the floating chunks for food, filling their bellies with indigestible trash. The pieces that remain wear away under the relentless rocking, rubbing microscopic plastic splinters and toxic chemicals into the water.

"The Pacific Garbage Patch is a trash vortex"

Deployed on 16 October 2018, System 001 aims to clear half of the rubbish from the Pacific Garbage Patch over the next five years. It is the first of a network of 60, and the result of more than 270 scale model tests and six prototypes. Pushed along by natural forces and equipped with solar-powered electronics, System 001 quietly follows the flow of the water. It's got lights and GPS to warn sailors, and it moves slowly enough that fish have plenty of time to get out of the way. Plastic, on the other hand, can't escape: trapped between the inflatable float and the solid skirt, it has nowhere to go. Load by load, sea-going rubbish trucks will retrieve the waste and start to clear the ocean. If all goes

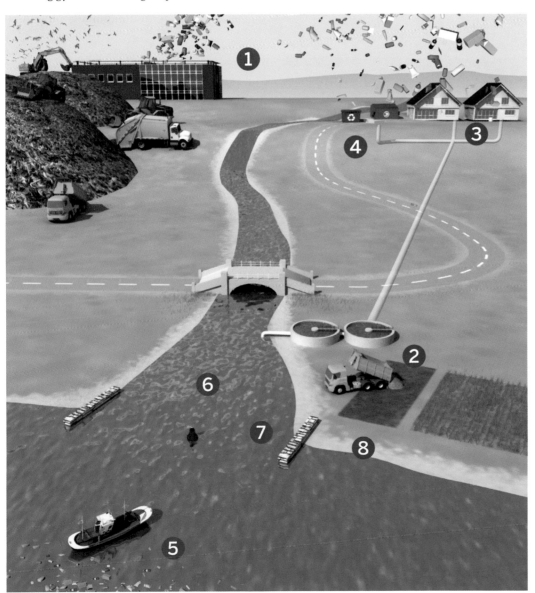

The plastic problem

How does plastic get out into the environment?

1 Constant consumption
The world produces 300 million tons of plastic each year, half of which we use just once before discarding it.

2 Contaminated water
Over 110,000 tons of microplastics wash over agricultural land in North America and Europe every single year.

3 In the laundry
Acrylic clothes release over 700,000 plastic fibres per 6kg wash. Polyester releases nearly 500,000.

4 Plastic per person
The average person in the EU makes 31kg of plastic waste every year.

5 Microplastic soup
There are more than 5 trillion pieces of plastic floating about in the oceans.

6 Rivers of rubbish
Our rivers carry around 100,000 rubbish trucks' worth of plastic waste out to sea each year.

7 Out to sea
12 million tons of plastic makes it out into Earth's oceans via rivers, beaches and drains every year.

8 On the beaches
For every mile of UK beach you can expect to find 5,000 pieces of discarded plastic waste.

well, the project could roll out across the globe to remove 90 per cent of our floating junk by 2040.

HOW DID WE GET HERE?

It's barely more than 100 years since Leo Baekeland invented the first fully synthetic plastic. Developed to insulate electrical wires at the tail end of the second industrial revolution, this new material was unlike anything seen before. Cheap to produce, resistant to heat and highly mouldable, it could be anything people wanted it to be, and its appearance kick-started a wave of chemical innovation.

All plastics have the same basic structure. Zoom in and most look like strings of pearls, with long, repeating chains that melt when they heat up and set hard as they cool. What makes them special is their versatility. We can extrude them into thin sheets, press them between rollers, blow them into bubbles, cast them like metal or vacuum mould them into 3D shapes. Changing the chemical building blocks of the chains can alter their flexibility, melting point and ability to resist chemicals. Additives between the chains can change their colour, make them fire-proof or kill bacteria, and adding branches to the chains can make them tangle, forming knots that don't melt and locking finished plastics into permanent shapes.

These incredible materials are cheap, clean and waterproof. They can be thick or thin, bendy or brittle, brightly coloured or completely clear. We can wear them against our skin, wrap them around our food and use them to construct everything from pens and tinsel to smartphones and spaceships. Plastics are strong enough to support buildings, light enough to fly and slippery enough to stop eggs sticking to frying pans. But these wonder materials are so cheap that we don't think twice about throwing them away.

Today, we make 300 million tons of plastic a year, half of which goes straight in the bin. We waste 1 million plastic bottles a minute, half a million plastic straws a day and 4 trillion plastic bags every year. Of all the plastic we have ever made, nearly 80 per cent is in landfill or littering the natural world. Nearly a third of plastic packaging goes straight out to sea,

Durable chains

Strong plastic is both useful and an environmental threat

Oxygen
Carbon
Hydrogen

Simple links
The monomers (repeating units) synthesised into plastics are often derived from fossil fuels.

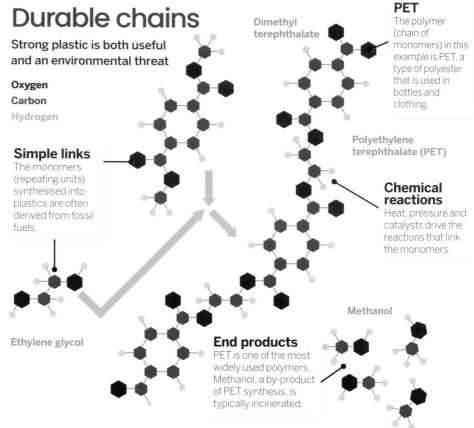

Dimethyl terephthalate

PET
The polymer (chain of monomers) in this example is PET, a type of polyester that is used in bottles and clothing.

Polyethylene terephthalate (PET)

Chemical reactions
Heat, pressure and catalysts drive the reactions that link the monomers.

Methanol

End products
PET is one of the most widely used polymers. Methanol, a by-product of PET synthesis, is typically incinerated.

Ethylene glycol

where it will stay for several human lifetimes; enzymes made by living things can't touch the human-made chains that make plastic so strong and durable.

WHAT CAN WE DO?

The Ocean Cleanup project sits at the very end of the plastic economy, mopping up the river of waste pouring out of our homes and businesses. But, as System 001 scours the sea, people across the globe are stepping up to battle the plastic production line.

The biggest plastic-producing sector is packaging. There are bags, trays and films made from low-density polyethylene (LDPE); milk and shampoo bottles made from high-density polyethylene (HDPE); water bottles and cleaning fluid bottles made from polyethylene terephthalate (PET); plates, cups and cutlery made from polystyrene; insulated packaging made from expanded polystyrene; and bottle caps, crisp packets and ice cream tubs made from polypropylene. Across the world, we use an estimated 10 million plastic bags every single

> *"Making paper produces more pollution than making plastic"*

minute. To stem the plastic tide, it makes sense to start here.

Since it launched in 2017, more than 50 countries have signed up to the UN Environment Clean Seas campaign. Single-use plastic is now firmly in the firing line, and countries across the world are phasing them out. Taiwan is ramping up to a total ban on single-use straws, cups and plastic bags, Zimbabwe plans to ban expanded plastic food packaging, and Kenya has already made plastic bags illegal; people found making, selling or using them face a fine of up to £30,000 (approximately $38,000) or up to four years in prison. They may seem drastic, but these tactics are working. In the UK, a 5p tax on single-use plastic bags has seen the number of bags used in England drop by more than 80 per cent.

Bags, straws and microbeads are some of the easiest targets; switching to non-plastic alternatives is cheap and simple. But when it comes to other single-use products like bottles, cutlery and coffee cups, the challenge is greater. One option is to replace plastics with traditional materials. We could use glass, metal, paper, card or jute (vegetable fibre). Yet, while recyclable, these materials

The bacteria that eat plastic

In 2016, scientists found a plastic-munching bug at a bottle recycling facility in Japan

PETase
The bacteria makes enzymes called PETases, which break down the plastic polymer chains.

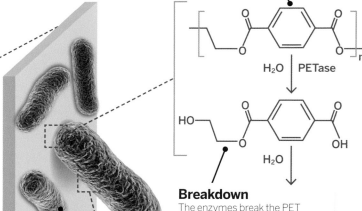

Breakdown
The enzymes break the PET polymer into chunks of mono(2-hydroxyethyl) terephthalic acid.

Ethylene glycol + Terephthalic acid

Digestion
The bacteria take up the chemical chunks and split them apart to make their own molecules.

PET
Polyethylene terephthalate (PET) is the kind of clear plastic used in drinks bottles.

Ideonella sakaiensis
Scientists discovered a species of bacteria that has evolved to use PET as food.

WHAT IS PLASTIC?

Plastic polymers are long chains of molecules linked by carbon-carbon bonds.	Polymer chains contain thousands of repeating subunits called monomers.	Polymers also exist in nature, but their chemical bonds break down more easily.	Thermo-plastics melt when they get hot, reforming into new shapes.	Thermosets fix into one shape and don't melt when heated.	Chemical additives, like dyes, can slot between the polymer chains.	There are seven kinds of plastic, sorted according to their chemical similarities.	The raw ingredients for plastics are hydro-carbons from coal, gas and oil.

5 FACTS ABOUT COMPANIES MAKING CHANGES

1 Ecostrawz
Ecostrawz make reusable and single-use straws without any plastic. Their glass and metal options last for a good few years, while their bamboo and wheat versions rapidly decompose.

2 KeepCup
The makers of these reusable cups designed them with takeaway coffee in mind. With replaceable parts made from plastic, glass and silicone, they're designed to last for years, not minutes.

3 BioCellection
This California-based start-up focuses on contaminated plastic waste that's too dirty to recycle. They shred the waste, decompose the polymers and turn the plastic into chemicals that can be used for something new.

4 Recycling Technologies
This company uses heat to crack through plastic polymers. Their recycling process breaks up the long strands, turning them back into oil and gas that can then be used again.

5 Vegware
This company sell plant-based disposable packaging to cafes, restaurants and bars. When combined with food waste and sent to industrial recycling facilities Vegware becomes compost in just 12 weeks.

The challenge of recycling
Some items are harder to reycle than others

▲ Easy ▲ Difficult
▲ Manageable ▲ Very difficult

① PET
Polyethylene terephthalate
Bottles, food jars, clothing, carpet fibre, some shampoo and mouthwash bottles.
11%
(global plastic waste, 2015)

② HDPE
High-density polyethylene
Detergent and bleach bottles, snack boxes, milk jugs, toys, buckets, plant pots and bins.
14%

③ PVC
Polyvinyl chloride
Credit cards, window and doorframes, gutters, pipes and synthetic leather.
5%

④ LDPE
Low-density polyethylene
Packaging film, bags, bubble wrap, flexible bottles, wire and cable insulation.
20%

⑤ PP
Polypropylene
Bottle tops, drinking straws, lunch boxes, coolers, fabric and carpet fibres, tarps and nappies.
19%

⑥ PS
Polystyrene
Plastic-foam cups, egg boxes, meat trays, packing peanuts, coat hangers, yoghurt pots and insulation.
6%

⑦ OTHER
Nylon fabrics, baby bottles, compact discs, medical storage containers, car parts and watercooler bottles.
24%

aren't always better for the environment. Making paper produces more pollution than making plastic, and it also consumes more energy and more water. And, while glass production is more environmentally friendly, the containers themselves are heavy and bulky, racking up more pollution when products are eventually shipped out.

Creative start-ups are already experimenting with new options, including cutlery made from wheat, water bottles made from seaweed and six-pack rings made from barley. Designed to disappear after you use them, they satisfy the craving for single-use solutions without polluting the planet. But knocking plastic off the top spot will take time. Until then, we need to work with what we've got.

In Japan, there are no plastic bans yet. Instead, they focus on waste management, prioritising recycling so that trash never reaches the sea. Non-recyclable plastics pass through incinerators, releasing heat that turns turbines to make electricity. This approach tries to turn our linear model of product design, consumption and waste into a more circular system. The dream would be to close the loop so that all discarded plastics become raw materials for future production. Changes to design and recycling could make products last longer, make them easier to repair and easier to repurpose at the end of their life, and changes to energy recovery methods could help us to get more out of plastics too contaminated for reuse.

A lifetime of plastic

We produce it by the ton but use it for a relatively short time

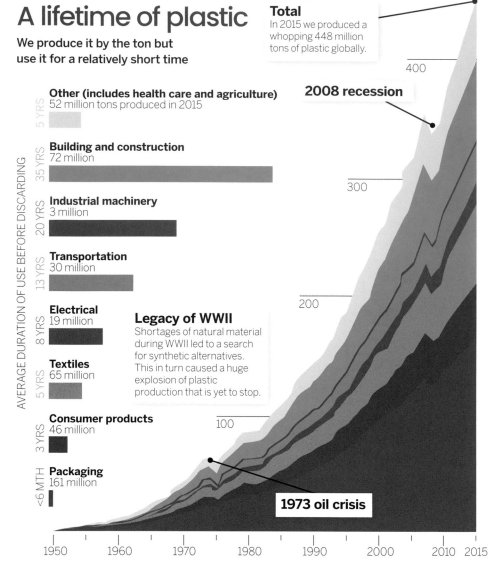

Total
In 2015 we produced a whopping 448 million tons of plastic globally.

2008 recession

AVERAGE DURATION OF USE BEFORE DISCARDING

Other (includes health care and agriculture)
5 YRS — 52 million tons produced in 2015

Building and construction
35 YRS — 72 million

Industrial machinery
20 YRS — 3 million

Transportation
13 YRS — 30 million

Electrical
8 YRS — 19 million

Legacy of WWII
Shortages of natural material during WWII led to a search for synthetic alternatives. This in turn caused a huge explosion of plastic production that is yet to stop.

Textiles
5 YRS — 65 million

Consumer products
3 YRS — 46 million

Packaging
<6 MTH — 161 million

1973 oil crisis

400
300
200
100

1950 1960 1970 1980 1990 2000 2010 2015

The Ocean Cleanup
The floating nets collecting waste in the oceans

1 Chasing plastic
A three-metre skirt dangles from a 600-metre floater. Wind and waves push against the floater, moving it through the water faster than the plastic, which floats in the current.

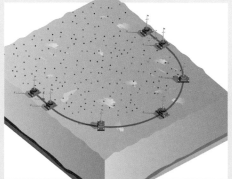

2 Corralling the plastic
Plastic particles cannot get over the floater or under the skirt. As the wind and waves move the structure through the water the plastic becomes trapped inside.

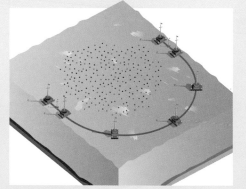

3 Build up
Pressure on the skirt from the current bends the system into a U-shaped trap, preventing plastic from escaping. It moves with the wind, tracking the plastic through the water.

How much plastic do we produce?

1950
2M
METRIC TONS

2017
8.3B
METRIC TONS

2050
34B
PROJECTED METRIC TONS

How heavy is 8.3 billion metric tons?

160,985 x Sydney Harbour Bridge
58,200 metric tons

4 million x London Eye
2,100 metric tons

75 million x Dreamliner
110 metric tons

1 billion x Elephant
7.5 metric tons

This process is already underway. In Europe, a goal set in December 2017 aims to see 55 per cent of plastic packaging recycled by 2030. But there's only so much we can do in our own homes to recycle the goods we buy. To help us to achieve this goal, policy changes could start to make companies responsible for what happens to their products after we've used them. In South Africa, for example, members of the PET Recycling Company pay a levy on the raw materials for plastic production. This money then goes back into redesigning packaging and recycling post-consumer waste. Not only does this help the planet, it also creates jobs, which can be better for economies than banning plastics all together. Back in the

UK, the UK Plastics Pact is working with the packaging sector to transition to reusable, recyclable or compostable plastics. They also want to bring plastic recycling to 70 per cent by 2025.

Scientists are experimenting with biodegradable plastics, like polylactide (PLA). It's made from lactic acid, which comes from corn, and it takes just 12 months to break down. For plastics that we can't recycle, new methods hope to capture more energy from waste by turning them into fuels. A process called gasification heats plastics with air to make a gas that can be burnt. Another, called pyrolysis, heats them without air to make a liquid fuel like oil.

There are still problems to iron out with these new technologies. Burning plastic waste can be hazardous, and to make enough biodegradable plastics to replace the real thing we would need to turn over vast areas of land to corn monocultures. Then there is the fact that even though biodegradable plastics can break down, it doesn't mean that they will. They need to reach temperatures over 50 degrees Celsius, which is achievable inside industrial composters, but not when plastics escape into the ocean. But we're moving in the right direction, and we all have a part to play.

We as individuals can choose alternatives to plastics and put pressure on governments and brands to make bigger changes. If we focus on reduction, reuse and recycling, we could close the loop in the plastic economy and stop this incredible material leaking out into the sea.

Why won't plastic biodegrade?

Microbes quickly get to work on organic waste, like paper and vegetable peelings, but they can't get to grips with plastic. This might seem odd, as we make plastic from oil, which comes from the remains of ancient plants and animals, but it's all down to the way plastic is made.

Natural polymers use chemical links called peptide bonds, while plastic polymers contain carbon-carbon bonds. These bonds are much stronger, and that's both a gift and a curse. Most of the enzymes living things use to break organic molecules down can't manage to break these links. This helps to make plastics so durable, but it also makes them hard to get rid of.

There are only a handful of organisms, including some fungi and bacteria, capable of breaking them down. Scientists are still working out how best to use them. Ironically, if more organisms learn this trick, it could put the durability of vital plastic structures under threat.

Approximately 2.1 billion tons of waste is dumped globally every year

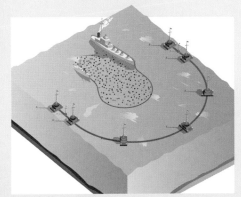

4 Clean up
The system sends signals to satellites overhead, keeping operators updated about its status. As plastic starts to build up, support vessels come in to gather the waste.

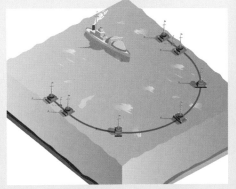

5 Recycling
The collected plastic returns to shore for proper disposal. Meanwhile, the system continues to move through the water collecting even more waste.

How long does waste take to break down?

1 month
For a paper bag to decompose

2 months
To get rid of a cardboard box

1 million years
For an aluminium can to break apart

2 years
To compost an orange peel

12 years
For a cigarette butt to disintegrate

20 years
Until a plastic bag breaks apart

DRINK
450 years
For a plastic bottle to fall to bits

WHAT CA

CARRY A REUSABLE CUP AND WATER BOTTLE WITH YOU

According to the World Wildlife Fund, people in the UK throw away more than 7 million coffee cups every day. Invest in a reusable cup and bottle and ditch the disposables. Many coffee outlets offer a discount if you bring your own cup, and you can find free places to refill your water bottle using the app Refill.

SAY NO TO SINGLE-USE CUTLERY

We only use plastic cutlery for a few minutes before we throw it away, so minimise your plastic footprint by refusing disposable knives, forks and straws. Pop a normal fork in your bag for lunch on the go and invest in a washable metal straw if you can't go without. If you find yourself caught out, look for outlets offering biodegradable or edible cutlery.

TRY ZERO-WASTE SHOPPING

Rather than picking a pre-filled plastic bag from a shelf, try bringing your own bags and opting for loose fruit, vegetables and bread. Some 'zero-waste' supermarkets also allow you to buy loose dried foods like oats, nuts, tea, spices and crisps. Even if you don't live near one, you can still save on plastic by saying no to products with excessive wrappers. Opt instead for store cupboard staples with metal, glass or cardboard packaging.

AN YOU DO?

INVEST IN REUSABLE BAGS AND BOXES

Ditch cling-film, freezer bags and foam takeaway packets and invest in a set of reusable bags and boxes for your lunch and leftovers. Hard, recyclable plastic boxes last much longer than their disposable counterparts and can be stored in the fridge or freezer and put in a microwave. Or, if you'd prefer to be completely plastic free, you could opt for glass, metal or dishwasher-safe silicone.

SWAP LIQUIDS FOR BARS AND POWDERS

Laundry detergent, hand soap, shampoo and other cleaning products contain a lot of water, and because they're wet we need to store them in plastic. Adding the water yourself at home can save a mountain of packaging. Where possible, switch to dry versions packed in paper or card, like solid soap and laundry powder. When you do need to buy liquids look for concentrated versions and dilute them down at home.

SWITCH TO REUSABLE NAPPIES

Reusable nappies have come a long way since bulky terry towelling. No longer pinned together, they now offer poppers and velcro and there are no fancy folds to learn; they go on just like disposables. They have three parts: a waterproof wrap on the outside, an absorbent nappy in the middle, and a biodegradable or washable liner next to the skin. Pre-rinse cold in the washing machine and then run a long, warm wash to get them clean. Not only do they prevent nappies going to landfill, but they work out cheaper, even with all the washing.

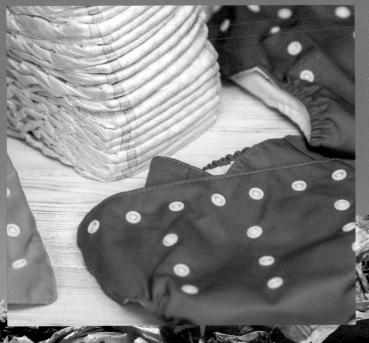

10
ENDANGERED OCEAN SPECIES

Meet the incredible marine species highlighting why we need to act now to save our oceans

Words by **Zara Gaspar**

Conservationist Jacques Cousteau once said, "People protect what they love," so why are we pushing more and more ocean species to the brink of extinction? Our oceans cover over 70 per cent of the planet, yet only 3.4 per cent of those waters are protected by law, and species are still being killed illegally. Perhaps because we can't see ocean creatures as easily as land animals, it's easier to turn a blind eye to the effect we're having on them, or maybe it's because the ocean is so vast that we feel there's an endless supply for our demands.

A 2015 International Union for the Conservation of Nature (IUCN) study found 514 land animals disappeared from the Earth in the past 500 years, but only 15 ocean species, such as the great auk, became extinct in this time. There are an estimated one million marine species and many more yet to be discovered, but we are pushing them to the edge of existence. According to the IUCN, in 2007, 80 per cent of the marine species listed on the Red List were threatened with extinction. Over a third of marine mammals are threatened, and 50 per cent of coral reefs have been lost over the past 150 years, largely because of humans. In 2014 alone, there were 5.25 trillion pieces of plastic found in the ocean. We're killing animals by polluting the seas with our waste and using the ocean as a transport route causing noise pollution, oil spills and boat collisions.

Our actions are also contributing to global warming and the rise in sea level temperatures. Billions of unwanted fish die needlessly due to unsustainable fishing – 90 per cent of the world's fisheries are overexploited. As our populations grow and we develop more coastline we are destroying habitats by pouring untreated sewage, chemicals and pesticides into the water.

Worst of all, animals are still being poached, not only for food, but for fur, medicine, jewellery and other goods. Some species have existed for millions of years, long before humans. They make up an important part of the world's ecosystems and we need them to survive. If we don't act now, they'll soon be lost forever.

The coral reefs that hawksbill turtles feed on have declined by 80 per cent over the last century

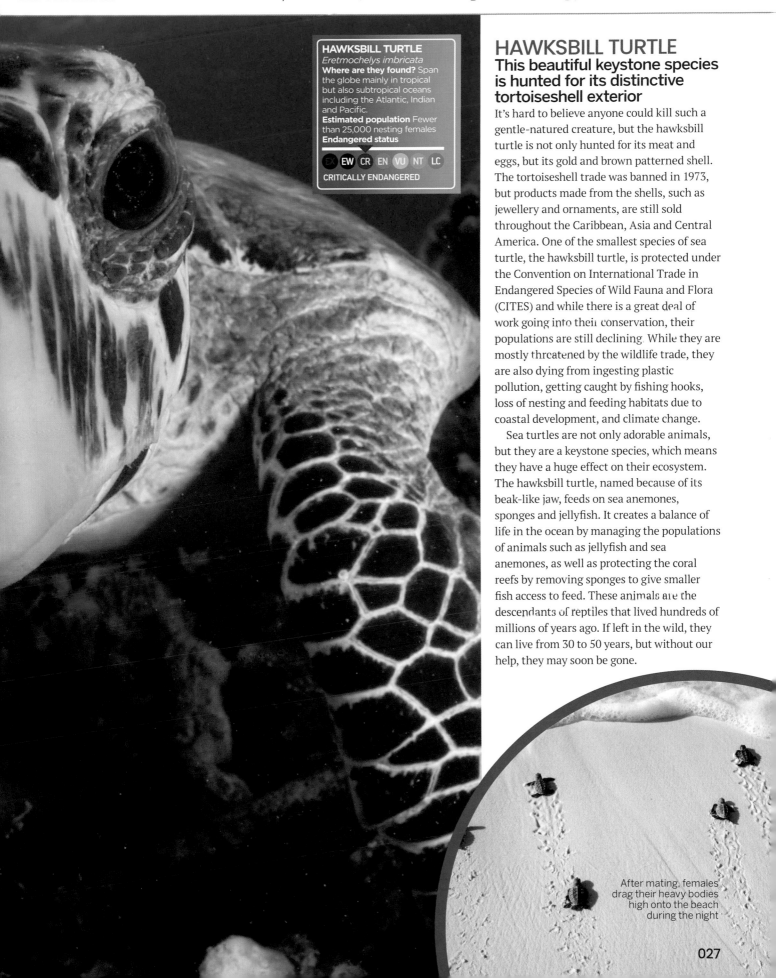

HAWKSBILL TURTLE
Eretmochelys imbricata
Where are they found? Span the globe mainly in tropical but also subtropical oceans including the Atlantic, Indian and Pacific.
Estimated population Fewer than 25,000 nesting females
Endangered status

EX EW **CR** EN VU NT LC

CRITICALLY ENDANGERED

HAWKSBILL TURTLE
This beautiful keystone species is hunted for its distinctive tortoiseshell exterior

It's hard to believe anyone could kill such a gentle-natured creature, but the hawksbill turtle is not only hunted for its meat and eggs, but its gold and brown patterned shell. The tortoiseshell trade was banned in 1973, but products made from the shells, such as jewellery and ornaments, are still sold throughout the Caribbean, Asia and Central America. One of the smallest species of sea turtle, the hawksbill turtle, is protected under the Convention on International Trade in Endangered Species of Wild Fauna and Flora (CITES) and while there is a great deal of work going into their conservation, their populations are still declining. While they are mostly threatened by the wildlife trade, they are also dying from ingesting plastic pollution, getting caught by fishing hooks, loss of nesting and feeding habitats due to coastal development, and climate change.

Sea turtles are not only adorable animals, but they are a keystone species, which means they have a huge effect on their ecosystem. The hawksbill turtle, named because of its beak-like jaw, feeds on sea anemones, sponges and jellyfish. It creates a balance of life in the ocean by managing the populations of animals such as jellyfish and sea anemones, as well as protecting the coral reefs by removing sponges to give smaller fish access to feed. These animals are the descendants of reptiles that lived hundreds of millions of years ago. If left in the wild, they can live from 30 to 50 years, but without our help, they may soon be gone.

After mating, females drag their heavy bodies high onto the beach during the night

The great hammerhead has declined by 80 per cent in the past 25 years

GREAT HAMMERHEAD SHARK
Sphyrna mokarran
Where are they found?
Worldwide throughout tropical and warm temperate seas
Estimated population
Unknown
Endangered status

EX · EW · CR · EN · VU · NT · LC

CRITICALLY ENDANGERED

GREAT HAMMERHEAD SHARK
While fairly harmless to humans, this amazing hunter is still being killed to make shark fin soup

Measuring up to 6.1 metres (20 feet), the great hammerhead shark is the largest of the nine species of hammerheads. Distinguished by its famous T-shaped head, its eyes are set far apart, giving it a better visual range and making it an efficient hunter as it uses its electrical receptors to search out its prey. Thanks to its size, this amazing fish species has no predators other than humans. While it may be big and aggressive when hunting for smaller fish, crustaceans, squid and octopus, it is mostly harmless, and few attacks on humans have been recorded. However, it still suffers from overfishing and is targeted for its big fin. Once caught, the shark's fin is cut off, and the shark thrown back into the sea to bleed to death. The great hammerhead has no protection from the Endangered Species Act and is still mercilessly killed. As it only reproduces every two years, numbers are still on the decline.

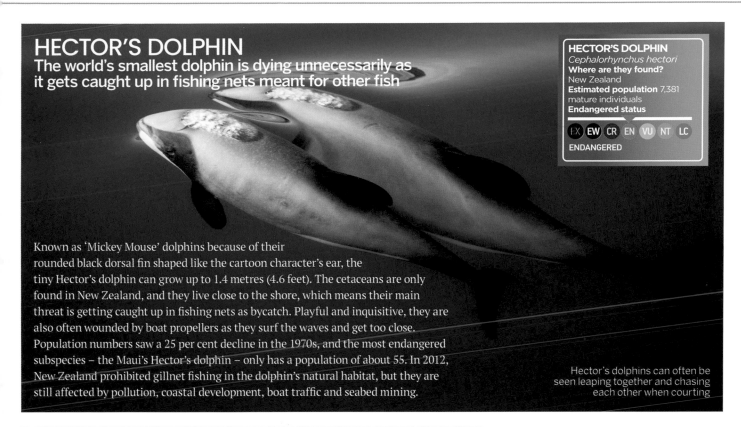

HECTOR'S DOLPHIN
The world's smallest dolphin is dying unnecessarily as it gets caught up in fishing nets meant for other fish

HECTOR'S DOLPHIN
Cephalorhynchus hectori
Where are they found?
New Zealand
Estimated population 7,381
mature individuals
Endangered status

EX · EW · CR · EN · **VU** · NT · LC

ENDANGERED

Known as 'Mickey Mouse' dolphins because of their rounded black dorsal fin shaped like the cartoon character's ear, the tiny Hector's dolphin can grow up to 1.4 metres (4.6 feet). The cetaceans are only found in New Zealand, and they live close to the shore, which means their main threat is getting caught up in fishing nets as bycatch. Playful and inquisitive, they are also often wounded by boat propellers as they surf the waves and get too close. Population numbers saw a 25 per cent decline in the 1970s, and the most endangered subspecies – the Maui's Hector's dolphin – only has a population of about 55. In 2012, New Zealand prohibited gillnet fishing in the dolphin's natural habitat, but they are still affected by pollution, coastal development, boat traffic and seabed mining.

Hector's dolphins can often be seen leaping together and chasing each other when courting

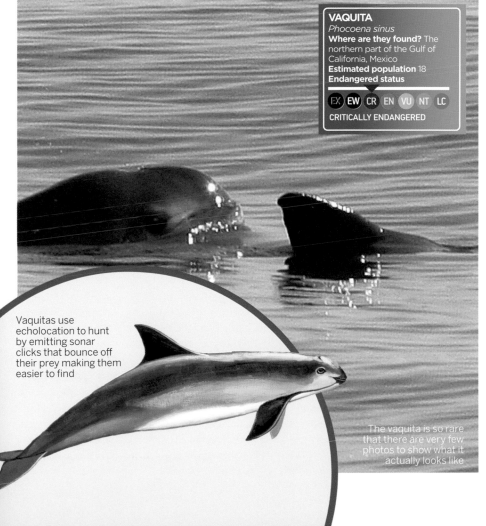

VAQUITA
Phocoena sinus
Where are they found? The northern part of the Gulf of California, Mexico
Estimated population 18
Endangered status

EX · EW · **CR** · EN · VU · NT · LC

CRITICALLY ENDANGERED

Vaquitas use echolocation to hunt by emitting sonar clicks that bounce off their prey making them easier to find

The vaquita is so rare that there are very few photos to show what it actually looks like

VAQUITA
This shy, unique species of porpoise is dangerously close to extinction thanks to illegal fishing

First discovered in 1958, the vaquita – or 'little cow', as it's known in Spanish thanks to the dark circles around its eyes – is the smallest and rarest marine mammal on Earth. Its population declined by 90 per cent from 2011 to 2016, and now there are thought to be only around 18 left in the world. Found only in a 4,000 square kilometre area in the Gulf of California between Mexico and Baja California, these shy creatures live in shallow water or in open water less than 25 kilometres from the shore, yet they are rarely seen. The worst culprit for their decline is illegal gill-netting (using fixed fishing nets). The practice was banned by the Mexican government in 2017, but is still used. The animals are trapped in the nets and drown as they are unable to surface to breathe. Around 15 per cent die a year as they become entangled in fishing nets, and others are killed from chlorinated pesticides in the water. Vaquitas only reproduce once every two years. Calves were spotted with their mother in 2019, so they're still reproducing, but who knows for how long they will survive.

BLUE WHALE
These fascinating giants of the deep face a new challenge after being persecuted for decades

Weighing a massive 200 tons (the equivalent of 33 elephants) and measuring up to 33 metres (110 feet), the blue whale is the world's largest living animal. It also sets the record for the loudest animal on Earth, reaching calls of 188 decibels (more than a jet engine). Blue whales have unique vocalisations that they use to communicate, and these have inspired the technology behind watercraft sonar and wind turbine blades. These giants are at the top of the food chain, and vital for maintaining a healthy ocean ecosystem. But despite being one of the most fascinating species, they are also one of the most persecuted marine mammals. Whales have a long history of being hunted for their meat and blubber, not only for food but to make oil, soap, perfume and cosmetics. Fortunately, since they were granted legal protection by the International Whaling Commission in 1966, commercial whaling is not as much of a threat, but now they face new challenges including entanglement in fishing nets, noise pollution from gas and oil developments, a decline in food sources due to the decline in krill being caught to feed farm-raised fish, and climate change. With as few as 5,000 left, we are pushing them to their limits.

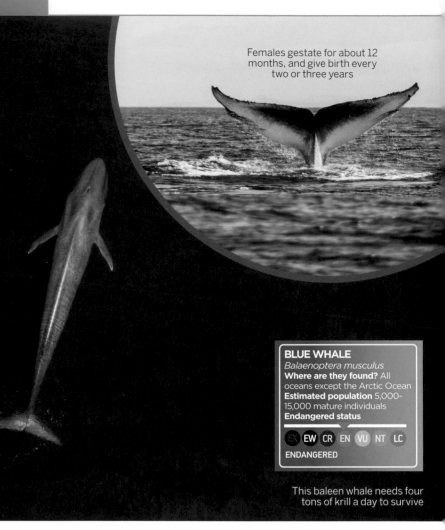

Females gestate for about 12 months, and give birth every two or three years

BLUE WHALE
Balaenoptera musculus
Where are they found? All oceans except the Arctic Ocean
Estimated population 5,000-15,000 mature individuals
Endangered status

EX **EW** CR EN **VU** NT LC
ENDANGERED

This baleen whale needs four tons of krill a day to survive

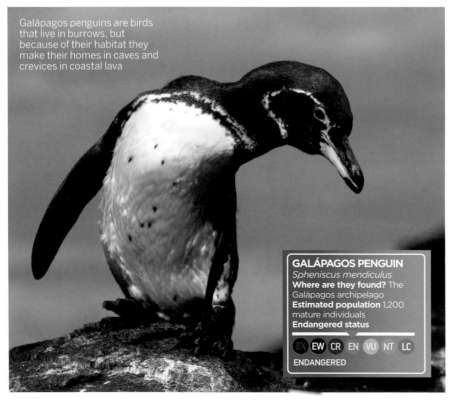

Galápagos penguins are birds that live in burrows, but because of their habitat they make their homes in caves and crevices in coastal lava

GALÁPAGOS PENGUIN
Spheniscus mendiculus
Where are they found? The Galápagos archipelago
Estimated population 1,200 mature individuals
Endangered status

EX **EW** CR EN **VU** NT LC
ENDANGERED

GALÁPAGOS PENGUIN
There's only one love for this tuxedo-wearing bird, but it's running out of time to mate

Endemic to the Galápagos Islands, the Galápagos penguin is the smallest of the South American penguins, and the only species that lives north of the equator. It is one of the few animals on Earth that has one mate for life, but its love life isn't going anywhere thanks to its conservation status. The biggest threat to this endangered bird is climate change. The 1982 El Nino storm saw a 77 per cent decline in the Galápagos penguin population. The weather changes not only affect breeding success with the loss of food sources, but rising sea temperatures affect the Humboldt Current that the birds rely on. They can live between 15 to 20 years in the wild, but may not last if they can't reproduce. Numbers have also declined due to the introduction of species such as cats, rats and dogs to the islands; snakes, owls and hawks on land; and sharks and seals in the water. Other threats to survival include plastic pollution and becoming bycatch.

SEA OTTER
Their fur may make them cute and loveable, but it's also the reason so many are being killed

One of the smallest marine mammals, the sea otter has the densest fur of any animal, with one million hairs per square inch. They're not only cute and furry, but highly skilled as well. They are the only marine mammals that use rocks to crack open shells like mussels, and they hold hands while they sleep to prevent themselves floating away from each other. Sea otters are also keystone species, which means they're an important part of their environment. By feeding on sea urchins, they help ensure kelp forests continue to thrive. You may wonder how anyone could kill such an adorable creature, but their pelts were once highly sought-after. Fortunately, a ban on large-scale hunting was introduced in 1911, and numbers have risen since then, but they are still endangered with threats including pollution, oil spills and entanglement in fishing nets.

Sea otters need to eat 25 to 40 per cent of their body weight to keep warm

SEA OTTER
Enhydra lutris
Where are they found? Along the coasts of the Pacific Ocean in North America and Asia
Estimated population Around 3,000
Endangered status

EX | EW | CR | EN | **VU** | NT | LC

ENDANGERED

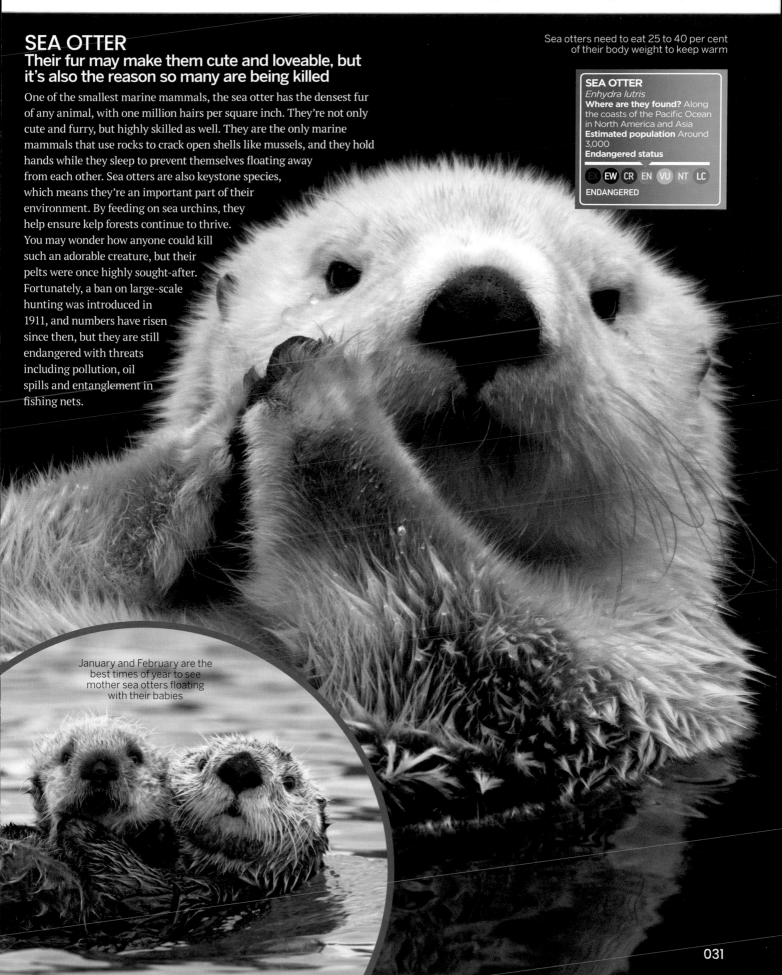

January and February are the best times of year to see mother sea otters floating with their babies

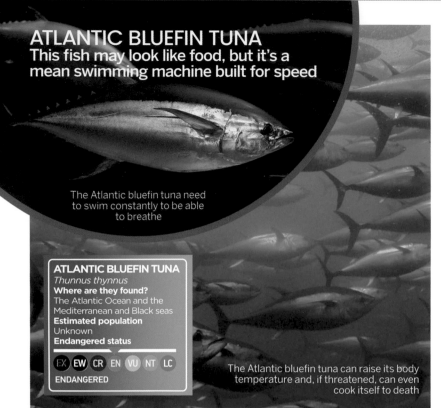

ATLANTIC BLUEFIN TUNA
This fish may look like food, but it's a mean swimming machine built for speed

The Atlantic bluefin tuna need to swim constantly to be able to breathe

ATLANTIC BLUEFIN TUNA
Thunnus thynnus
Where are they found?
The Atlantic Ocean and the Mediterranean and Black seas
Estimated population
Unknown
Endangered status

EX EW CR EN **VU** NT LC

ENDANGERED

The Atlantic bluefin tuna can raise its body temperature and, if threatened, can even cook itself to death

Humans enjoy tuna for its high fat content and as a healthy dose of Omega-3, but demand for bluefin tuna rose during the 1970s as sushi and sashimi became big in Japan. Measuring two metres (6.5 feet) and weighing 250 kilograms (550 pounds), it has a market value of tens of thousands of pounds. One fish even sold for $1.75 million. Fishing for tuna has been overexploited, especially in the eastern and western Atlantic where fishing boats often ignore quotas and time closures and, although management of fisheries has improved, we won't see the results of this in fish stocks for years to come. The largest and most endangered species of tuna, the Atlantic bluefin tuna is still endangered, but the tragedy is that this fish species is seen as food or a prize in sport, when it has so much more to offer as one of the ocean's greatest predators. This fish is built for speed with its torpedo-shaped body. Its metallic-blue colour helps it camouflage from above and below in the water, and it has the sharpest vision of any bony fish. It hunts in packs and can dive 914 metres (3,000 feet) as it searches for herring and mackerel. But it is not only a skilled hunter. The species is also an important part of the food chain and its ecosystem. It lives in the open seas, but only breeds in the Mediterranean Sea and the Gulf of Mexico.

HAWAIIAN MONK SEAL
The second most-endangered pinniped, this earless seal on the brink of extinction is in a real tangle

One of the last two surviving monk seals, the Hawaiian monk seal (alongside the Mediterranean monk seal) is in danger of going extinct just like the Caribbean monk seal. Unlike most seals that live in the cold, this solitary creature enjoys a tropical climate, and is one of only two mammals endemic to Hawaii. The Hawaiian monk seal has been listed as Endangered by the US Endangered Species Act since 1976. It was driven to the brink of extinction in the 19th century, as it was persecuted for its meat, oil and skin, but since then it has seen a continuous decline with a 20 per cent population drop from 1983 to 2011. It is hunted by tiger and Galápagos sharks, and pups are often killed by aggressive males, but deaths are mainly at the hands of humans. It not only has one of the highest rates of entanglement of all marine mammals, but it also suffers from ingesting plastic pollution, the destruction of its habitat and food sources due to coastal development, rising sea level and erosion from storms, and human interactions. You can't help but smile as you see them enjoy sunbathing, but the threats against them and their slow reproductive rate mean there may soon be none left to smile at.

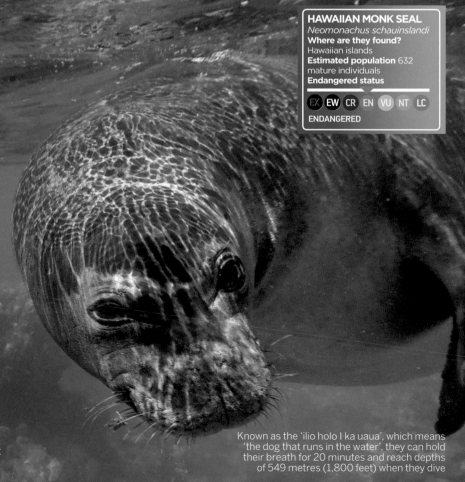

HAWAIIAN MONK SEAL
Neomonachus schauinslandi
Where are they found?
Hawaiian islands
Estimated population 632 mature individuals
Endangered status

EX **EW** CR EN VU NT LC

ENDANGERED

Known as the 'ilio holo I ka uaua', which means 'the dog that runs in the water', they can hold their breath for 20 minutes and reach depths of 549 metres (1,800 feet) when they dive

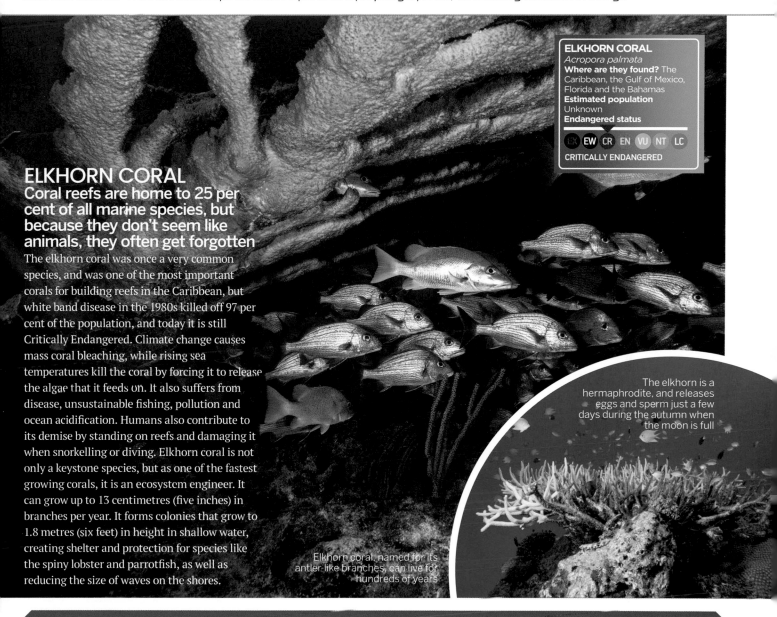

ELKHORN CORAL
Acropora palmata
Where are they found? The Caribbean, the Gulf of Mexico, Florida and the Bahamas
Estimated population Unknown
Endangered status

EX | EW | CR | EN | VU | NT | LC

CRITICALLY ENDANGERED

ELKHORN CORAL

Coral reefs are home to 25 per cent of all marine species, but because they don't seem like animals, they often get forgotten

The elkhorn coral was once a very common species, and was one of the most important corals for building reefs in the Caribbean, but white band disease in the 1980s killed off 97 per cent of the population, and today it is still Critically Endangered. Climate change causes mass coral bleaching, while rising sea temperatures kill the coral by forcing it to release the algae that it feeds on. It also suffers from disease, unsustainable fishing, pollution and ocean acidification. Humans also contribute to its demise by standing on reefs and damaging it when snorkelling or diving. Elkhorn coral is not only a keystone species, but as one of the fastest growing corals, it is an ecosystem engineer. It can grow up to 13 centimetres (five inches) in branches per year. It forms colonies that grow to 1.8 metres (six feet) in height in shallow water, creating shelter and protection for species like the spiny lobster and parrotfish, as well as reducing the size of waves on the shores.

The elkhorn is a hermaphrodite, and releases eggs and sperm just a few days during the autumn when the moon is full

Elkhorn coral, named for its antler-like branches, can live for hundreds of years

What can be done?

Humans may be one of the main reasons for the threats facing these species, but we can also be the solution. Some of the conservation programmes that have been introduced to help protect these species from extinction include designating marine protected areas, reducing destructive fishing practices and the amount of fish caught accidentally, and recording survey results. But, as individuals, there is also plenty we can do from not littering to recycling and buying eco-friendly MSC-certified fish. You can also cut down on your carbon footprint by travelling by foot or bicycle where possible, and reduce water use by switching off taps and taking showers instead of baths. It only takes that first step to make a difference.

One way to help our oceans' species is to reduce our carbon footprint by cycling instead of travelling by car

SECRETS OF THE SEA

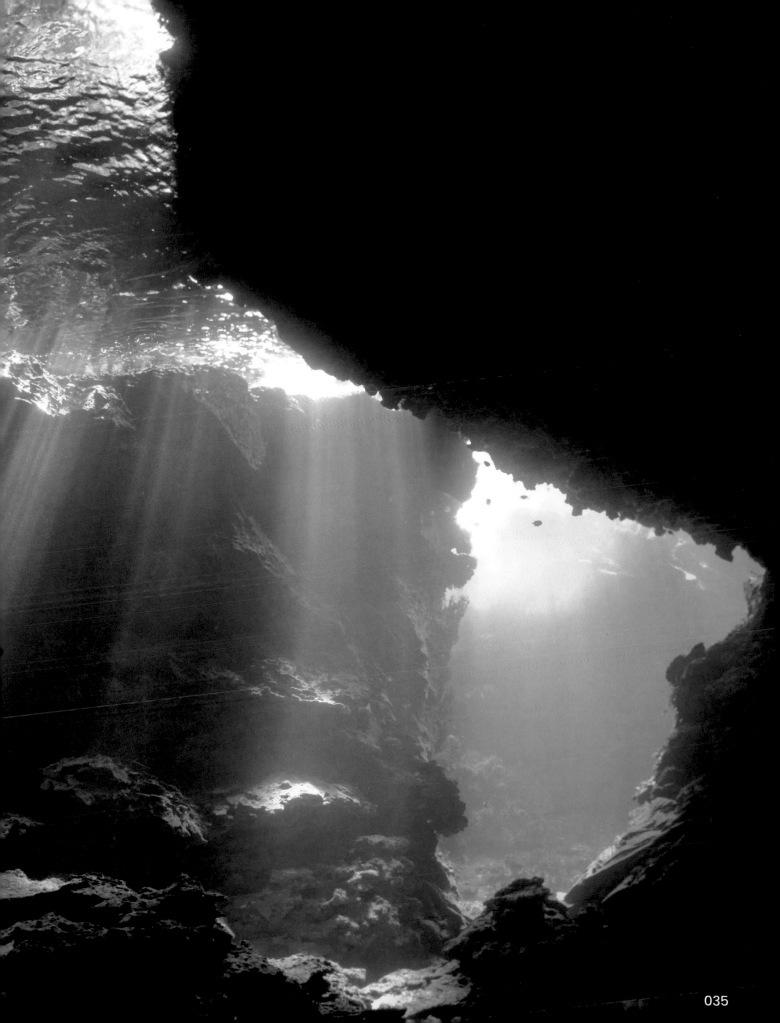

Extreme oceans

Counting down the deepest, deadliest, stormiest and downright most hostile environments on Earth

Where: New South Wales, Australia
Oceans: Tasman Sea / South Pacific

1 Most shark-infested

Just like Jaws, only less cinematic trickery and more lose-a-leg scary

When it comes to shark attacks, there are three species that sit firmly at the top of the food chain: the great white shark, the tiger shark and the bull shark. This is one gnarly trio of hungry fish, who are all keen predators with heightened senses.

The most extreme place on Earth for shark attacks recently is New South Wales coast in Australia and over the last year the country has seen two fatalities, 29 attacks and 18 injuries. It's thought that changing ocean currents are bringing the sharks' prey closer to shore, luring in the ocean beasts alongside the fish.

However, before you march out with your torch and pitchfork to chase the sharks from the bays, it's worth bearing in mind that many more people are killed by the water that sharks swim in than by shark attacks themselves. Humans are naturally not a good diet choice for a shark – we are too bony with far too little blubber on us. Sharks need prey that is high in fat, such as seals.

Very often a great white shark will bite a human as a curious nip to find out what they are, rather than in an attempt to feast on them. That said, when you're swimming in an area with a known shark presence, the best advice is to get out of the water. Swim calmly and smoothly, as thrashing around will only draw the shark's attention, and don't ever wear jewellery or anything shiny that could make the shark think that you're a tasty fish covered in scales.

The subterranean canyon off the coast of Nazaré creates incredibly tall waves, making it a popular surfing spot

65,000 km
Length of the Mid-Ocean Ridge

2 Tallest waves

It's the stuff of every big-wave surfer's dreams: the 30-metre wave. Praia do Norte near the coastal village of Nazaré in Portugal is at one of the most westerly points of Europe, and bears the brunt of the sweeping Atlantic swells. Europe's largest underwater canyon, Nazaré Canyon, lies just offshore, which is a 200-kilometre long ravine that works to combine the energy from waves that have travelled across the Atlantic, currents from the canyon, gusting winds and local tidal forces into colossal waves.

Where: Nazaré, Portugal
Ocean: Atlantic Ocean

31 DAYS
The longest-lasting hurricane

3 Fastest growing

Plate tectonics can cause chaos through earthquakes, but they can also cause oceans to grow. The region offshore from Chile and Peru on the East Pacific Rise, where the Pacific plate is pulling away from the Nazca plate, is the site of the fastest seafloor spreading on Earth. This is where two plates pull away from each other, and magma bubbles up from the Earth's core to fill the gap. In this region, up to 16 centimetres of new seafloor is produced per year.

Where: East Pacific Rise
Ocean: Pacific Ocean

WHERE ARE THEY?

2

ARCTIC OCEAN

NORTH AMERICA

EUROPE

ASIA

ATLANTIC OCEAN

AFRICA

PACIFIC OCEAN

CIFIC EAN

SOUTH AMERICA

INDIAN OCEAN

AUSTRALIA

SOUTHERN OCEAN

3

1

© Corbis

4 Extreme storms

Where: Tropical Pacific
Ocean: Pacific Ocean

Is there such a thing as the 'perfect storm'?

Fishermen who make their living out on the waves, battling everything the Pacific throws at them, will tell you that this is one of the cruellest oceans on Earth.

It's the tropical region that whips up this meteorological frenzy and creates the mother of all storms: hurricanes. Fed by very warm, moist air, these weather systems usually form between June and November, and need to reach 120 kilometres per hour or more to be classified as a hurricane, typhoon or cyclone. These three terms describe the same event and just depend on the origin of the storm. In the Atlantic and Northeast Pacific the storms are hurricanes; in the Northwest Pacific they're known as a typhoon; and in the South Pacific and Indian Ocean the weather system is termed a cyclone.

Hurricanes can travel huge distances across oceans, spinning anticlockwise in the Northern Hemisphere and clockwise in the Southern Hemisphere, fed by the warm conditions of the tropics.

A storm name is retired if, like Katrina, it has had catastrophic effects

1.3bn km³
Amount of water (approximate) in the oceans

WHERE ARE THEY?

5 — NORTH AMERICA
7 — ATLANTIC OCEAN
4 —
5 —
9 —
ARCTIC OCEAN
EUROPE
ASIA
PACIFIC OCEAN
5 — PACIFIC OCEAN
AFRICA
INDIA OCEAN
5 —
6 — SOUTH AMERICA
INDIAN OCEAN
8 —
AUSTRALIA
SOUTHERN OCEAN

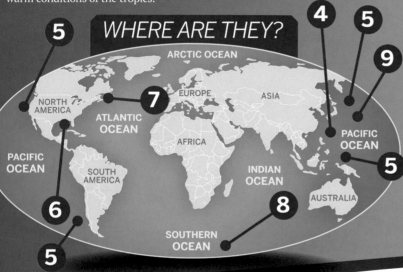

Eye of the storm
Cool, dry air sinks
Outflow of cold air
Warm air continues to rise and cool
Cloud formation
Air sucked inwards to updraft
Clouds begin to spin
Warm, moist air rises in bands

Hurricane formation
How the vast, swirling storms begin life at sea

1 Cloud formation
Over warm, tropical waters, seawater begins to evaporate. As it rises, it cools to rapidly form clouds. Cooler air from the surrounding area rushes in to replace the warm air, which then warms up and rises again, causing updrafts.

2 Rotation begins
The warm air continues to rise, cool and suck in more air from the surroundings below, gaining energy. As the Earth rotates, the clouds start to spin too. A hurricane is formed once wind speeds reach 120km/h.

3 Mature storm
Warm, moist air continues to rise from the ocean and forms clouds in bands around the eye of the storm. Cool, dry air sinks through the eye and also flows out between the cloud bands at the edges of the storm.

5 Deadliest

An entire ocean poised and ready for destruction

Beneath the Pacific Ocean lies a patchwork of molten terror known as the Ring Of Fire. The Earth's crust is made up of tectonic plates that fit together like a jigsaw, floating over a layer of molten rock. At boundary zones, plates rub against each other, push against one another or pull away from one another, each with differing consequences. In the Pacific Ring Of Fire, the landmasses that surround the ocean are at the boundaries of these plates. Home to 90 per cent of earthquakes, the Ring Of Fire is a hotbed of tectonic activity.

In 2011, an earthquake caused devastation in Japan, which is on the edge of the Ring of Fire

Where: South America, North America, across the Bering Strait, Japan and New Zealand
Ocean: Pacific Ocean

Where: Gulf of Mexico dead zone
Ocean: Atlantic Ocean

6 Most polluted

The dead zone in the Gulf of Mexico is one of the most extreme cases of ocean pollution. It covers almost 17,000 square kilometres of hypoxic water – where very little or no oxygen is present. Nothing can grow there, as almost all organisms require oxygen to survive. Dead zones are caused by nutrient runoff from the land (such as agricultural fertilisers) that cause an excess of algal growth. When the algae dies, it decomposes and consumes all of the oxygen in the water.

Dead zones occur in various oceans and inland water bodies, shown here with red dots

Where: Bay Of Fundy, Canada
Ocean: Atlantic Ocean

7 Most extreme tides

At the head of the Bay of Fundy, at the right time of the month, the difference in high tide and low tide can be a huge 16 metres. When the tide is this high, the bay fills and empties 100 billion tons of seawater during each tidal cycle. The huge tide is a result of the bay's shape and depth, as the water within the bay oscillates (like water sloshing from one end of a bathtub to another) in sync with tides from the Atlantic.

The Bay of Fundy stretches for 270km along Canada's east coast and is a tourist hotspot

1,000 YEARS
Time for 1m³ of water to travel around the world's currents

At the very bottom of the globe, surrounding frozen Antarctica, swirls the untameable Southern Ocean. It's home to some of the fastest winds and tallest waves, and also boasts the largest ocean current (the Antarctic Circumpolar Current) that transports more water than all the world's rivers combined. Temperatures can reach a bitterly cold -2 degrees Celsius, because the ocean's salinity lowers its freezing point.

Animals that live in the Southern Ocean also have to adapt to survive. Extra layers of blubber and super-insulating feathers are just a few adaptations, but one of the most extreme has to be that of the Antarctic icefish. This critter has evolved a type of 'antifreeze' protein to prevent ice crystals forming in its body when the temperature plummets.

An incredible feat of survival, the icefish can survive temperatures of -2°C

Where: Surrounding Antarctica
Ocean: Southern Ocean

8 Coldest

Welcome to life in the liquid freezer

10,000–50,000
Number of icebergs produced in the Arctic annually

9 Deepest

Where: Mariana Trench
Ocean: Pacific Ocean

Take a breath and dive deeper than Everest is tall

Gulper eel
True to its name, this eel has a colossal mouth, an excellent weapon for devouring large and nutritious prey.

Chain catshark

Jellyfish

Blue whale
One of the largest ocean denizens, blue whales can reach up to 30m in length and can dive to 500m.

Orange roughy
With an exceptionally long lifespan, this fish gathers in large shoals and is vulnerable to commercial fishing.

Black swallower fish

Wolf eel

Hammerhead shark

Lobster

Fangtooth fish
With their oversized fangs, these fish have the largest teeth relative to body size of any marine species.

Giant squid

Cuttlefish

Barracuda

Bluefin tuna

Great white shark

Surviving in the abyss

What lives in the deepest parts of the ocean?

EPIPELAGIC ZONE
The uppermost layer of oceanic water receives enough light to allow photosynthesis to occur.

MESOPELAGIC ZONE
Sometimes known as the 'twilight' zone, this extends from 200-1,000m down, where the light disappears completely.

BATHYPELAGIC ZONE
Extending down to 4,000m, the only light here is produced by the animals themselves, where bioluminescence rules.

ABYSSOPELAGIC ZONE
Stretching down to 6,000m, three quarters of the deep-ocean floor lies within the abyssal zone.

Tripod fish
This fish's specialised bony fins help it to rest above the thick silt of the abyssal plain in wait for food.

Deep-sea dragonfish
The dragonfish uses its bioluminescent lure to attract and ambush prey.

HADOPELAGIC ZONE
Encompassing the ocean trenches, this zone extends from the abyssal plains right down to the bottom of the world.

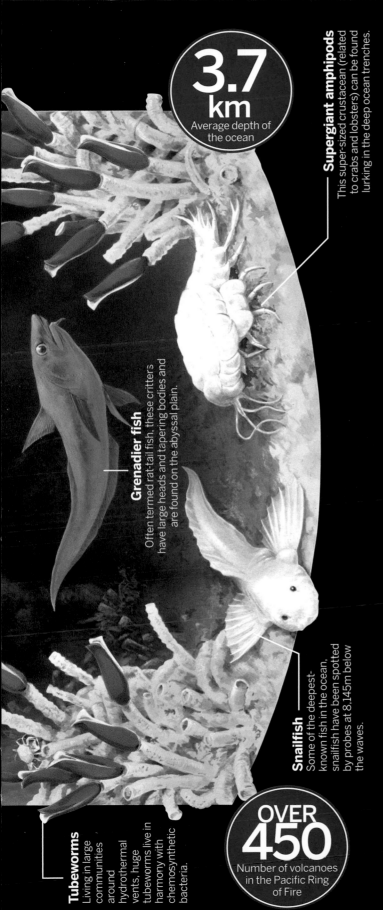

3.7 km
Average depth of the ocean

Supergiant amphipods
This super-sized crustacean (related to crabs and lobsters) can be found lurking in the deep ocean trenches.

Grenadier fish
Often termed rat-tail fish, these critters have large heads and tapering bodies and are found on the abyssal plain.

Snailfish
Some of the deepest-known fish in the ocean, snailfish have been spotted by probes at 8,145m below the waves.

Tubeworms
Living in large communities around hydrothermal vents, huge tubeworms live in harmony with chemosynthetic bacteria.

OVER 450
Number of volcanoes in the Pacific Ring of Fire

At the very bottom of the ocean, just shy of 11,000 metres below the surface, sunlight is long gone and all that is left is inky blackness. The Challenger Deep is part of the Mariana Trench, a deep score across the sea floor of the Pacific basin that is formed at a subduction zone, where one tectonic plate disappears beneath another. It is the deepest point in Earth's oceans, and with over ten kilometres of water overhead, the hydrostatic pressure is 1,100 atmospheres – the equivalent of inverting the Eiffel tower and balancing it on your big toe.

The water temperature at the bottom of the Challenger Deep is just above freezing, and the trench is filled with clouds of silt, formed from millions of years of ocean garbage falling from above and slowly rotting away. However, despite the pressure, darkness and coldness of the environment, life still prevails! The deep sea is home to an array of strange and wonderful creatures that survive against all odds, having developed clever mechanisms to deal with the extreme conditions.

The Challenger Deep was first explored in 1960 by Swiss scientist Jacques Piccard and US Navy Lieutenant Don Walsh in the Trieste submersible, which set a record by diving to a depth of just over 10,915 metres. Since that seminal dive there have been multiple attempts by both manned and unmanned vehicles, the most recent made by explorer and film-maker James Cameron, who managed to reach a depth of 10,898 metres in his Deepsea Challenger submarine.

Hydrothermal vents

Often forming at mid-ocean ridges where tectonic activity is high, hydrothermal vents are cracks and fissures in the Earth's crust where super-heated water escapes into the ocean. The temperature of this water can reach 400 degrees Celsius, but doesn't boil due to the extreme pressure.

Hydrothermal vents can support vast communities of life. The organisms that live around them use chemosynthesis – as opposed to photosynthesis – to survive. The primary producers of a chemosynthetic food chain are microbes that use the chemicals expelled by the vents as the basis to create energy, akin to how plants on land use sunlight.

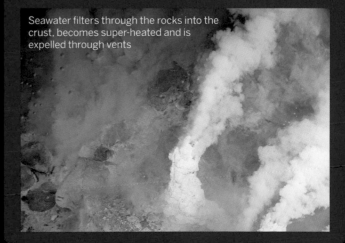

Seawater filters through the rocks into the crust, becomes super-heated and is expelled through vents

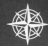
Submarine volcanoes

Our planet's most productive volcanic activity happens at the crushing depths of ocean ridges

The boundaries of Earth's tectonic plates are areas of pure fire and brimstone! Where the plates rub up against one another, or pull apart from each other, the super-heated innards of our planet are waiting to spill out, and this is where volcanoes can be found.

An underwater volcano forms when magma – molten rock from underneath the Earth's crust – builds up in a deep chamber. As the pressure increases, the magma finds its way upward until it reaches the seabed and the pressure is released in the form of a gigantic lava flow.

When a volcano erupts beneath the sea, super-hot lava gushes out, just like you might see on land. In relatively shallow water, this can send a spray of rocks, ash and gas through the water and out into the air. Deep-sea volcanoes are under crushing pressure from the water above, but the sheer force of the eruption still sends lava out of the fissure. Lava that oozes out is quenched almost as soon as it hits the water, and so the most common type of lava flow from an underwater volcano is 'pillow lava'. The outside of the lava flow hardens, but the inside stays molten, breaking through the end of the quenched blob and splurging forward – building up a string of pillow shapes before hardening to solid rock. These eruptions build layer upon layer of rock, and this is how the volcano grows in size.

Volcanic chains

Not all submarine volcanoes are located at tectonic boundaries. Long, linear chains of volcanoes such as the Hawaiian Islands and their underwater neighbours can form in the middle of oceanic basins. This is a by-product of continental drift – the gradual movement of tectonic plates. As the plate rests over a magma plume (an intense build-up of magma beneath the Earth's crust, sometimes known as a 'hotspot') the magma pushes its way up to the surface and a volcano will form, a process that takes thousands of years. The volcano may even stay active long enough to breach the ocean surface, forming an island. Then as the continental plate moves on, taking the volcano with it, a brand-new volcano eventually forms on the part of the continental crust that is now positioned over the magma plume. This means the volcanoes in the chain get older the further they extend from the magma plume.

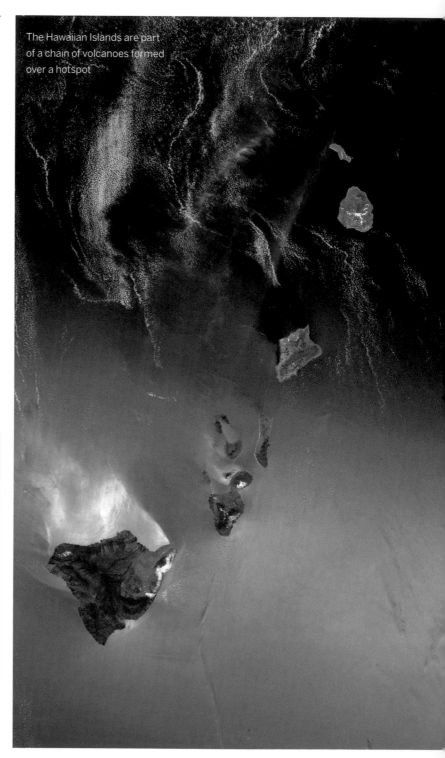
The Hawaiian Islands are part of a chain of volcanoes formed over a hotspot

Erupting under the sea

What goes on in the water and beneath the seabed as magma bubbles up from below

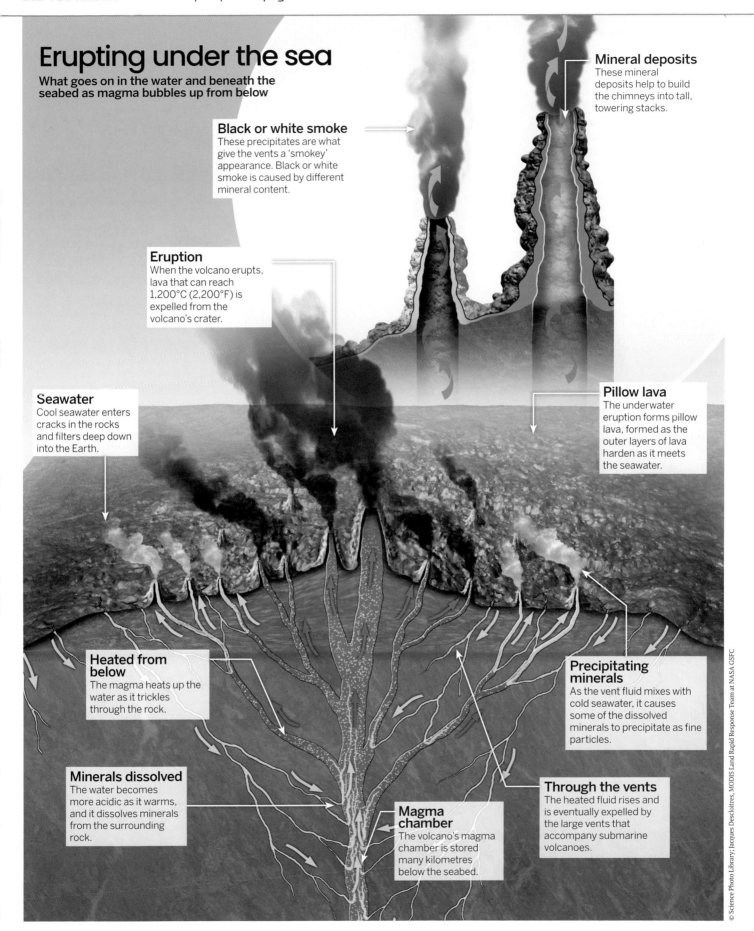

Mineral deposits
These mineral deposits help to build the chimneys into tall, towering stacks.

Black or white smoke
These precipitates are what give the vents a 'smokey' appearance. Black or white smoke is caused by different mineral content.

Eruption
When the volcano erupts, lava that can reach 1,200°C (2,200°F) is expelled from the volcano's crater.

Pillow lava
The underwater eruption forms pillow lava, formed as the outer layers of lava harden as it meets the seawater.

Seawater
Cool seawater enters cracks in the rocks and filters deep down into the Earth.

Heated from below
The magma heats up the water as it trickles through the rock.

Precipitating minerals
As the vent fluid mixes with cold seawater, it causes some of the dissolved minerals to precipitate as fine particles.

Minerals dissolved
The water becomes more acidic as it warms, and it dissolves minerals from the surrounding rock.

Magma chamber
The volcano's magma chamber is stored many kilometres below the seabed.

Through the vents
The heated fluid rises and is eventually expelled by the large vents that accompany submarine volcanoes.

How does wind create waves?

Friction between air and water molecules transfers energy from the wind to the water

Explore how energy passes through water to shape our coastlines

The constant rolling waves that ripple across the ocean may look as though they are transporting water from one place to the next, but this isn't the case. Although the water is certainly moving, it's only in a circular motion, ending up back where it started to begin the process again.

The one thing waves do move forwards through the ocean is energy, which comes from the wind that starts them off. They can transport this energy for thousands of kilometres across the globe, until they eventually reach land and use it to shape the shore through erosion or the deposition of material.

Energy transfer
Energy is transferred from the air to the surface water, causing the surface mass of water to rotate.

Wind blows
The wind blowing over the surface of the water causes friction, creating a continual disturbance.

Circular wave
The water continues to move in a circular motion as the kinetic energy is transferred through it.

Beneath the surface
A column of water below each surface wave completes the same circular movement.

In the shallows
The lower part of the wave slows down and compresses, forcing the crest higher.

Breaking point
Eventually, the wave becomes unstable and comes crashing down, transferring its energy into the surf.

What makes a wave break?

Find out what happens when the ocean meets the shore

Waves are formed when the wind blows over the surface of the sea. Energy from the wind sets particles in the water rotating around each other, creating a wave that can roll for several kilometres. When the wave reaches the shore and the water becomes shallower, friction from the seabed begins to slow it down. It loses energy from the bottom first, causing it to bunch up on itself and get taller until the back of the wave overtakes the rest and breaks into whitewash. On gently sloping shores the wave simply spills over, but steep slopes create dramatic crashing waves.

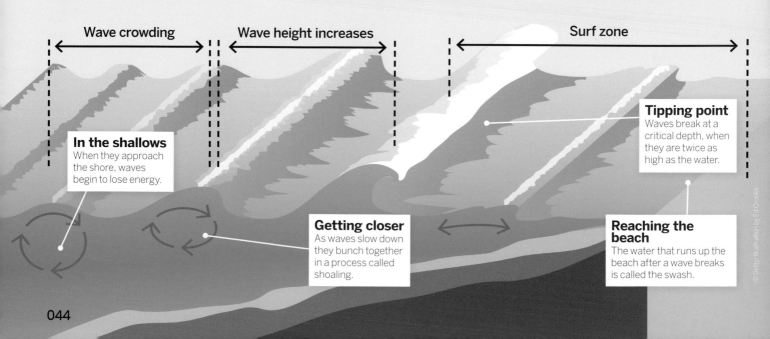

Wave crowding

Wave height increases

Surf zone

In the shallows
When they approach the shore, waves begin to lose energy.

Getting closer
As waves slow down they bunch together in a process called shoaling.

Tipping point
Waves break at a critical depth, when they are twice as high as the water.

Reaching the beach
The water that runs up the beach after a wave breaks is called the swash.

© Getty; Illustration by Ed Crooks

Ocean currents explained

The conveyor belt that keeps the oceans healthy

When ice forms off the coast of Antarctica, the seawater around it gets saltier because the water freezes first, leaving the salt behind. The extra salt makes the remaining seawater denser, so it sinks down the side of the continental shelf and spreads slowly along the ocean floor.

The sinking water has to be replaced from somewhere, so this creates a surface current that pulls warmer water in from the north. This is called thermohaline circulation (from the Greek for temperature and salt), and it is the main force behind the deep ocean currents. But at the surface, the Sun's heat causes winds, and these create a different set of much shallower currents. The Earth's rotation twists these into circling currents called 'gyres', which rotate clockwise in the Northern Hemisphere and anticlockwise in the Southern Hemisphere.

Currents are vital to the ocean's ecosystems. Most marine life is found near the surface, where it would quickly run out of nutrients were it not for currents sweeping up fresh supplies from the sea floor. At the same time, downward currents supply vital oxygen-rich water to the inhabitants of the deep sea.

Current affairs
Earth's ocean currents are all connected in a series of swirling eddies

Equatorial currents
The North and South Equatorial Currents carry warm waters westward, while the Equatorial Counter Currents return some warm waters eastward.

Gulf Stream
The Gulf Stream brings warm water from the Caribbean towards western Europe. The Canary Current circulates cold water back again.

Norwegian Current
Warm water breaks away from the Gulf Stream, pushing cold water back, past Greenland.

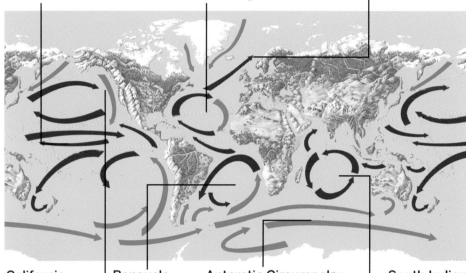

California Current
The cold water from northwestern Canada brings the characteristic coastal fog to California's coastline.

Benguela Current
Cold water flows north past South Africa, warms and returns as the Brazil Current.

Antarctic Circumpolar Current
This is the dominating current in the Southern Ocean, circling the continent of Antarctica from west to east. It creates some of the roughest seas on Earth.

South Indian Current
This flows north from the Antarctic Circumpolar to connect to the West Australian current.

What are brinicles?

These so-called 'ice fingers of death' are a chilling phenomena

Found in both the Arctic and Antarctic seas, brinicles are formed when conditions are both calm and very cold. Usually occurring as winter sets in, these stalactite-like icy pillars grow downwards into the water from the sea ice.

As new sea ice forms, water freezes, and salt and other ions are forced out, producing salty brine. This fluid trickles through cracks and pores in the ice until it finds its way out.

The brine is much denser and colder than the seawater beneath the sea ice, which is usually around -1.9 degrees Celsius. As it hits the seawater, the brine begins to sink and the water around it freezes instantly. A brittle tube – or brinicle – is formed, and through this more brine trickles and freezes. Providing that sea conditions are calm, and no wildlife cruises past to knock it down, this process can continue until the brinicle reaches the seabed. Then it can spread out in a deadly frozen web, killing everything in its path. Scientists have reported seeing 'black pools of death' near brinicle formation, as the descending frozen brine has encased every nearby organism in ice.

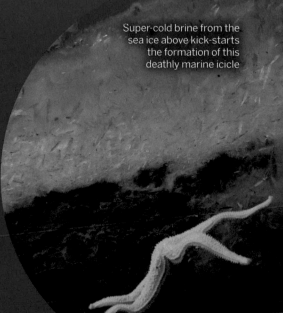

Super-cold brine from the sea ice above kick-starts the formation of this deathly marine icicle

MEGA TSUNAMI

Among the most epically destructive forces on Earth, tsunamis cause catastrophic levels of carnage, unearthing trees, levelling buildings and ending life. How It Works delves to the bottom of the ocean to track and explain their causes and formation

Tsunamis form through a complex, multi-stage process that emanates from the massive energy release of a submarine earthquake, underwater or coastal landslide, or volcanic eruption.

The first stage in this formation begins when the tectonic upthrust caused by the quake or impulse event causes massive amounts of ocean water to be displaced almost instantaneously. This action kick-starts a simple series of progressive and oscillatory waves that travel out from the event's epicentre in ever-widening circles throughout the deep ocean. Due to severe levels of energy propagated from the impulse, the waves build in speed very

quickly, reaching up to an incredible 500mph. However, due to the depth of water, the speed of the waves is not visible as they expand to have incredibly long wavelengths that can stretch between 60-120 miles. Because of this, the wave amplitudes (the wave height) are also very small as the wave is extremely spread out, only typically measuring 30-60 centimetres. These long periods between wave crests – coupled with their very low amplitude – also mean that they are particularly difficult to detect when out at sea.

Once generated, the tsunami's waves then continue to build in speed and force before finally approaching a landmass. Here the

depth of the ocean slowly begins to reduce as the land begins to slope up towards the coastline. This sloping of the seabed acts as a braking mechanism for the high-velocity tsunami waves, reducing their speed through colossal friction between the water and the rising earth. This dramatic reduction in speed – which typically takes the velocity of the tsunami to 1/10th of its original speed – also has the effect of reducing the length of its waves, bunching them up and increasing their amplitude significantly. Indeed, at this point coastal waters can be forced to raise as much as 30 metres above normal sea level in little over ten minutes.

Following this rise in sea level above the

Durable chains

How tsunamis are formed

4. APPROACH

As the tsunami waves approach the coastline of a landmass they are slowed dramatically by the friction of their collision with the rising seabed. As the velocity lessens, however, the wavelengths become shortened and amplitude increases.

5. IMPACT

Finally, with the wavelength compressed and heightened to large levels (often between five and ten metres), the giant waves collide with the shore causing massive damage. The succeeding outflow of water then continues the destruction, uprooting trees and washing away people and property.

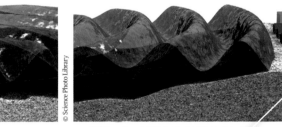

© Science Photo Library

1. TECTONIC

Tectonic upthrust in the form of earthquakes and ocean floor volcanoes cause vast quantities of water to be displaced in a very short space of time, generating a massive amount of energy

2. BUILD

The energy from the quake or impulse causes a train of simple, progressive oscillatory waves to propagate over the ocean surface in ever-widening circles at speeds as fast as 500mph.

3. TRAVEL

The wavelengths of the tsunami continue to grow, with the waves' periods (the lengths of time for successive crests or troughs to pass a single point) varying from five minutes to more than an hour.

Cause

Tsunamis initiate when an earthquake causes the seabed to rupture (bottom centre), which leads to a rapid decrease in sea surface height directly above it.

Effect

As the tsunami reaches the shore the shallow, long and exceedingly fast waves pile up, reducing the wavelength and increasing their height dramatically.

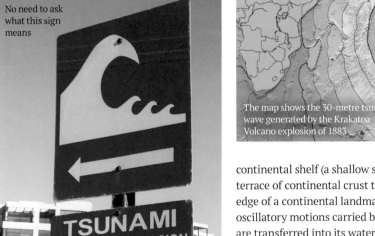

No need to ask what this sign means

TSUNAMI
RUTA DE EVACUACION

ROUTE OF EVACUATION

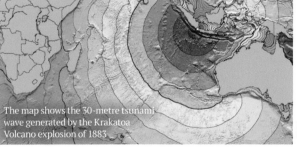

The map shows the 30-metre tsunami wave generated by the Krakatoa Volcano explosion of 1883

© NOAA

Head to Head

BIG

1. Messina

The Messina earthquake of 1908 triggered a large tsunami 12 metres high that levelled entire buildings and killed more than 70,000 people in Sicily and southern Italy. The earthquake that generated it measured 7.5 on the Richter scale and caused the ground to shake for between 30 and 40 seconds.

BIGGER

2. The Valdivia earthquake

The Valdivia earthquake of 1960 caused one of the most damaging tsunamis of the 20th Century. Thousands of people were killed by it and it stretched as far as Hilo, Hawaii. Measuring 9.5 on the Richter scale, the earthquake caused waves up to 25 metres to assault the Chilean coast. The earthquake also triggered landslides and volcanic eruptions.

BIGGEST

3. Lituya Bay

After an earthquake caused a landslide at the head of Lituya Bay, Alaska, in July 1958, a massive tsunami was generated measuring over 524 metres in height, taller than the Empire State Building. Amazingly, despite the awesome height of the tsunami, only two fishermen operating in the bay were killed by it.

continental shelf (a shallow submarine terrace of continental crust that forms at the edge of a continental landmass) the oscillatory motions carried by the tsunami are transferred into its waters, being compressed in the process. These oscillations under the pressure of the approaching water are then forced forwards towards the coast, causing a series of low level but incredibly fast run-ups of sea water, capable of propelling and dragging cars, trees, buildings and people over great distances. In fact, these run-ups are often responsible for a large proportion of the tsunami's damage, not the giant following waves. Regardless, however, following the run-ups the tsunami's high-amplitude waves continue to slow and bunch into fewer and fewer megawaves before breaking at heights between five and ten metres over the immediate coastline, causing great damage and finally releasing its stored energy.

Due to the severe hazards that tsunamis pose, research into their causes and tracking of their formation has increased through the 20th and 21st Centuries. Currently, the world's oceans are monitored by various tsunami detection and prevention centres, such as the NOAA (National Oceanic and Atmospheric Administration) run Pacific Tsunami Warning Center (PTWC) based in Honolulu, Hawaii.

Set up back in 1949, the PTWC utilises a series of tsunami monitoring systems that delivers seismic and oceanographic data to it on a daily basis, with information transferred to it and other stations by satellite connection. This is one of two American-run centres that monitors the Pacific Ocean and it is responsible for detecting and predicting the size and target of any approaching tsunamis.

Tsunami prevention has also seen advances as construction techniques and materials have developed over the past century. Now areas that are prone to tsunamis, such as Japan's west coast, are fitted with large-scale sea walls, artificial deep-sea barriers, emergency raised evacuation platforms and integrated electronic warning signs and klaxons in coastal resorts and ports.

Areas that have been affected by tsunamis in the past are also fitted with physical warning signs and have specific evacuation routes that best allow for large numbers of people to quickly move inland. Unfortunately, however, despite many advances being made to ensure prone areas are protected and warned in advance, due to the transcontinental nature of generated tsunamis, remote or under-developed areas are still affected regularly, the consequences of which have been recently shown in the disastrous 2004 tsunami in the Indian Ocean that claimed over 200,000 lives.

The DART II tsunami detection system

Introducing the system and technology that aids scientists in detecting upcoming tsunamis

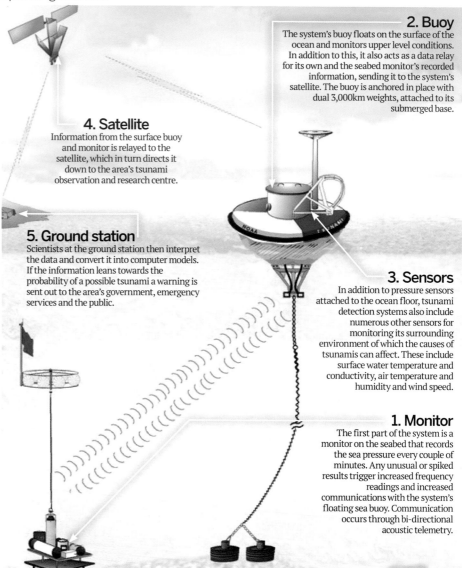

2. Buoy
The system's buoy floats on the surface of the ocean and monitors upper level conditions. In addition to this, it also acts as a data relay for its own and the seabed monitor's recorded information, sending it to the system's satellite. The buoy is anchored in place with dual 3,000km weights, attached to its submerged base.

4. Satellite
Information from the surface buoy and monitor is relayed to the satellite, which in turn directs it down to the area's tsunami observation and research centre.

5. Ground station
Scientists at the ground station then interpret the data and convert it into computer models. If the information leans towards the probability of a possible tsunami a warning is sent out to the area's government, emergency services and the public.

3. Sensors
In addition to pressure sensors attached to the ocean floor, tsunami detection systems also include numerous other sensors for monitoring its surrounding environment of which the causes of tsunamis can affect. These include surface water temperature and conductivity, air temperature and humidity and wind speed.

1. Monitor
The first part of the system is a monitor on the seabed that records the sea pressure every couple of minutes. Any unusual or spiked results trigger increased frequency readings and increased communications with the system's floating sea buoy. Communication occurs through bi-directional acoustic telemetry.

A tsunami early-detection buoy is removed from the ocean for maintenance

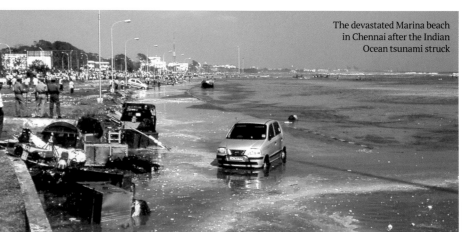

The devastated Marina beach in Chennai after the Indian Ocean tsunami struck

© NOAA

© Kotoviski

The 2004 Indian Ocean tsunami

Claiming the lives of over 200,000 people, the Indian Ocean tsunami of 2004 was literally off-the-scale in terms of both damage and destruction

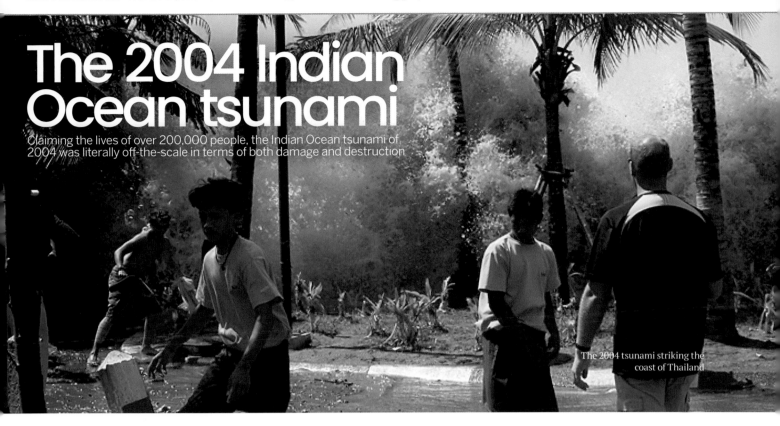

The 2004 tsunami striking the coast of Thailand

On 26 December 2004, an undersea megathrust earthquake caused a huge earth subduction and triggered a series of devastating tsunamis that ravaged almost all landmasses bordering on the Indian Ocean, killing over 230,000 people in 14 different countries. The hypocentre of the main earthquake was approximately 100 miles off the western coast of northern Sumatra and emanated from the ocean floor 19 miles below the area's mean sea level. Here, a massive rupture in the ocean floor caused massive tectonic plate movement as well as the creation of numerous secondary faults that elevated the height and speed of generated waves to titanic levels.

The fallout from the earthquake and resulting tsunami was the worst for over 50 years, with the event releasing a total of 1.1×10^7 joules of energy. This level of energy release was comparable to 26.3 megatons of TNT, over 1,502 times the energy released by the Hiroshima atomic bomb. Indeed, the rupture was so severe that the massive release of energy was so great it slightly altered the Earth's rotation, causing it to wobble on its axis by up to 2.5cm.

Further, when the British Royal Navy vessel HMS Scott surveyed the seabed around the earthquake zone with a multi-beam sonar system, it revealed that it has drastically altered its topography. The event has caused 1,500m ridges to collapse into massive landslides kilometres long.

The momentum of the water displaced by tectonic upshift had also dragged massive million-ton rocks over 10km on the seabed and an entirely new oceanic trench had been exposed.

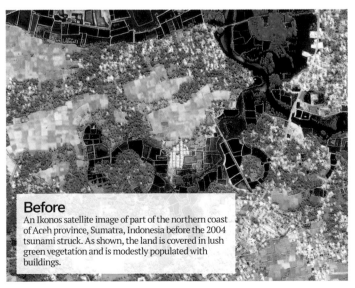

Before
An Ikonos satellite image of part of the northern coast of Aceh province, Sumatra, Indonesia before the 2004 tsunami struck. As shown, the land is covered in lush green vegetation and is modestly populated with buildings.

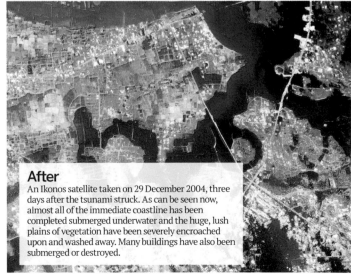

After
An Ikonos satellite taken on 29 December 2004, three days after the tsunami struck. As can be seen now, almost all of the immediate coastline has been completed submerged underwater and the huge, lush plains of vegetation have been severely encroached upon and washed away. Many buildings have also been submerged or destroyed.

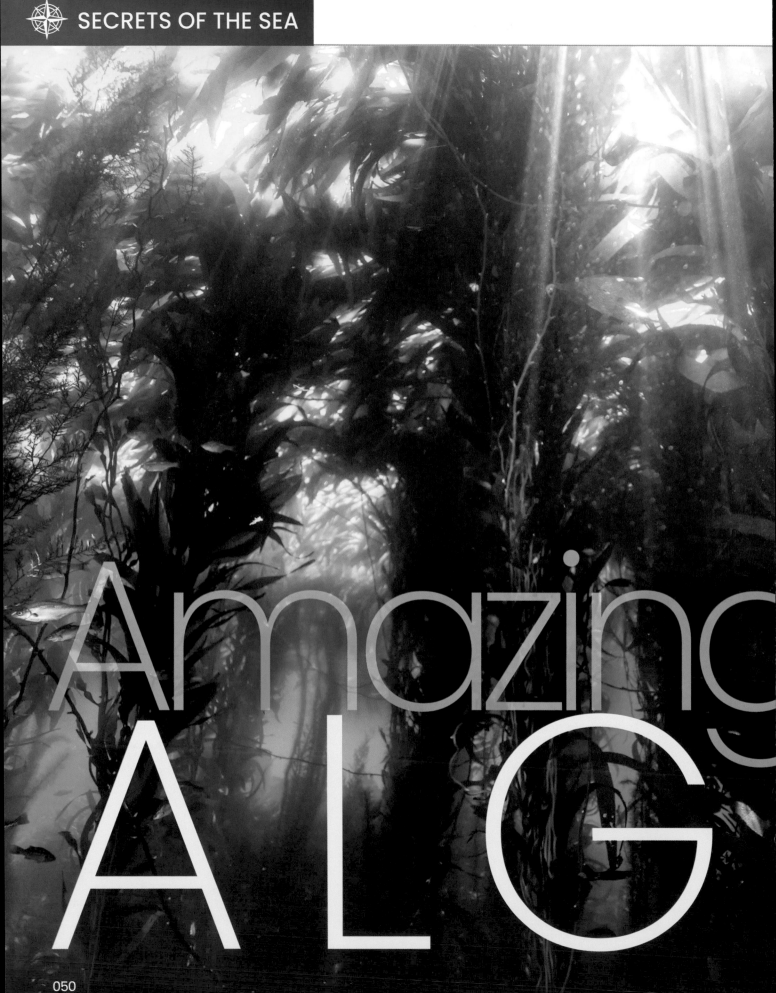

Amazing ALG

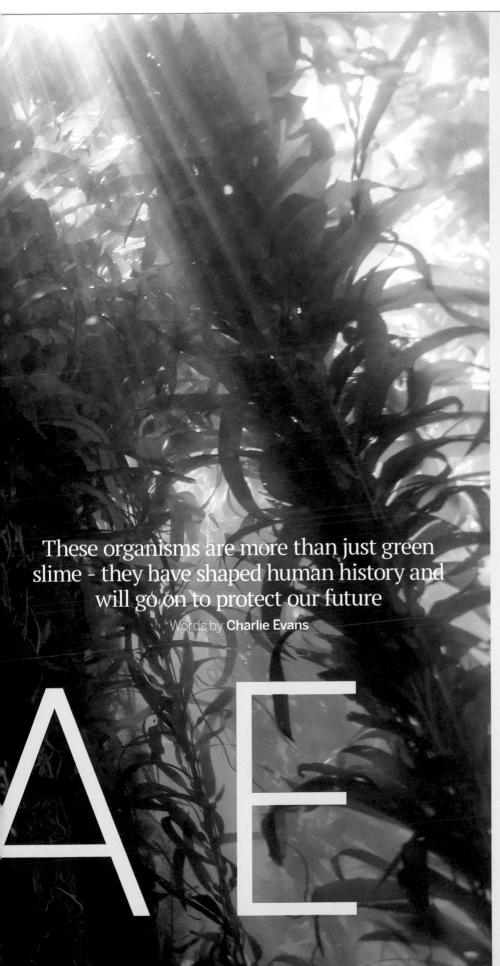

These organisms are more than just green slime - they have shaped human history and will go on to protect our future

Words by **Charlie Evans**

You can find algae almost anywhere you can find water, from magnificent giant kelp forests rising from the ocean floor to the thin green film resting on a shallow pond. Over millions of years they have evolved to survive in the most extreme environments: deep within the ice of the Arctic, around acidic ocean vents and in lava flows. Even in puddles, within the bark of trees, and inside droplets of dew on grass in the morning, microscopic algae diatoms will be thriving – they are masters of survival.

Algae have shaped life on our planet, and without them many of the species alive today wouldn't exist. Entire ocean ecosystems rely on them as a source of food, and over half of the oxygen we breathe comes from these remarkable organisms. Algae even play a role in the formation of clouds.

Throughout human history they have sustained us through famines and provided our species with medicine and nutrition. Today, having harnessed the power of algae, we use them in everything from food and pharmaceuticals to cosmetics and fuel. They are arguably the most important organisms in the world, but could they offer us even more in the future? Around the world people are looking towards algae to provide solutions to some of our planet's greatest challenges.

WHAT ARE ALGAE?

Algae are a genetically diverse group of over 48,000 different species. They come from a wide range of different evolutionary lineages that can't be truly classified as animals or plants. As a result they are lumped into a group known as protists – a category for predominantly single-celled living organisms that don't fit into any other. They are also ancient – fossil records indicate that red algae date back at least 1.6 billion years.

These simple organisms contain chlorophyll, which gives them the ability to photosynthesise, and they inhabit almost every body of water in the world. For freshwater and marine life, algae are the ultimate food source. Whether they eat algae directly, or eat an animal that does, every other organism in the water relies on them to obtain energy – they are the very foundations of the food chain, and some research suggests they might well be the foundations of all life.

The types of algae alive today are numerous, but they can be divided into two large groups

© Getty

051

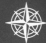

– macroalgae and microalgae. You're probably familiar with macroalgae, or seaweed. Microalgae are their microscopic relatives.

Seaweeds are plant-like organisms that live in the ocean or coastal areas by attaching themselves to rocks. They don't have roots or leaves, instead absorbing all the nutrients they need directly from the surrounding water. Their root-like structures are called holdfasts and these attach the seaweed to a hard surface, such as rocks or the seafloor. However, they don't have the ability to move (translocate) fluid or minerals like plants' roots do.

The largest of the macroalgae is giant kelp, which grows in expansive underwater forests that can rise taller than a 20-storey building from the ocean floor. Just like a forest on land, these aquatic jungles support ecosystems. From tiny critters living among the holdfasts to larger animals like seals and otters that use them as feeding grounds, many creatures rely on these places for shelter, food, play and sleep.

At the other end of the seaweed spectrum are the microalgae, single-celled organisms that are invisible to the naked eye. Many microalgae belong to a group called diatoms, which come in a kaleidoscope of colours and a variety of jewel-like shapes. Their unique silica shells, which form almost completely symmetrical patterns, are perforated to allow materials to diffuse across them. It's thought that they first evolved around the Jurassic period, and they can be found today in almost any body of water.

When these organisms die, they fall to the bottom of the sea or lake they inhabit and get mixed up with organic matter and clay to form a type of sediment known as diatomite. We use diatomite for many purposes, including water filters, cat litter, paints and facial scrubs. But the most valuable use of diatoms is within forensics – particularly in cases where a person may have drowned. In a victim who has inhaled water, diatoms can enter their bloodstream and spread around the body. By examining a cadaver, scientists can determine if the victim was alive when they entered the water if they find diatoms in the bone marrow. Investigators can even determine if a body was moved based on the particular species of diatom present.

SEAWEED SUPERPOWERS

We know that humans have eaten algae since prehistoric times. Edible seaweed is still a common ingredient in many countries, such as the nori that surrounds many Japanese sushi dishes. Algae are far less common in Western diets, but there are growing efforts to change this. Consuming algae is a delicious way of introducing more vitamins and minerals into your diet. They are particularly rich sources of beta-carotene (provitamin A) and iodine, which we need to make hormones that keep our metabolism

Entire ecosystems rely on the large kelp forests in our oceans

Dinoflagellates: dazzling and dangerous

Dinoflagellates are a curious group of organisms that are similar to diatoms: they are microscopic, single-celled and many species can photosynthesise. While they are sometimes classed as algae, scientists regularly debate this taxonomic placement because dinoflagellates' genomes are much larger than those of other algae.

One of the best-known properties of dinoflagellates is that some species can bioluminesce. If they are disturbed, they emit a flash of bright blue light, causing the surface of the water to sparkle. The secret to their stunning light display is within the cytoplasmic bodies called scintillons that involves a luciferase-catalysed reaction of luciferin. To us it looks beautiful, but the dinoflagellates use the light as a defence mechanism to scare away potential predators.

A more sinister property of these tiny organisms is that some species can form 'red tides'. These huge blooms of dinoflagellates occur when their populations rapidly increase, forming a visible discolouration across the water. Some species even release toxins that are harmful to marine wildlife. The decomposition of these large blooms can also result in a depletion of oxygen in the water.

More than 18 dinoflagellates are bioluminescent; the majority of them emit a blue-green light

Even if the red tide dinoflagellates themselves aren't harmful, the decomposition of large blooms can indirectly harm the ecosystem

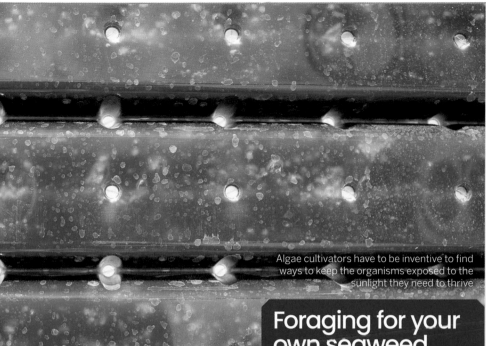

Algae cultivators have to be inventive to find ways to keep the organisms exposed to the sunlight they need to thrive

healthy. Studies suggest that iodine deficiency is rather common in the UK (which ranks seventh in the ten most iodine-deficient nations in the world); increasing our seaweed consumption could help reduce this problem.

Perhaps the most valuable algal product is as a source of fatty acid supplementation in food products, as it contains huge amounts of both mono- and polyunsaturated fats. If you want to try edible seaweed, it is easy to introduce into your diet and can be eaten raw or dried.

However, algae can do more than just fuel our bodies – they can fuel our vehicles too. As our planet starts to move away from fossil fuels, we have started to make biofuels from crops, but scientists are now investigating algal fuel as an even better alternative. The industry has even spawned a new word to describe it – algaculture. Some species of algae can produce more than 60 per cent of their dry weight in the form of oil, which is perfect for powering our vehicles. Even better, algae isn't a fussy grower. Unlike soy or corn, cultivators wouldn't need to drain the Earth's freshwater, because algae can thrive in salt water or even sewage. It would also give humanity the opportunity to utilise land that is unsuitable for traditional agriculture.

There are benefits for the environment too – devastating oil spills would be a

Foraging for your own seaweed snacks

- Check the law in your country to make sure you have permission to be harvesting seaweed in the area, and check that the water is clean.

- Select the species you would like to harvest and cut it carefully with scissors rather than pulling up the seaweed.

- Harvest the seaweed across a wide area, taking a little from each space to ensure that you don't do any damage to the growth of the species in the area.

- When you get home, clean the seaweed by washing it in a bowl of water at least three times, changing the water between each wash. Make sure all of the sand is removed and there are no little critters still attached.

- Almost all seaweed tastes great baked in the oven for half an hour, but to make the most out of your well-earned snack, check the best way to prepare it.

Seaweed on toast can make a delicious and nutritious snack

Q&A Tim van Berkel

Conservationist Tim van Berkel cofounded the Cornish Seaweed Company, which harvests quality edible seaweed from the southwest coast of the UK. The company is the first in England to trial seaweed cultivation, and it's the largest seaweed company in the country.

Which seaweeds are you harvesting?
We harvest a lot, including kelp, sea spaghetti, bladderwrack, dulse, gutweed and sea lettuce. We have also just started a small cultivation trial using sugar kelp. At the moment we only harvest from the wild in Cornwall, but the trial we have started is on lines in the sea.

Is there any impact on the environment to harvesting or cultivating seaweed?
We only work with local plants and we make sure we do it in an area where we don't impact on other species that are already there. The cultivation itself is beneficial for the environment. You don't need fertiliser or pesticides, and it soaks up carbon dioxide, nitrates and phosphates. It also forms a safe zone where fish and other animals can spawn.

How do you harvest seaweed from the wild?
We go down to the beach at low tide and walk around with scissors and give them a bit of a haircut. Then we wash it and dry it in specific drying kilns we developed ourselves. We also harvest by free-diving for some species, because it's easier than slipping over the rocks. We use a snorkel, mask, wetsuit, weight belts, and we go up and down 50 to 100 times to get the seaweed. It's fun. If the weather is good, it's great!

Are there any threats to the seaweeds' agriculture, such as disease or grazing marine life?
The biggest danger we have is climate change, especially the kelp and sea spaghetti – they are disappearing. We see species of kelp that shouldn't be here, but it's making its way up – that could take over our native species.

Why is seaweed so important to us?
It's the most nutritious food source in the world; it has more vitamins and more minerals than anything else you can think of [sic]. It's incredible. We are now learning they contain substances that are antiviral, antibacterial and may help fight a range of diseases – it's phenomenal. And it does more. Bioplastics [made from seaweed] is going to be the next thing – it's going to save the world.

Which seaweed is your favourite to eat? Do you recommend any for our readers to try?
Try sea spaghetti; that is definitely the nicest you can eat straight from raw. Dulse is probably my other favourite. It's bacony, quite salty – I like to eat it raw as a snack or add it to a curry.

© Getty

catastrophe of the past, as algal biofuel is almost completely harmless. Two possible species that are being investigated as a new fuel source include sargassum and chlorella, which have a harvesting cycle of less than ten days, meaning fuel could be produced much faster than the annual cultivation of current biofuel crops.

ALGAE IN THE FUTURE

Algae has shaped human history and every ecosystem on our planet, and it plays a part in controlling our climate, but what will these protists be helping us with in the future? Companies around the world are using these organisms as architectural cladding, lampshades, yarn and textile dye. It could even help us tackle climate change and plastic pollution. Every plastic straw you ever used still exists – and it will probably still exist when your great grandchildren are born. This is because plastic doesn't degrade, it just breaks down into smaller and smaller toxic pieces. It's become a massive problem for our oceans, but scientists and designers have started to look at algae for a solution. Both new and established companies are investigating ways of using seaweed-based bioplastics to replace conventional plastics in their products, from bottles to car bodies.

Algopack, based in Saint-Malo, France, is one of these pioneering companies. They've developed a bioplastic that uses a naturally occurring polymer from algae to produce fully biodegradable granules that completely decompose within 12 weeks in soil and just five hours in water. And they're not the only ones who want to start a bioplastic revolution.

Dutch designers Erin Klarenbeek and Maartje Dros have spent years perfecting a bioplastic polymer that can be used to print 3D objects. The entrepreneurs cultivate algae before drying and processing it, and they can make everything from tableware to shampoo bottles.

Even larger companies are now getting involved. In 2009, the car manufacturer Toyota announced that it is looking to develop a kelp-based bioplastic to be used for car bodies. "[Carbon-fibre-reinforced plastic] is made from oil. In the future, I'm sure we will have access to new and better materials... In fact, I want to create such a vehicle from seaweed because Japan is surrounded by the sea," said the project manager, Tetsuya Kaida.

Can you imagine yourself sipping from an algae water bottle before preparing yourself a seaweed snack, then getting into your algae bioplastic car? One day this may be a reality.

Channelled wrack
This deep-green-coloured brown algae is found high on the shoreline attached to a hard substrate.

Gutweed
This bright green algae is found in rock pools and can attach itself to sand, mud and hard substrates.

Ulva lactuca
Sporting crumpled, translucent fronds, this species is found along all but the most exposed shorelines.

Seaweed distribution

These global species live on the shoreline, each thriving in a different spot

Seaweed dishes around the world

JAPAN
Nori (Pyropia yezoensis/tenera)
This dried red algae is used to wrap sushi and to garnish/flavour noodles and soups. It is farmed in the ocean and made into sheets in a process similar to papermaking.

ICELAND
Dulse (Palmaria palmata)
This bacon-flavoured seaweed is eaten in Iceland, historically by boiling it with milk or eating it alone with butter. Today it is used to flavour soups and casseroles or garnish dishes.

NEW ZEALAND
Karengo (Pyropia columbina)
Karengo is eaten by the Maori of New Zealand, who pick and Sun-dry it. It is then steamed or simmered before being used in dishes that include soups, rice and omelettes.

WALES
Laverbread (Porphyra umbilicalis)
A puree is made from boiling laver seaweed and mixing it with lemon juice, olive oil, salt and pepper. It is served with shellfish, hot buttered toast or as part of a fried breakfast.

PHILIPPINES
Sea grapes
(Caulerpa lentillifera)
This is a soft and succulent seaweed eaten raw with vinegar, usually in a salad dressed with fish sauce and accompanied by chopped raw shallots and tomatoes.

The longest giant kelp on record reached a height of

65m

– equivalent to a 21-storey building!

50–85%

The estimated proportion of Earth's oxygen produced by algae

Around **1,000km²** of shallow coastlines are farmed for nori in Japan

Algal blooms can contain up to

20 MILLION

dinoflagellate cells per litre

There are approximately 16,500–19,500 species of the edible brown, red and green seaweeds, of which...

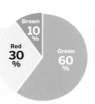

Brown 10%
Red 30%
Green 60%

Just **1g** of seaweed can provide between 11–1,989% of your daily recommended iodine, depending on the species

Fucus spiralis
This variety displays a characteristic ridge along the edge of its receptacles.

Dulse
Similar only in name to the pepper dulse, this species has tough, red, blade-shaped fronds.

Bladderwrack
This mid-shore algae has distinctive paired air bladders that keep its fronds afloat.

Fucus serratus
This olive-brown seaweed displays serrated edges, and its fronds have an orange peel-like texture.

Dumonts
This small red algae has irregular dark red-brown tubular fronds and flourishes in winter.

Nori porphyra
This seaweed consists of delicate, thin purple-brown fronds and is able to bore into calcium carbonate substrates.

Pepper dulse
This small, red, cartilaginous algae features flattened fronds and is found in the tidal zone.

Forest kelp
This tough kelp grows in flat, broad blades with large branched holdfasts.

Sea spaghetti
As the name suggests, this brown seaweed resembles spaghetti. It grows from small, button-shaped thalli (roots).

Sugar kelp
This large brown kelp displays individual fronds with an undulating margin that resembles a frill.

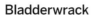

Indonesian seaweed farms are an important food source for many local people

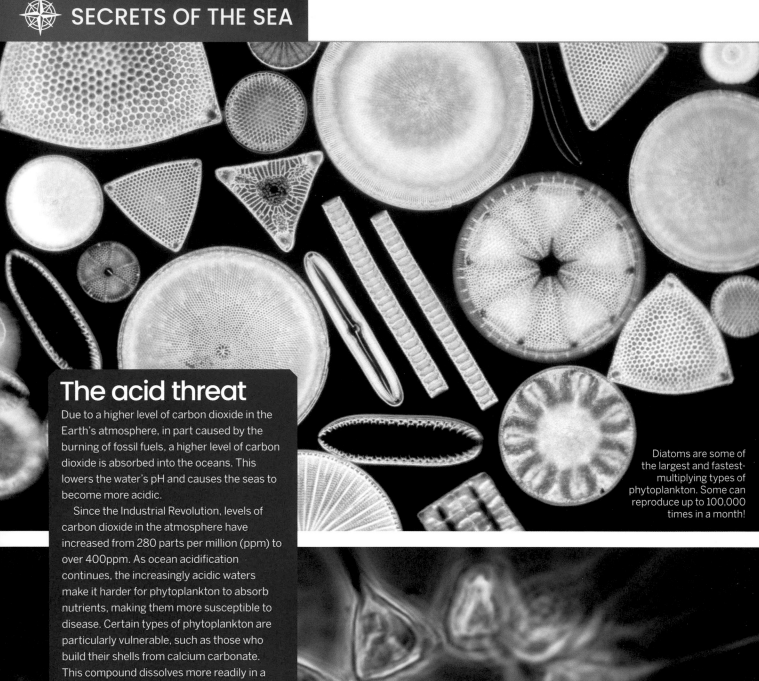

The acid threat

Due to a higher level of carbon dioxide in the Earth's atmosphere, in part caused by the burning of fossil fuels, a higher level of carbon dioxide is absorbed into the oceans. This lowers the water's pH and causes the seas to become more acidic.

Since the Industrial Revolution, levels of carbon dioxide in the atmosphere have increased from 280 parts per million (ppm) to over 400ppm. As ocean acidification continues, the increasingly acidic waters make it harder for phytoplankton to absorb nutrients, making them more susceptible to disease. Certain types of phytoplankton are particularly vulnerable, such as those who build their shells from calcium carbonate. This compound dissolves more readily in a more acidic ocean, and the primary building block of their shells (carbonate ions) are less available in the water.

This has huge implications for the entire marine ecosystem, the production of oxygen for our atmosphere and eventually change the balance of plankton species in our waters.

Diatoms are some of the largest and fastest-multiplying types of phytoplankton. Some can reproduce up to 100,000 times in a month!

Phytoplankton cell lengths span several orders of magnitude: From less than 2 micrometres to about 200 micrometres

The importance of phytoplankton

Forget whales, sharks and the giant squid: it's the smallest living organisms in the briny blue that keep life on our planet working as it should

Phytoplankton are the definition of the phrase 'all good things come in small packages'. Simply put, most of these little ocean drifters are microscopic, single-celled plant-like organisms that photosynthesise and can be found in both marine and freshwater and are present in all of the world's oceans. They live in the euphotic zone (the topmost layer of the ocean) where sunlight is plentiful. There are so many that if you scooped up a Coke can of seawater you'd probably have bagged yourself as many as 75–100 million individual phytoplankton.

Accompanying the phytoplankton in this heady mix of ocean soup are the zooplankton, which are tiny animals — some are the larval stages of much bigger creatures, others will remain as just tiny beasts. All plankton are unable to swim against the ocean currents and so they float at the mercy of the waves. However, there are areas where more phytoplankton occur, usually where upwelling (deep, cold water rises up to the surface) brings essential nutrient-rich water to the surface.

Phytoplankton are crucial for life on Earth — it's almost unimaginable to think of a world without them. The tiny organisms form the basis of the entire oceanic food web, photosynthesising to turn sunlight into energy and providing food for small filter-feeders and grazers, which in turn are food for larger animals, including the fish on our own plates.

The phytoplankton also have a huge impact on our atmosphere as they are responsible for producing at least 50 per cent of Earth's oxygen. They are also an important carbon sink, taking in carbon dioxide from the atmosphere that is then pulled to the bottom of the ocean when the phytoplankton dies. Over millions of years these plankton (along with other marine creatures and organic matter) build up in layers on the seabed, which, under intense pressure and heat, can form oil or natural gas.

Some species of phytoplankton are bioluminescent — they emit light when they are disturbed

Tracking the blooms

When ocean conditions are right, the plankton population can boom very quickly. In just a few days (or sometimes even hours) a stretch of clear blue ocean can be transformed into a soupy green liquid — this happens to such an extent that great swathes of plankton blooms are easily visible from space.

This ability to watch the plankton from afar has allowed scientists to build up a comprehensive study of plankton blooms over many years, which in turn can be used as an indicator of global climate changes. Satellite imagery shows where the blooms are occurring, along with the size, rate and density of the bloom. They can also identify the type of plankton and even track the development of harmful algal blooms. While most phytoplankton blooms are non-toxic, there are some species that can cause harmful or toxic effects in marine animals and humans.

Blooming in the lakes, seas and oceans, plankton can clearly show the whirls and tracks of currents

Common types of phytoplankton Not to scale

There are around 5,000 types of phytoplankton. Here are five of the most common ones

Cyanobacteria
Not actually algae, these bacteria were the first organisms to produce significant volumes of oxygen via photosynthesis some 2.4 billion years ago — changing the Earth's atmosphere forever.

Diatom
A common type of phytoplankton, the diatom's cell wall is made of silica (which is the main component of glass) and the many beautiful perforations allow nutrients to enter and remove waste.

Dinoflagellate
Some dinoflagellates are bioluminescent while others produce toxic 'red tides' that are lethal to marine life. They have 'flagella', tiny whip-like structures that allow for movement in the water.

Green algae
Members of this huge, informal group of algal types (which contains about 8,000 species) are the ancestors of land plants. They live as single cells as well as forming large colonies in marine and fresh water.

Coccolithophore
The single cell of the coccolithophore is covered in minuscule discs made of calcite, or chalk, which accumulate on the seabed when the cell dies. Billions of coccolithophores created the white cliffs of Dover.

CORAL REEFS

2016 saw some surprising discoveries in the study of coral, including brand-new reefs

A coral polyp on its own can measure just a few millimetres in size, but when it joins with others to form a colony, and the colony joins with other species to make a reef, those tiny polyps create one of the largest structures on Earth. It's thought that coral reefs contain 25 per cent of our planet's biodiversity, but cover just 0.2 per cent of its surface!

There are two types: hard and soft. The hard corals are the reef architects – they secrete a hard, slow-growing skeleton of calcium carbonate that fuses together over time to create the giant, natural barriers. Soft corals secrete skeletons that aren't as tough, but they still play a key part in reef growth and health.

The corals that grow in the shallows need super clear water, as light is essential for their growth. Their tissues contain tiny algal cells called zooxanthellae that photosynthesise and provide the coral with food. The algae also gives the coral its tropical, vibrant hue, turning the reef into a riot of submarine colour.

Deep-water corals don't rely on symbiotic algae for food because they live in the dark, so instead they catch their own. Corals have a surprising method of predation. Each individual polyp in a colony has stinging cells called nematocysts that are triggered by touch. Depending on the species, the nematocysts can deliver a powerful and sometimes lethal toxin, allowing the coral to take down prey.

With everything in delicate balance, coral reefs that live near land often rely on other interlinked ecosystems nearby to thrive. Mangroves are important, as these salt-water trees trap sediment and run-off from the land, filtering pollution and providing nutrients. Their long, submerged roots are also important nursery grounds for species that then make their way to the reef as adults.

Similarly, seagrass meadows often grow between mangroves and reefs, providing essential food for grazers and stabilising the

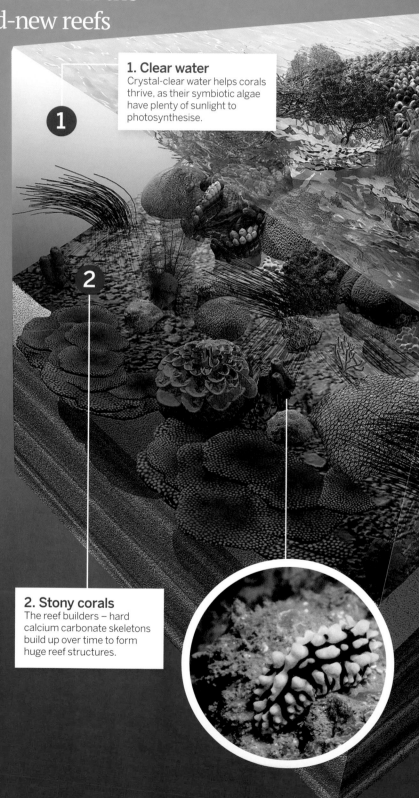

1. Clear water
Crystal-clear water helps corals thrive, as their symbiotic algae have plenty of sunlight to photosynthesise.

2. Stony corals
The reef builders – hard calcium carbonate skeletons build up over time to form huge reef structures.

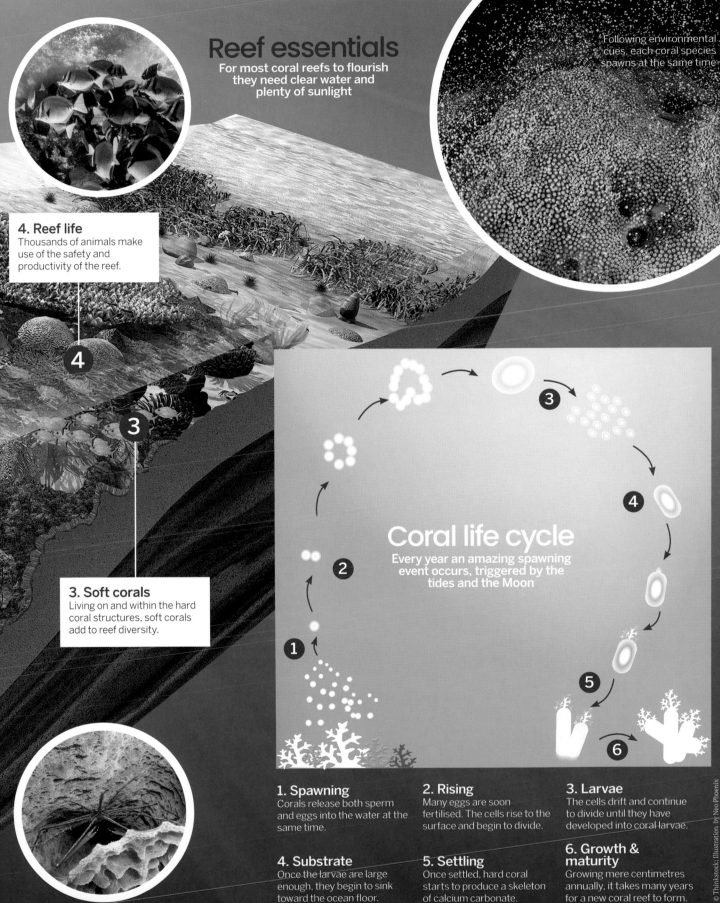

Reef essentials
For most coral reefs to flourish they need clear water and plenty of sunlight

Following environmental cues, each coral species spawns at the same time

4. Reef life
Thousands of animals make use of the safety and productivity of the reef.

4

3

3. Soft corals
Living on and within the hard coral structures, soft corals add to reef diversity.

Coral life cycle
Every year an amazing spawning event occurs, triggered by the tides and the Moon

1 **2** **3** **4** **5** **6**

1. Spawning
Corals release both sperm and eggs into the water at the same time.

2. Rising
Many eggs are soon fertilised. The cells rise to the surface and begin to divide.

3. Larvae
The cells drift and continue to divide until they have developed into coral larvae.

4. Substrate
Once the larvae are large enough, they begin to sink toward the ocean floor.

5. Settling
Once settled, hard coral starts to produce a skeleton of calcium carbonate.

6. Growth & maturity
Growing mere centimetres annually, it takes many years for a new coral reef to form.

© Thinkstock; Illustration by Neo Phoenix

seabed, keeping the water clean. Research has also shown that coral reefs that grow in conjunction with mangroves may not be as susceptible to bleaching.

Coral bleaching events happen when the corals undergo thermal stress. To thrive, most tropical coral species need a water temperature of 18-29 degrees Celsius; they are highly sensitive to temperature fluctuation. If water temperatures get too high, the corals react by expelling their symbiotic zooxanthellae. This turns them a bright white colour, which can lead to their death.

2016 saw one of the worst ever coral bleaching events. As sea surface temperatures have risen by one degree Celsius over the last century, corals have been pushed to the brink. Some 67 per cent of corals were affected in the worst-hit areas of the Great Barrier Reef and

some publications even published obituaries for the marine site. But luckily, for now, the Great Barrier Reef still prevails.

There are some coral types that have already adapted to temperature extremes – the corals of Kimberley in western Australia make up one such reef. The area has the largest tropical tides in the world (up to ten metres) and the corals are repeatedly exposed to the air and soaring midday temperatures, as well as super-heated stagnant tidal pools. These conditions would be deadly to coral species living elsewhere, but the Kimberley corals flourish! Interestingly, the corals exposed to these extremes showed a better resistance to hot water when tested, indicating that a highly variable environment may hint to bleaching resistance in corals.

Another incredible adaptation of coral is the

'phoenix affect'. In 1998 a disastrous coral bleaching event killed off nearly 16 per cent of the world's corals. Divers in Rangiroa Lagoon in French Polynesia had noticed that the super-hardy porites corals had also succumbed to bleaching and projected that, based on growing rates, it would take the reef over 100 years to recover. However, 15 years later those same divers returned to find the reef back to the thriving oasis it had once been.

One theory about how the corals were able to recover so quickly is that perhaps the giant structures aren't as 'dead' as originally thought. It's believed that if some of the colony tissue hidden deep within the skeleton was more protected, then it was able to recolonise across the original skeleton once temperatures improved. Another astounding discovery from 2016 was the Amazon Reef, an extensive

Artificial reefs

An artificial reef is anything in the sea built by humans that has been colonised by coral and algae or other encrusting species. Oil platforms, piers, jetties and sunken debris are all artificial reefs, providing substrate for all kinds of marine life to cling to, which in turn brings fish and many other creatures to the reef in search of the food and protection available.

Many reefs have been sunk deliberately to encourage marine life to an otherwise featureless location, such as decommissioned warships, train carriages and out-of-service oil rigs. Settlers begin to arrive almost immediately, and after a few months marine life will be flourishing on the underwater structure.

Placement
The structure is placed in a marine location usually devoid of life. Purpose-built reefs are made of pH- balanced material and feature hollows and indentations to attract settlers big and small.

Within weeks
The first settlers, such as sedentary organisms like sponges, anemones and barnacles, are encrusting. Small fish such as snappers will soon be attracted to inspect and graze on the growing colonists.

Within years
A fully developed artificial reef will have calcareous coral species settled on it in a matter of years. The smaller fish attract much larger predators, completing a complex and balanced food web.

Climate change and coral reefs
As our planet warms its coral reefs are at risk from varying factors and threats

Warming ocean
Rising temperatures induce thermal stress in corals. They expel their symbiotic zooxanthellae and whole colonies can die in a process called bleaching. Temperature increases also raise the risk of diseases.

Sea level rise
This can be accompanied with higher levels of sedimentation, which can smother coral and also pollute the water. This prevents sunlight from reaching the zooxanthellae, so they cannot photosynthesise for the coral.

Storms
Climate change can affect the intensity, frequency and distribution of storm patterns. Although reefs can recover from storm damage, this takes time. A period of storms may severely damage a reef.

deep-water reef system of sponges, corals and rhodoliths living precisely where scientists never thought corals could – under the muddy sediment plume of the mouth of the Amazon River. 120 kilometres off the coasts of Brazil and French Guinea, between 50 and 100 metres below the water's surface, the reef sits unencumbered by the river outflow.

The topography of the seabed and the intensity of the currents mean that the slick of sediment-laden fresh water that spills from the Amazon doesn't reach deep enough to affect the corals, which need a saline environment to thrive. Despite having lower biodiversity than expected in an established warm-water reef, it is an incredible oceanographic discovery.

New techniques in remote sensing are making it even easier to study coral reefs and get a clearer picture of how they work and the state of their health worldwide. We can view reefs from the air and from the sea with state of the art equipment like ROVs. We can even analyse coral (live and fossilised) to learn more about Earth's prehistoric climate by analysing the chemical properties of their skeletons.

Coral reefs provide a habitat and food for fish that we eat, they protect our land from storms and erosion, they dissipate wave energy and reefs also provide thousands of jobs for people worldwide. Despite coral being an incredibly hardy and resilient creature, it is still under threat from ocean acidification and warming temperatures. The loss of a reef can cause a catastrophic ecosystem shift where great swathes of ocean life suffer as a consequence. They are tough, but coral also need protection so that generations to come may enjoy the same reef benefits as we do today.

Cold-water reefs

Not all corals are found in tropical water; in fact, some of the most widespread corals found in all ocean basins are in deep water. These amazing species don't need light or photosynthesising zooxanthellae to survive, and they are able to expand and thrive in the depths of complete darkness, albeit slowly. They get their energy and nutrients by catching food particles that float by in the water.

These coral types prefer to live in areas with fast-flowing currents where food will be plentiful, such as continental shelves, seamounts, ledges and pinnacles. They have even been found living in water as cold as -1 degree Celsius and as far south as Antarctic waters.

The largest cold-water coral reef is off the coast of Røst Island in Norway, which measures around 40 kilometres in length. Like warm-water reefs, the cold-water varieties provide a haven for all kinds of marine life, including starfish and worms.

The secret reef

Hiding behind the Great Barrier Reef is another giant reef system that until 2016 was largely unknown. Nicknamed the 'doughnut reef', it primarily comprises bioherms – large calcified structures left behind and built upon by the green algae halimeda.

Scientists were shocked to see that the bioherm reef covers a whopping 5,957 square kilometres. All was revealed when high-resolution airborne LiDAR technology was used to create an accurate 3D map of the seafloor.

The bioherms are deeper than the Great Barrier Reef, but it is estimated they are about the same age. Some measure nine metres high and over 180 metres across. The fast-growing algae deposits a calcium carbonate skeleton as it ages, like rings on a tree, allowing researchers to see the age of the bioherms. Studying these structures also allows scientists to tap into records of ocean temperature and acidity that date back to the last Ice Age contained within the mineral deposits.

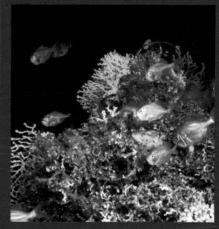

Cold-water corals have a wide distribution because they do not rely on sunlight to survive

Increased run-off
An excess of fresh water, along with run-off from land containing fertilisers and chemicals can cause algal blooms. These spread across the sea surface, taking precious nutrients the coral need to survive.

Changes to ocean currents
This can cause problems with ocean temperatures and the flow of nutrients through the ecosystem, as well as coral dispersal and spawning, and also alter the availability of food for deep-water corals.

Ocean acidification
The ocean absorbs approximately one-third of excess CO_2 in the atmosphere, making it more acidic. This slows the rate that corals can create $CaCO_2$ skeletons, hampering growth and weakening structure.

LIFE BENEATH THE WAVES

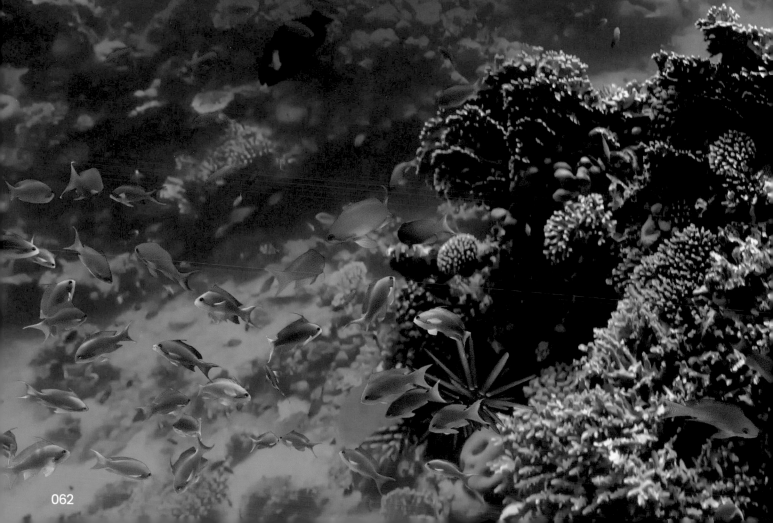

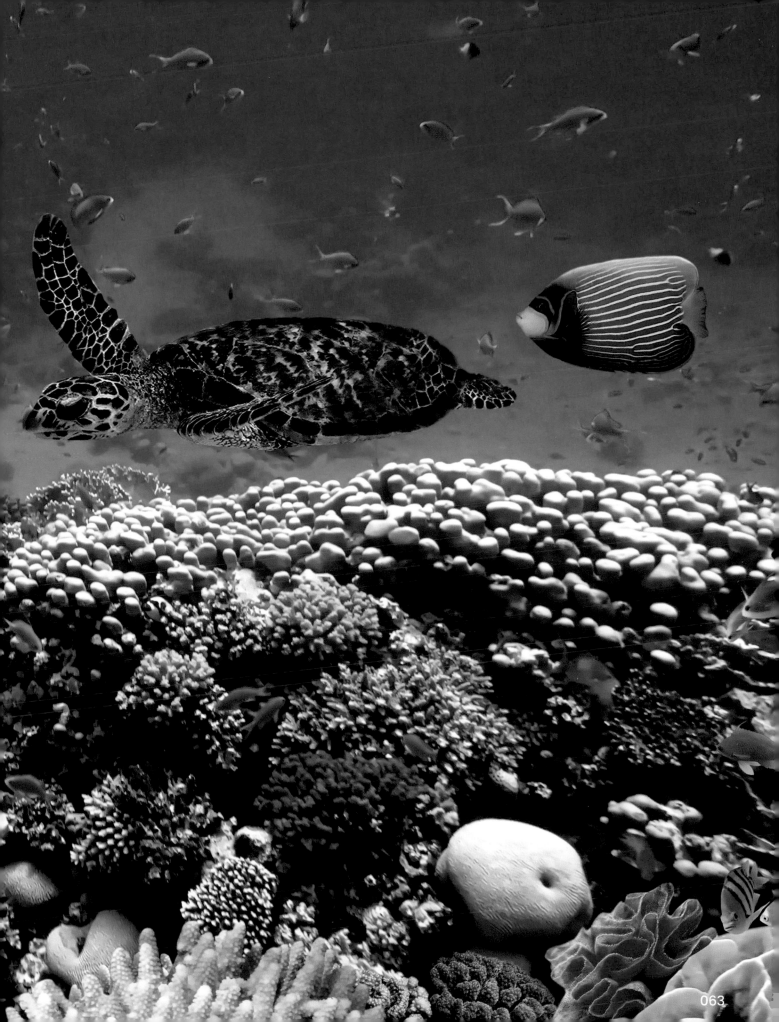

Life on the coral reef
Explore the rainforest of the seas and the creatures that call it home

Coral reefs are one of the most diverse ecosystems on the planet, and thousands of sea creatures call it home, from microscopic organisms to enormous predators. In fact, the coral is an entire colony of living animals in itself, because unlike plants, corals do not make their own food. They spread across the ocean floor and provide shelter and food for the reef's other residents. Tiny plantlike organisms called phytoplankton sit at the bottom of the reef food chain, getting their energy from the sunlight that penetrates the shallow water. They serve as food for larger zooplankton, which are in turn eaten by corals, sponges, sea urchins and a whole host of other creatures. Several species of fish, mollusc and crustacean then take advantage of this buffet, before they become lunch for the sharks, rays and the marine mammals at the top of the chain. Each creature plays an important role in this delicate ecosystem, which requires a specific set of characteristics to survive.

Anatomy of coral

Coral is in fact a colony of hundreds or thousands of animals called polyps

Size
Most polyps range from 1-3mm (0.04-0.1in) in diameter, but some corals have single polyps that can grow to up to 25cm (10in) in diameter.

Stomach
The stomach at the centre of each polyp has a single opening that is used to ingest food and excrete waste.

Tentacles
Tentacles, typically in sets of six, are used for defence and to capture and pass food into the mouth.

Shallow reefs
Reefs typically grow best at depths of 18-27m (60-90ft), shallow enough for sunlight to reach the coral for photosynthesis.

Stinging cells
Nematocysts fire from each tentacle, injecting poison into the coral's prey to immobilise or kill them.

Reproduction
Polyps can reproduce both sexually and asexually in their lifetime, helping them to increase diversity and spread further.

Tissue layer
The coral skeleton is covered with a layer of tissue that allows the polyps to distribute nutrients between them.

Photosynthesis
Zooxanthellae algae lives in the coral's tissue, trapping sunlight to provide energy and receiving carbon dioxide and nitrogen from the polyps in return.

Deep-sea coral
Some coral reefs can be found at depths up to 6,000m (20,000ft) but all their energy comes from consuming prey instead of photosynthesis.

Skeleton
Hard coral polyps secrete calcium carbonate from their base, forming a protective skeleton that connects them together.

Growth
Polyps initially attach to rocks and other debris. Eventually, new polyps grow on dead polyp skeletons to build up as coral.

Protection
Coral polyps can retract their tentacles into their hard skeleton for protection if a predator approaches.

25%
of all marine life can be found in coral reefs

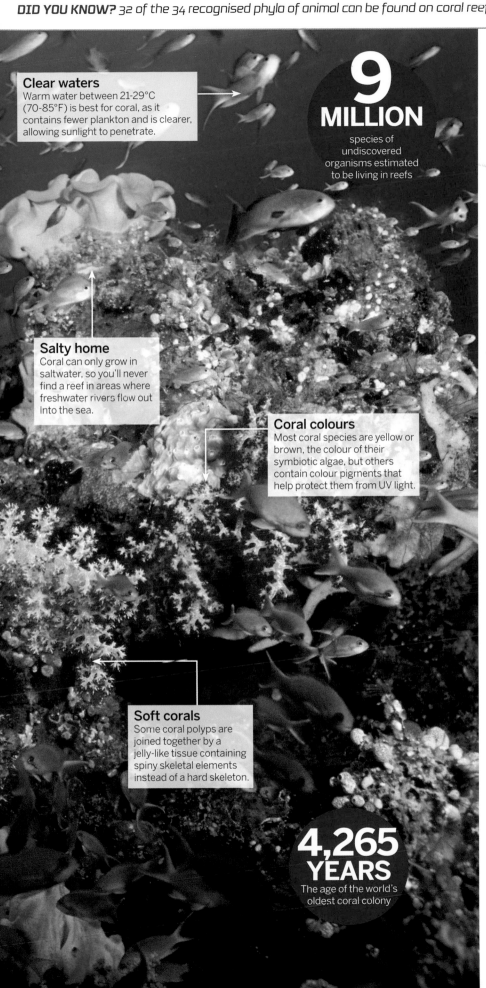

Clear waters
Warm water between 21-29°C (70-85°F) is best for coral, as it contains fewer plankton and is clearer, allowing sunlight to penetrate.

9 MILLION
species of undiscovered organisms estimated to be living in reefs

Salty home
Coral can only grow in saltwater, so you'll never find a reef in areas where freshwater rivers flow out into the sea.

Coral colours
Most coral species are yellow or brown, the colour of their symbiotic algae, but others contain colour pigments that help protect them from UV light.

Soft corals
Some coral polyps are joined together by a jelly-like tissue containing spiny skeletal elements instead of a hard skeleton.

4,265 YEARS
The age of the world's oldest coral colony

Types of coral reef

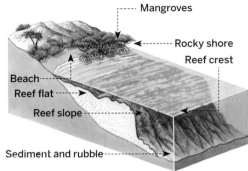

Mangroves
Rocky shore
Reef crest
Beach
Reef flat
Reef slope
Sediment and rubble

Fringing reef
The most common type of reef is a fringing reef. They grow directly from land, creating a border along the shoreline.

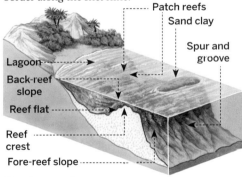

Patch reefs
Sand clay
Spur and groove
Lagoon
Back-reef slope
Reef flat
Reef crest
Fore-reef slope

Barrier reef
Although they also form parallel to the land, barrier reefs grow further out to sea and are separated from the shore by a lagoon.

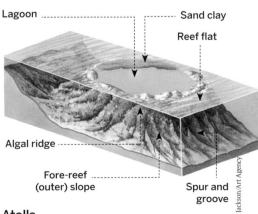

Lagoon
Sand clay
Reef flat
Algal ridge
Fore-reef (outer) slope
Spur and groove

Atolls
Over time, a volcano or seamount surrounded by a reef erodes or rising sea levels cause it to flood. This forms an atoll with a lagoon in the centre.

CREATURES OF THE REEF
The valuable benefits of these underwater communities

As well as serving as a home and restaurant for an incredible array of creatures, coral reefs provide huge benefits for humans too. The underwater structures help to protect shorelines, absorbing 90 per cent of the energy from wind-generated waves. This significantly limits the damage caused by storms and erosion.

The fishing industry is also reliant on the reefs, as its inhabitants are a major food source for over a billion people worldwide and capturing them provides vital income for those living in remote areas. The trade of ornamental aquarium fish is also a big industry, and other creatures and plants found on the reef are important sources of medicines, used to treat a range of conditions from arthritis to cancer.

However, tourism is perhaps the biggest benefit as the millions of snorkelers and scuba divers that visit the reefs each year inject an estimated £6.2 billion ($9.6 billion) into the global economy.

<0.1% of the world's ocean floor is covered by coral reefs

9 Loggerhead sea turtle
Larger specimens of these enormous sea reptiles can exceed 2m (6.6ft) in length and reach weights of over 450kg (992lb).

"Coral reefs help to protect shorelines, absorbing 90 per cent of the energy from wind-generated waves"

1 Fire coral
One of the few corals harmful to humans, its stinging cells release a toxin that creates a burning sensation on the skin.

2 Giant clam
The coloured spots on this clam sense light. If a shadow falls over it, the clam retreats into its shell.

4,000 species of fish supported by coral reefs

3 Brain coral
So called because of its striking resemblance to the human brain, these coral mounds can grow up to 2.4m (8ft) in diameter.

4 Orange starfish
This colourful echinoderm feeds on small sea sponges and algae. They can also regenerate damaged limbs.

5 Purple sea urchin
Each urchin can grow to a diameter of 10cm (4in) and its sharp spines are used to deter predators.

6 Queen angelfish
One of the most striking species of reef fish, these colourful creatures are very shy and often live alone.

7 Clownfish
Clownfish clean and protect the sea anemones in which they live in exchange for a safe home.

8 Orange fireworm
When touched, this sea worms feathery bristles release a toxin that causes pain and itching for several days.

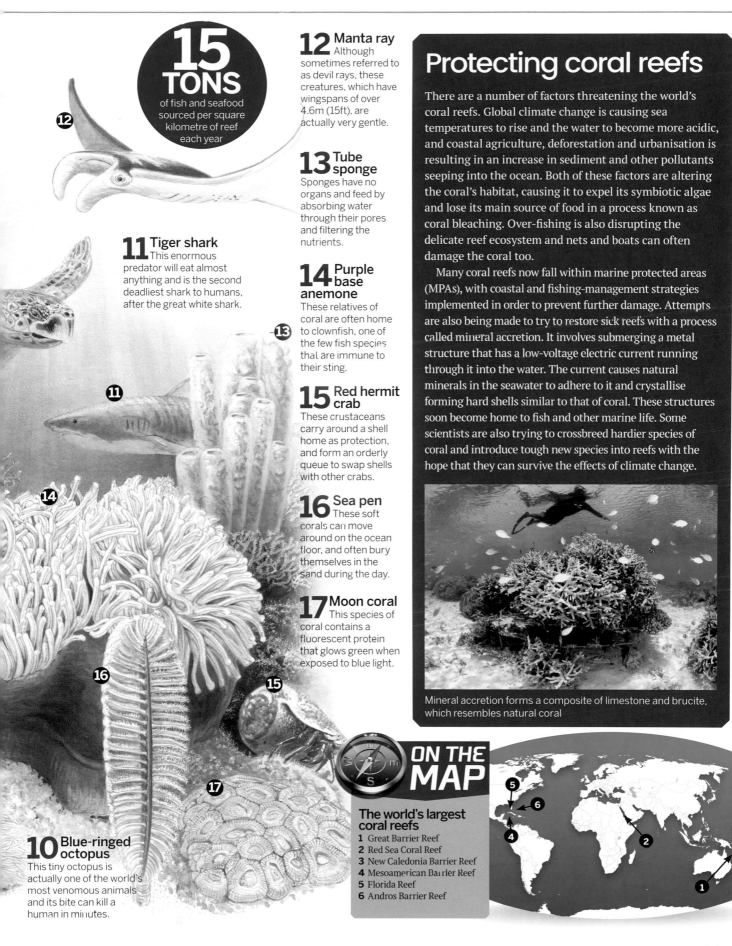

15 TONS
of fish and seafood sourced per square kilometre of reef each year

12 Manta ray
Although sometimes referred to as devil rays, these creatures, which have wingspans of over 4.6m (15ft), are actually very gentle.

13 Tube sponge
Sponges have no organs and feed by absorbing water through their pores and filtering the nutrients.

11 Tiger shark
This enormous predator will eat almost anything and is the second deadliest shark to humans, after the great white shark.

14 Purple base anemone
These relatives of coral are often home to clownfish, one of the few fish species that are immune to their sting.

15 Red hermit crab
These crustaceans carry around a shell home as protection, and form an orderly queue to swap shells with other crabs.

16 Sea pen
These soft corals can move around on the ocean floor, and often bury themselves in the sand during the day.

17 Moon coral
This species of coral contains a fluorescent protein that glows green when exposed to blue light.

10 Blue-ringed octopus
This tiny octopus is actually one of the world's most venomous animals and its bite can kill a human in minutes.

Protecting coral reefs

There are a number of factors threatening the world's coral reefs. Global climate change is causing sea temperatures to rise and the water to become more acidic, and coastal agriculture, deforestation and urbanisation is resulting in an increase in sediment and other pollutants seeping into the ocean. Both of these factors are altering the coral's habitat, causing it to expel its symbiotic algae and lose its main source of food in a process known as coral bleaching. Over-fishing is also disrupting the delicate reef ecosystem and nets and boats can often damage the coral too.

Many coral reefs now fall within marine protected areas (MPAs), with coastal and fishing-management strategies implemented in order to prevent further damage. Attempts are also being made to try to restore sick reefs with a process called mineral accretion. It involves submerging a metal structure that has a low-voltage electric current running through it into the water. The current causes natural minerals in the seawater to adhere to it and crystallise forming hard shells similar to that of coral. These structures soon become home to fish and other marine life. Some scientists are also trying to crossbreed hardier species of coral and introduce tough new species into reefs with the hope that they can survive the effects of climate change.

Mineral accretion forms a composite of limestone and brucite, which resembles natural coral

ON THE MAP
The world's largest coral reefs
1 Great Barrier Reef
2 Red Sea Coral Reef
3 New Caledonia Barrier Reef
4 Mesoamerican Barrier Reef
5 Florida Reef
6 Andros Barrier Reef

DEADLY OCEAN PREDATORS AND THEIR
FIGHT FOR SURVIVAL

SHARKS

Thanks to Spielberg's 1975 smash-hit Jaws, the great white shark is the poster animal for fear. As probably the most famous shark species out there, it's true that these fish are colossal chunks of muscle and teeth. But there's so much more to the great white shark – and indeed all shark species – than being the fictional man-eater of Amity Island.

All sharks belong to the class Chondrichthyes that also includes skates and rays. These critters all have cartilaginous skeletons (the same material that makes up the structure of our ears and noses), which makes them very light, enabling them to cut through the water. Their streamlined shape is of a pointed, tapered silhouette with angular fins and a strong tail.

There are many different types of sharks that are found in oceans across the world, from colossal hunters to tiny little bottom-dwelling species. They are often organised into eight orders according to their body shape and other taxonomic factors. The great white, for example, is a member of the Lamniformes, or the

"Each shark has a killer set of adaptations for hunting, from nose to tail tip"

'mackerel sharks'. Along with others such as the basking, sand tiger and mako sharks, these fish are large and ferocious-looking, with mouths that extend behind their eyes, two spine-free dorsal fins and five gill slits, among other features.

Each shark has a killer set of adaptations for hunting, from nose to tail tip. Even their skin is prepped for the cause – this is made up of a series of scales called dermal denticles, which act as an outer coating for easy movement.

Having conquered most of the oceans, specific shark species have evolved amazing ways of dealing with their environment. For example, the hammerhead's mallet-like skull is a direct adaptation for finding its favourite food – rays – on the ocean floor. Similarly, blue sharks have gills that have evolved a type of net across them, known as gill rakers, which prevent small prey from escaping from the gill slits. As food can be scarce, all prey is invaluable and therefore cannot be allowed to escape.

Sharks are portrayed all too often as public enemy number one, but it's important to realise that they don't see us as food. Read on to learn more about these amazing aquatic predators and find out how you can help save them from extinction in our oceans.

Born survivors

Baby sharks are born with both a full set of teeth and all the instinctive knowledge that they need to survive. Straight from birth they are ready to take care of themselves. There's no parent-child bonding in this family; a newborn shark pup's fight-or-flight response kicks in immediately after birth, and they quickly swim away from their mother, who they perceive as a threat (she may well eat them!)

It's this instinct that guides them through life. Unlike many mammals, shark parents don't teach their young to hunt; they automatically know how to. But even innate abilities can be overruled. For example, the great white instinctively rolls its eyes back into its head to protect them when it attacks prey. However, these sharks have been witnessed taking chum meat without rolling their eyes back – indicating that they have learned that the chum is not a threat.

When a shark emerges from its egg, the baby is on its own and instinctively knows how to survive

With sensory organs spread over a wide head, hammerheads are well-equipped to sense prey

© Thinkstock; Alamy; WIKI

Sharks by numbers

70 YRS
Life span of a male great white shark

21 kg
Amount of plankton a 6m whale shark can eat in a single day!

50km/h
Speed of the shortfin mako shark

50%
Estimates of decline of Northwest Atlantic sharks since the 1970s

24hrs
Some sharks can replace teeth in this time

409 MILLION
Age in years of the oldest shark fossil ever discovered

Yellow-brown pitted skin has earned the lemon shark its common name

SHARK ANATOMY

Powerful swimming muscles help great white sharks to charge at prey

This streamlined fish is built for hunting. Check out the specs on this killer model

The shark's body type is slender and streamlined, designed to cut through the water to keep maximum water flowing over its gill slits (this is why they can't swim backwards) and to allow for quick hunting attacks. They all have strong swimming muscles attached to a web of supportive, durable and flexible collagen for efficient movement.

Sharks also possess a unique arsenal of senses, with chemoreception (detecting chemical signals in the water) and electroreception (detecting electrical pulses) both essential when hunting. Great whites have small receptors for both of these senses across their head region, which work in unison with their other sensory organs. For example, shark eyes contain a layer of mirrored crystals beneath the retina called the tapetum lucidum – this helps them to see in dark water. This, combined with their 'super senses', allows them to track down food in any situation.

Muscular frame
There are two muscle types: red and white. Red is used for slow swimming over long periods. White is for bursts of speed.

Cartilage
A skeleton made of this flexible, lightweight and tough material makes for efficient swimming.

Endothermic
Great whites are able to retain heat that is generated by swimming. They are not completely cold-blooded, as is often presumed.

Inside the beast
Specialised and adapted, these animals are built to predate

The shark's eyes are surprisingly good and can see well in dark, murky water

Liver
A large, fatty liver aids buoyancy, and liver oil can provide fuel for long ocean swims.

All over the shark's rostrum (nose) are sensitive pores that help the great white to hunt

Gills
Some species of shark are able to 'pump' water over the gills for more oxygen.

Ampullae of Lorenzini
Tiny pores in the rostrum connect to nerves to detect electromagnetic pulses in the water.

Eyes
With eyes at either side of its head, a shark has near 360-degree vision.

Heart
Great whites have a huge volume of blood. This is pumped around the body by their two-chambered heart.

Floating jaw
Flexible connecting joints allow the jaws to swing forward away from the head for a clean bite.

Teeth
Arranged in rows, the shark's pointed and serrated teeth are continually replaced.

Shark menu
Great whites are known hunters, but what is the catch of the day?

Seals
The fatty blubber of these pinnipeds makes for a delicious and nutritious meal for mature great whites. They often attack from below to catch the seal unawares.

Cetaceans
If they are hungry enough, great white sharks will turn their razor-sharp teeth to many other marine mammals, hunting down dolphins and even small whales.

Fish
Some adult great white sharks may stick to eating a more juvenile type of diet, choosing to only feed on smaller fish and squid rather than hunting down large marine mammals.

Leftovers
Despite being skilled hunters, great whites will take a free meal. Individuals have been witnessed tucking into ocean carrion such as whale carcasses.

Great white teeth
The teeth of a great white shark are broadly triangular shaped, with serrated edges that come into play as the shark shakes its prey from side to side in order to take a bite. When tapered to an extreme point, these needle-like teeth are useful for impaling slippery prey like fish and blubb... seals...

Shark teeth routinely fall out and are replaced from rows growing behind the 'working' teeth.

Sharks don't hunt people – we're not as nutritious as other prey...

SHARK WARNING
HAAIWAARSKUWING / ISILUMKISO SOOKREBE

HIGH RISK AREA
HOËRISIKOGEBIED / INDAWO YOKUDADA EYINGOZI

SWIM AT OWN RISK
SWEM OP EIE RISIKO / UDADA NGOBAKHO UBUTYALA

EMERGENCY NUMBERS
NOODNOMMERS / IINOMBOLO ZEXESHA LIKAXAKEKA
☎ 107 ☎ 021 480-7708 / 080 911-4357 ☎ 021 449-3500

AMAZING SHARKS OF THE WORLD

Far from being just a tropical fish, sharks have conquered a surprising array of habitats

There are sharks in all oceans of the world. These predators are very adaptable – species such as the blue shark have made their home in deeper waters both cool and warm. At one end of the temperature chart, the tropical seas are home to species such as black-tipped reef sharks. Sharks inhabit both the shallows (such as the mighty hammerhead) and the deep ocean, which is the home of the curious cookie-cutter shark. There are even species like the bull shark that are known to swim in brackish, estuarine water.

Sharks of many varying species are also present throughout the water column, with some crossing open oceans, while others, such as the wobbegong, prefer to lurk on the seafloor and hunt for food. There are even migratory species – the hardy critters that cross entire ocean basins such as Nicole, the great white shark that was tracked swimming an incredible 11,100 kilometres in 99 days, from South Africa all the way to Australia!

"Thresher sharks execute a 'handbrake turn' to unleash their tail whip"

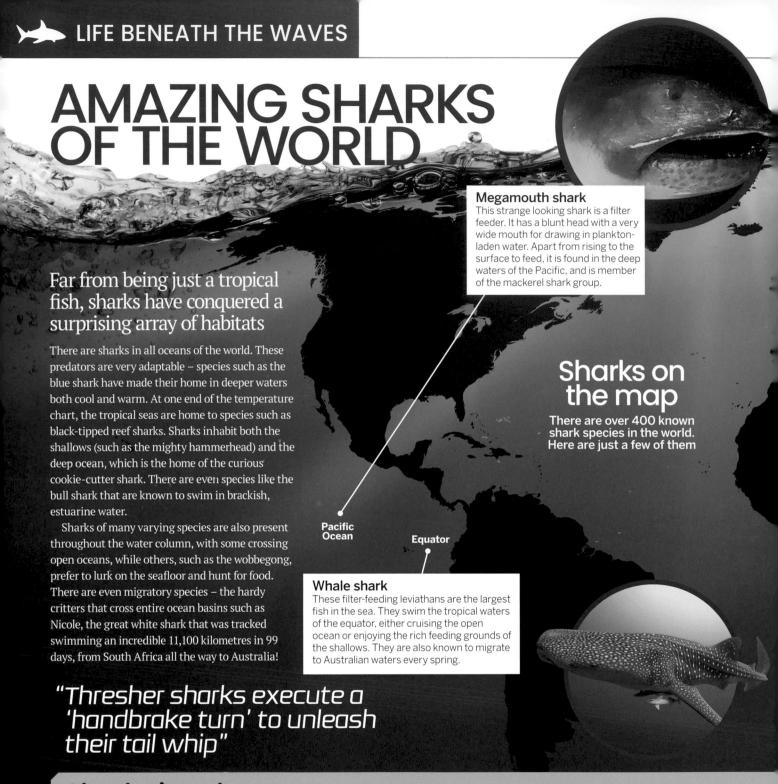

Megamouth shark
This strange looking shark is a filter feeder. It has a blunt head with a very wide mouth for drawing in plankton-laden water. Apart from rising to the surface to feed, it is found in the deep waters of the Pacific, and is member of the mackerel shark group.

Sharks on the map
There are over 400 known shark species in the world. Here are just a few of them

Pacific Ocean

Equator

Whale shark
These filter-feeding leviathans are the largest fish in the sea. They swim the tropical waters of the equator, either cruising the open ocean or enjoying the rich feeding grounds of the shallows. They are also known to migrate to Australian waters every spring.

Shark signals Here's how body language plays a key role in the lives of great whites

Parallel swimming
Swimming side by side can be a way of sizing up the competition and figuring out rank between sharks. The less dominant will swim away.

Swim-by
Sharks swim directly towards one another and pass close by. This behaviour may be used to identify the other shark and also to establish their rank.

Hunch displays
When the shark hunches its dorsal fin, this is often seen as a confrontational sign to either attack or flee from a more dominant shark.

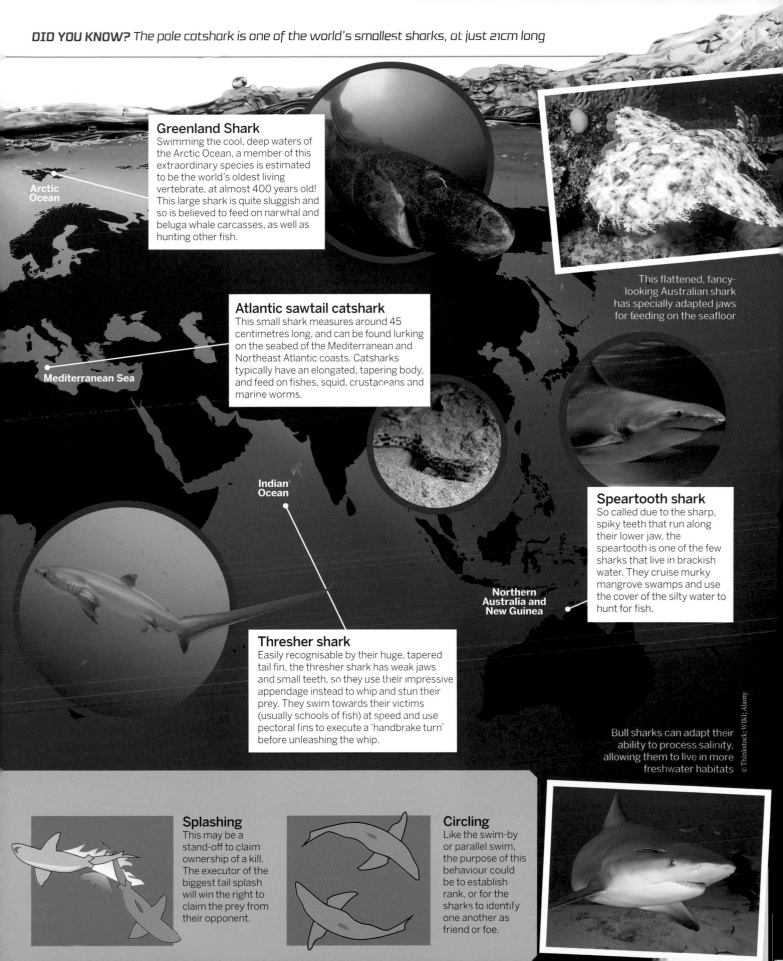

Greenland Shark
Swimming the cool, deep waters of the Arctic Ocean, a member of this extraordinary species is estimated to be the world's oldest living vertebrate, at almost 400 years old! This large shark is quite sluggish and so is believed to feed on narwhal and beluga whale carcasses, as well as hunting other fish.

Arctic Ocean

This flattened, fancy-looking Australian shark has specially adapted jaws for feeding on the seafloor

Atlantic sawtail catshark
This small shark measures around 45 centimetres long, and can be found lurking on the seabed of the Mediterranean and Northeast Atlantic coasts. Catsharks typically have an elongated, tapering body, and feed on fishes, squid, crustaceans and marine worms.

Mediterranean Sea

Indian Ocean

Speartooth shark
So called due to the sharp, spiky teeth that run along their lower jaw, the speartooth is one of the few sharks that live in brackish water. They cruise murky mangrove swamps and use the cover of the silty water to hunt for fish.

Northern Australia and New Guinea

Thresher shark
Easily recognisable by their huge, tapered tail fin, the thresher shark has weak jaws and small teeth, so they use their impressive appendage instead to whip and stun their prey. They swim towards their victims (usually schools of fish) at speed and use pectoral fins to execute a 'handbrake turn' before unleashing the whip.

Bull sharks can adapt their ability to process salinity, allowing them to live in more freshwater habitats

© Thinkstock; WIKI; Alamy

Splashing
This may be a stand-off to claim ownership of a kill. The executor of the biggest tail splash will win the right to claim the prey from their opponent.

Circling
Like the swim-by or parallel swim, the purpose of this behaviour could be to establish rank, or for the sharks to identify one another as friend or foe.

WHY ARE SHARKS IN DANGER?

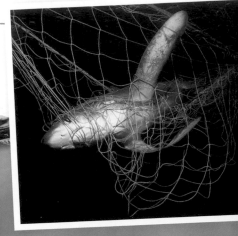

Sharks become tangled in fishing nets or drifting ocean debris, which immobilises them and causes them to drown

Despite being ice-cold predators, sharks are under threat

Unfortunately, as is very often the case with endangered species, human activity is the biggest threat to many of the shark species in our oceans – it's thought that overfishing puts one-third of all oceanic shark species at risk of extinction. The main issues arise from both direct and indirect fisheries of these ocean creatures.

In 2014 it was estimated that a staggering 100 million sharks are removed from the ocean each year, mainly as a result of the demand for shark-fin soup. In many Asian countries this is considered a delicacy and can reach staggering prices of over $1,100 (£875) per kilogram of fin. As a result of this high demand for a luxury dish, illegal, unreported and unsustainable pirate fishing is a common occurrence and incredibly damaging to fragile shark populations.

Practices such as finning are exceptionally cruel, as fishermen illegally catch the sharks, de-fin them and toss them back into the ocean. The fin trade, where just two to five per cent of the shark is used, affects a huge range of shark species and is one of the biggest threats they face.

Sharks are also very susceptible to getting caught in the nets intended for other fish species, known as bycatch. Due to many sharks' need to have a constant flow of water over their gills, becoming ensnared in a net and unable to move means certain death by drowning for these creatures. If this shark is young and has not reached sexual maturity, not only has the ocean lost one shark, but also the potential for many more sharks is wiped out with it. As sharks are fished more and more, smaller specimens are being removed from the water and the species' chances of survival dwindle with the haul-out of every net.

Many fisheries don't report their bycatch of sharks, and this lack of data adds to the plight of shark species as researchers are not able to properly monitor both the fishery activity and the shark population. Pirate fishing causes the same problem. When sharks are illegaly removed from their ecosystem it's impossible to gauge their conservation status accurately, often before it is too late.

Researchers tag and monitor shark species to learn more about their biology and movements to aid conservation

Most endangered
These sharks are some of the most threatened shark types in the ocean

VULNERABLE	VULNERABLE	VULNERABLE	ENDANGERED	ENDANGERED
Porbeagle	**Basking shark**	**Oceanic whitetip**	**Scalloped hammerhead**	**Great hammerhead**
This coastal-dwelling shark is found across the world, and is highly fished for its meat and fins. Illegal fishing, as well as finning and bycatch, are the main threats.	Previously hunted for their cartilage and liver oil, and now also targeted for their giant fins, the slow-growing and infrequent breeding nature of these sharks makes them very vulnerable and numbers have declined dramatically.	With their distinctive white-tipped dorsal fin, these sharks are fished for their fins and are very susceptible to being taken as bycatch. This species was reported to have significantly declined in at least one region.	This species' fins are highly valued in Asian markets and they are targeted heavily throughout their range of temperate and tropical seas. Fisheries are taking young and juvenile sharks, decimating population numbers.	These sharks are heavily fished as they have a high number of fins on their body, making them highly attractive to the shark-finning industry. They live in shallow coastal waters, making them vulnerable to becoming bycatch.

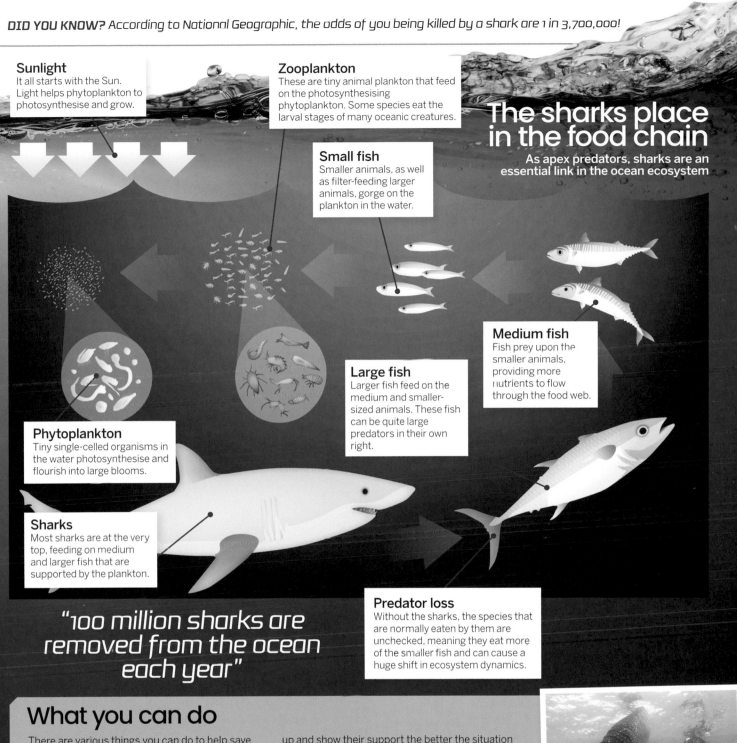

Sunlight
It all starts with the Sun. Light helps phytoplankton to photosynthesise and grow.

Zooplankton
These are tiny animal plankton that feed on the photosynthesising phytoplankton. Some species eat the larval stages of many oceanic creatures.

Small fish
Smaller animals, as well as filter-feeding larger animals, gorge on the plankton in the water.

The sharks place in the food chain
As apex predators, sharks are an essential link in the ocean ecosystem

Medium fish
Fish prey upon the smaller animals, providing more nutrients to flow through the food web.

Large fish
Larger fish feed on the medium and smaller-sized animals. These fish can be quite large predators in their own right.

Phytoplankton
Tiny single-celled organisms in the water photosynthesise and flourish into large blooms.

Sharks
Most sharks are at the very top, feeding on medium and larger fish that are supported by the plankton.

Predator loss
Without the sharks, the species that are normally eaten by them are unchecked, meaning they eat more of the smaller fish and can cause a huge shift in ecosystem dynamics.

"100 million sharks are removed from the ocean each year"

What you can do

There are various things you can do to help save shark species across the world. To learn more about the challenge facing sharks, you can watch documentaries such as *Sharkwater*, which shows the real extent of the issues.

Another key action is to help to raise awareness – you can do anything from fundraising to public speaking to get as many people as possible interested. If you live in a country where shark-fin soup is a delicacy, stop eating it and avoid restaurants that serve it. You can even write to the authorities to demand the sale or importation of shark fins is stopped. The more people that speak

up and show their support the better the situation will be for sharks.

You can also help sharks by taking a trip to see them – responsible tourism really helps because the more people that go to see sharks and realise that they need our help, the better the chance that the sharks have to survive.

It's also important to support shark conservation charities through fundraising, or even by adopting sharks and contributing towards the essential research and conservation projects that these organisations undertake. Check out WWF, The Shark Trust and Bite Back for more details.

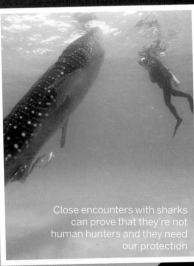

Close encounters with sharks can prove that they're not human hunters and they need our protection

Life cycle of a seahorse

Learn about the only species where the male bears the young

7. Mature adult

Once fully matured at around six months old, male and female seahorses can continue the life cycle during the breeding season. They can also live between one and five years in the wild.

6. Developing juvenile

After birth the young seahorse will continue to grow in size. They use their dorsal fin to swim and will feed on small crustaceans.

5. Floating fry

Most seahorse species produce around 100 to 200 young, and they can be as small as 2mm (0.08in) long. Once released they will float in surrounding water, often grasping to each other with their tails or onto objects nearby.

1. Courtship ritual

Male seahorses will compete to win over the female's affection by engaging in a courting ritual that can last several days. It involves the male and female entwining tails, dancing and even changing colour.

4. Birthing process

Once the young, known as fry, are ready to be released from the pouch, the male seahorse will contract surrounding muscles in order to expel the newborns.

2. Depositing the eggs

Once the female has chosen a mate, she will deposit her eggs into his brood pouch where they will be fertilised by his sperm and then embedded into the spongy pouch wall.

3. Male pregnancy

The male seahorse provides all of the oxygen and nutrients the embryos need in order to develop into fully formed young. Pregnancy can last between two and six weeks, depending on the surrounding water temperature and species of seahorse.

The world's most venomous fish

Almost invisible among the coral reefs, the Stonefish is a real-life killer

The Stonefish is the world's most venomous fish thanks to its ability to inject deadly neurotoxins from the spines on its dorsal fin into its target. The Stonefish's neurotoxins work by attacking the nerve cells of whatever it is injected into, causing severe pain, sickness, nausea, paralysis and, depending on depth of spine penetration into skin, death within three hours.

Unlike most other poisonous fish who dwell in the dark depths of the ocean - leaving little chance of human contact – Stonefish dwell in shallow waters and are likely to be found anywhere between just beneath the surface down to a depth of three metres.

"The Stonefish's neurotoxins work by attacking nerve cells"

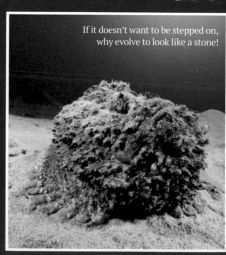

If it doesn't want to be stepped on, why evolve to look like a stone!

Life cycle of a clownfish

From courting and conception, to birth and beyond

"Clownfish are protandrous hermaphrodites, they are always born male but can change sex later"

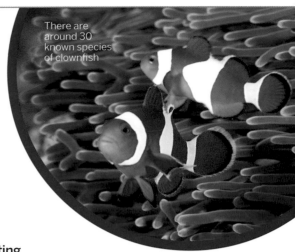

There are around 30 known species of clownfish

Group hierarchy

The clown anemonefish (Amphiprion ocellaris) lives in a social group, or school, with a strong hierarchy. The largest and most dominant fish is always female, and she will mate with the most dominant male. They will be the only two to reproduce within the group.

Courting

To attract the female, the male will exhibit courting behaviour, most typically via extended fins, biting and chasing. He will also build the nest on a bare rock close enough to their native anemone to provide protection from predators.

The father's role

The male will then pass over the eggs to fertilise them, and each fertilised egg will remain attached to the rock by fine adhesive threads. It is then the male's job to look after the eggs, fanning them with his fins to remove debris and prevent algae and fungi growth.

Breeding time

Breeding can occur all year round, but is typically concentrated around the full moon. This is thought to be because of increased visibility, stronger water currents for distributing the larvae and greater food supplies due to other fish spawning at the same time.

Changing sex

Clownfish are protandrous hermaphrodites, which means they are always born male, but can change sex later. If the dominant female in the group were to be removed or die, the most dominant male would then become female in order to carry on the life cycle.

Hatching

The eggs typically hatch after six to eight days, but the incubation period is longer in cooler water. It takes a further eight to 12 days for the larval stage to end, at which point the juvenile fish will then go in search of an anemone to inhabit.

Laying eggs

Once the nest is built, the male will then chase the female towards it. Over several hours she will make a few passes over it, releasing 100-1,000 eggs, depending on her age. The eggs are orange and about 3-4mm (0.11-0.16in) in size.

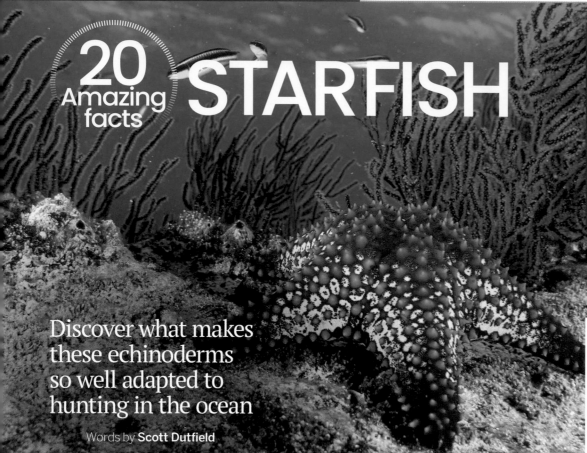

20 Amazing facts STARFISH

Discover what makes these echinoderms so well adapted to hunting in the ocean

Words by **Scott Dutfield**

1. How do they eat?
What makes starfish such effective hunters is their ability to encapsulate their prey with their own stomach. Ejected from their mouth, starfish cast out a net of their stomach to externally digest the soft parts of clams, fish and oysters. Releasing digestive enzymes, starfish break down their prey into a seafood stew that they then re-ingest along with their own stomach.

© Thinkstock

2. What if they lose a limb?
Hunting prey can be hard when you've lost limbs at the jaws of another predator. However, thanks to their ability to regenerate cells, starfish are able to grow back missing limbs. The process can take anywhere between a few months or years depending on the species. It's also been reported that some species are able to regenerate entirely from only half a body!

3. Are they common?
Starfish can be found in saltwater seas across the globe, with large populations in the Indo-Pacific Ocean region. They are, however, unable to survive in fresh water due to their dependence on saltwater calcium, which they use to create their super tough bodies.

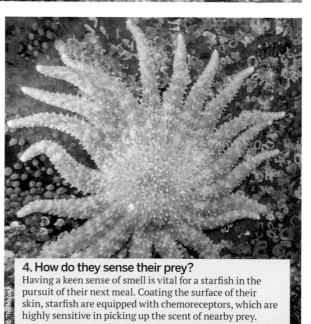

4. How do they sense their prey?
Having a keen sense of smell is vital for a starfish in the pursuit of their next meal. Coating the surface of their skin, starfish are equipped with chemoreceptors, which are highly sensitive in picking up the scent of nearby prey.

© Thinkstock

6. How do they hunt?
Starfish are solitary marine creatures, slowly scouring the seafloor looking for their next meal. As keen hunters, starfish won't pass up a chance to grab one of the many shellfish, fish and invertebrates they encounter. However, they are also opportunists and can never say no to a free meal. Collecting en masse upon detecting a whiff of a dead carcass (such as a seal that has fallen to the seafloor), hundreds of starfish will converge to eat the remains.

7. Can they catch fast prey?
Starfish often enjoy feasting on the flesh of slow-moving prey or scavenging on remains. However, in 2017, while exploring a ridge off Jarvis Island in the South Pacific Ocean, a group of scientists witnessed a brittlestar (a small-bodied, long, thin- limbed starfish) reach up and snatch small passing squid. Once entangled in its long legs, the squid was quickly moved to the mouth to be consumed.

5. How many species are there?
Starfish, or 'sea stars', are a common name for over 2,000 species of these marine invertebrates, all of which belong to the taxonomic class Asteroidea.

8. How low can they go?

Versatile in their choice of habitat, starfish can be found throughout the depths of the ocean, from the shallows around the shoreline down to more than 1,000 metres (around 3,280 feet) below the surface.

9. Can they see?

Placed at the end of starfish limbs are 'eyespots' – photoreceptor cells that allow them to detect light, shadows and large structures such as prey. If unobstructed, a starfish is able to 'see' 360 degrees.

10. How fast are they?

Although typically slow and steady in their pace on the seafloor at about 15 centimetres a minute, the sunflower starfish uses its 15,000 tubular feet to walk a metre in around one minute.

11. How are they able to eat shellfish?

Starfish limbs are strong enough to prise open the shells of prey animals such as mussels and clams.

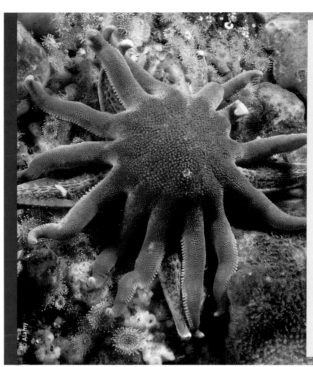

12. Do they have any defences?

To protect themselves from predators, the upper side of most starfish bodies are covered in calcium-carbonate plates. This tough exterior helps protect against other marine life such as crabs, fish and sea otters. To offer further protection a great deal of them sport thorn-like spines, which serve to deter predators from attacking.

13. How big are they?

Many starfish are small enough to fit into the palm of your hand. However, some species have grown to be giants of the sea. The sunflower starfish, for example, can grow to have a diameter of 1 metre (3.3 feet) wide, and the giant sea star can span up to 60 centimetres (23.6 inches).

14. How do they hold onto prey?

In order to grapple its prey into submission, a starfish uses its many limbs lined with hundreds of tubular sticky feet. These feet not only act as a conveyor belt to transport invertebrates to the mouth, but also allow them to manoeuvre over difficult terrain.

15. Why all the colours?

To evade detection from passing predators, many species of starfish have evolved to display different colours, patterns and exterior lumps to mimic and blend into their rocky surroundings.

16. Do any starfish have more than five legs?

While the majority of starfish have five limbs, several species have upwards of 20 to 40 limbs.

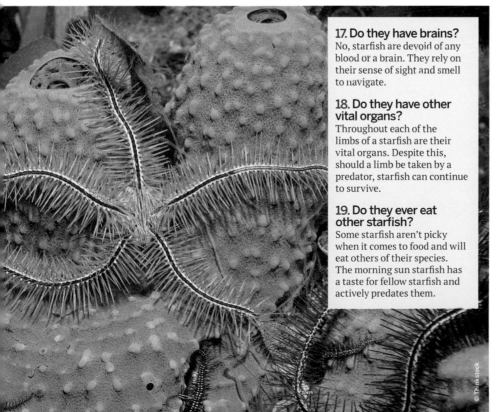

17. Do they have brains?

No, starfish are devoid of any blood or a brain. They rely on their sense of sight and smell to navigate.

18. Do they have other vital organs?

Throughout each of the limbs of a starfish are their vital organs. Despite this, should a limb be taken by a predator, starfish can continue to survive.

19. Do they ever eat other starfish?

Some starfish aren't picky when it comes to food and will eat others of their species. The morning sun starfish has a taste for fellow starfish and actively predates them.

20. Why are they so dangerous to coral?

A single crown-of-thorns starfish can eat six square metres (64.6 square feet) of coral a year. They are a major factor behind the destruction of the Great Barrier Reef.

EIGHT-LEGGED ALIENS?

Octopuses certainly don't look like earthlings, but could these brainy, blue-blooded creatures really be from another planet?

Words by **Ella Carter**

There's no denying that the octopus looks like something straight out of science fiction. Its eight-limbed, sucker-covered, slimy, colour-and-texture-changing body is as unfamiliar to us as can be. Add in the fact that they are capable of accomplishing surprisingly intelligent tasks and we are immediately suspicious. Many of the octopus' creepier features have been borrowed over the years by writers and directors to illustrate life from other planets, and there are even theories that our own earthly cephalopods came from outer space. However, octopuses are simply an incredible feat of earthling evolution.

The recent theory proposed by 33 authors in a paper published in the journal *Progress in Biophysics and Molecular Biology* suggests the Cambrian Explosion (a period in the fossil record where biodiversity boomed around 540 million years ago) was brought about by viruses crashing to Earth aboard extraterrestrial meteors, altering the genetic codes of species here. The authors highlighted the octopus as a specific example, which led to a flurry of outlandish headlines in the press.

This idea is furthering a controversial theory from the 1970s known as the panspermia hypothesis, which challenges the origins of life and suggests that instead of evolving on Earth, much of life was 'seeded' and brought to our planet on asteroids. Although an imaginative idea, this theory has been examined by many leading evolutionary biologists, and despite the octopus looking pretty alien, the evidence is overwhelming in favour of earthly evolution.

Our last common ancestor with the octopus lived around 750 million years ago and was most likely an aquatic worm-like critter. Cephalopods are molluscs, part of the same family as slugs and snails, yet given their higher intellect compared to their molluscan cousins it's fair to wonder how they became so advanced. However, the octopus genome was mapped in 2015 and showed that these eight-legged critters share DNA not only with their closest relatives but also with many other species, including humans.

Despite their blue blood (caused by the presence of haemocyanin), three hearts (one for each gill, one to pump blood around the organs), amazingly advanced eyesight, keen minds and otherworldly body shape, octopuses are very much of this Earth, even if they are wonderfully weird inhabitants of it.

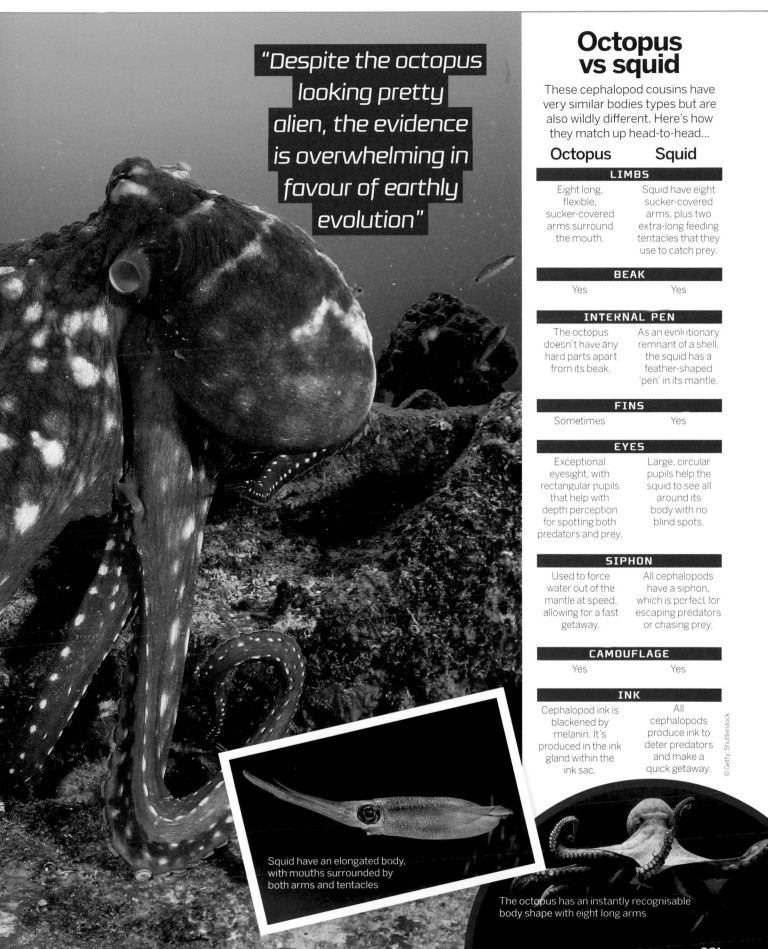

"Despite the octopus looking pretty alien, the evidence is overwhelming in favour of earthly evolution"

Octopus vs squid

These cephalopod cousins have very similar bodies types but are also wildly different. Here's how they match up head-to-head...

Octopus	Squid
LIMBS	
Eight long, flexible, sucker-covered arms surround the mouth.	Squid have eight sucker-covered arms, plus two extra-long feeding tentacles that they use to catch prey.
BEAK	
Yes	Yes
INTERNAL PEN	
The octopus doesn't have any hard parts apart from its beak.	As an evolutionary remnant of a shell, the squid has a feather-shaped 'pen' in its mantle.
FINS	
Sometimes	Yes
EYES	
Exceptional eyesight, with rectangular pupils that help with depth perception for spotting both predators and prey.	Large, circular pupils help the squid to see all around its body with no blind spots.
SIPHON	
Used to force water out of the mantle at speed, allowing for a fast getaway.	All cephalopods have a siphon, which is perfect for escaping predators or chasing prey.
CAMOUFLAGE	
Yes	Yes
INK	
Cephalopod ink is blackened by melanin. It's produced in the ink gland within the ink sac.	All cephalopods produce ink to deter predators and make a quick getaway.

© Getty, Shutterstock

Squid have an elongated body, with mouths surrounded by both arms and tentacles

The octopus has an instantly recognisable body shape with eight long arms

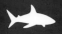

Octo physiology

Super senses, big brains, colour-changing bodies... Octopuses are some of the most fascinating underwater beings

Octopuses are cephalopods, which means 'head-foot'. Their eight arms (technically not tentacles) surround the mouth and are full of strong muscles. They also contain two-thirds of the octopus' neurons, which means they can quite literally think for themselves.

Each arm is equipped with over 250 suction cups, each able to be manipulated independently. They are also a sensory organ capable of smell and taste, ideal for seeking out food. But eight arms are a lot to keep track of, so what stops octopuses getting tied in knots?

Amazingly, its skin has a coating that prevents the suckers from sticking to itself. Arms can also be dismembered at will as a last-ditch attempt to escape a predator. They can then regrow the lost limb, a process that takes roughly two months.

These arms are also essential for swimming, but crawling over the seafloor is preferred. This is because when it swims, the octopus' third heart, which pumps blood to its organs, stops beating, so swimming is an exhausting activity.

The octopus' eyes are another incredible feature. Some of the most advanced in the animal kingdom, they are as complex as the vertebrate eye even though they evolved independently. Yet despite being colourful creatures, their eyes only have a single photoreceptor cell, which renders them technically colour-blind. However, they can pick out wavelengths of light by altering the shape of their lenses as the light enters their rectangular pupils. This allows them to focus on individual colours.

Octopus anatomy

Inside one of the strangest body types in the animal world is a very simple anatomical structure that performs complex tasks

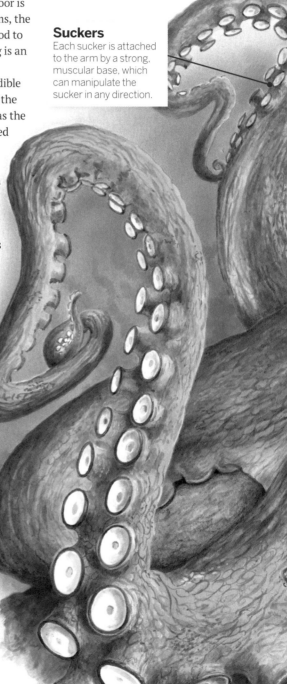

Suckers
Each sucker is attached to the arm by a strong, muscular base, which can manipulate the sucker in any direction.

Development
Females will often care for the eggs throughout their development, warding off hungry predators and ensuring eggs are oxygenated.

Egg laying
Female octopuses stitch their eggs together into braids and secure them in sheltered surroundings.

The circle of life

With short lifespans, 'live fast, die young' is an apt octopus motto

Hatching
The mother octopus gives the hatched babies a helping hand by wafting them out of the den. They are perfect miniatures of her.

Feeding
The next crucial months are spent voraciously feeding, changing their prey as the young octopuses get bigger and stronger.

Mating
Although solitary creatures, octopuses come together to mate. Unfortunately, this signifies the beginning of the end of their lives.

Growth
The common octopus lives around three years. They reach maturity at around 18 months.

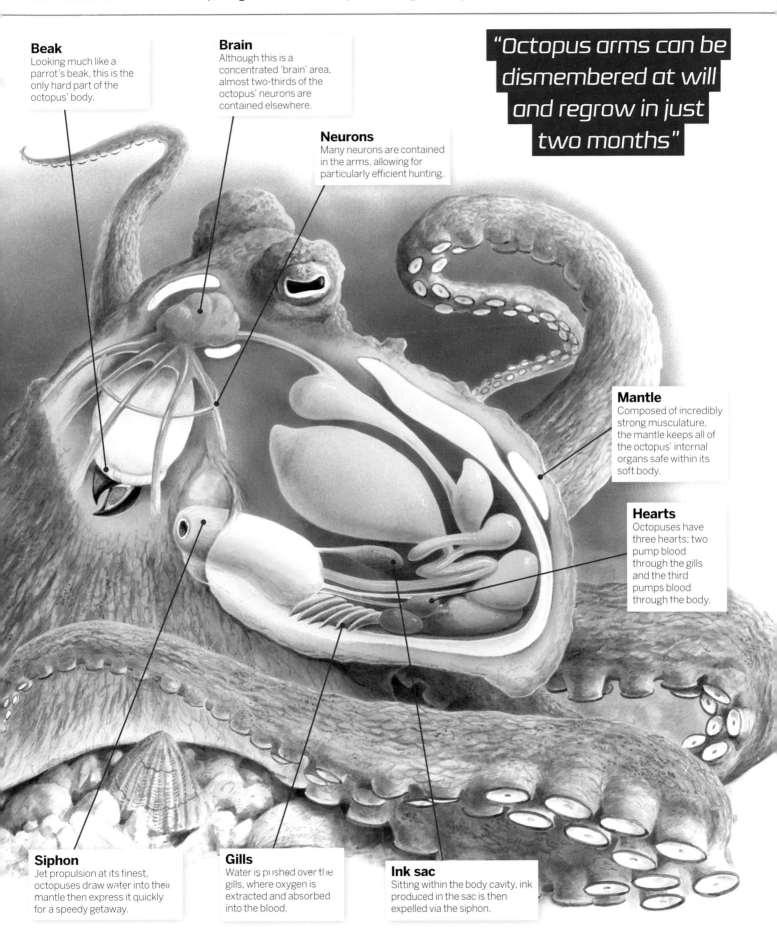

Beak
Looking much like a parrot's beak, this is the only hard part of the octopus' body.

Brain
Although this is a concentrated 'brain' area, almost two-thirds of the octopus' neurons are contained elsewhere.

Neurons
Many neurons are contained in the arms, allowing for particularly efficient hunting.

"Octopus arms can be dismembered at will and regrow in just two months"

Mantle
Composed of incredibly strong musculature, the mantle keeps all of the octopus' internal organs safe within its soft body.

Hearts
Octopuses have three hearts; two pump blood through the gills and the third pumps blood through the body.

Siphon
Jet propulsion at its finest, octopuses draw water into their mantle then express it quickly for a speedy getaway.

Gills
Water is pushed over the gills, where oxygen is extracted and absorbed into the blood.

Ink sac
Sitting within the body cavity, ink produced in the sac is then expelled via the siphon.

Subsea smarts

From escaping captivity to targeting people with jets of water, octopuses are nothing if not crafty

It's no secret that cephalopods are clever. With large brains (especially for creatures without backbones), octopuses are able to solve problems, learn from their encounters and even experience sleep and play. These have all been tested in laboratories across the globe, with octopuses obliging by navigating mazes, solving puzzles to gain access to food and using their elaborate arms to mischievously play with items in their tanks. One octopus even flooded the Santa Monica Pier Aquarium by tampering with a valve in her tank. There are also anecdotes of octopuses sneaking out of their tanks at night to feed on other aquarium residents.

This is all possible due in part to their eight dexterous appendages that contain the majority of their neurons, allowing them to work independently without input from the brain. With 500 million neurons present, this places octopuses close to the realm of dogs, although the amount of neurons isn't necessarily an indicator of intelligence.

Like dogs, however, those who have spent time with octopuses will attest to their various different personalities and how some octopuses in aquariums will squirt water at specific employees when they approach, testament to their powers of recognition.

The amazing mimic octopus is an expert at impersonating other sea creatures, such as lionfish, flounders or sea snakes

Masters of masquerade

Octopuses can change colour and texture at will. Colour changes are controlled by tiny cells in the octopus' skin called chromatophores, which are manipulated by muscles that cause the cells to expand or contract. These cells are connected to the nervous system, allowing these critters to easily match their surroundings.

Texture changes are controlled by organs known as papillae. They allow raised bumps to appear on the skin, blurring the octopus' outline into the background for an extra layer of protection.

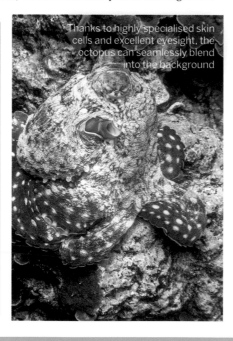
Thanks to highly specialised skin cells and excellent eyesight, the octopus can seamlessly blend into the background

Voracious hunters

Like the rest of the soft-bodied cephalopods, octopuses are both predator and prey. They have to be able to hunt quickly and efficiently, as if they hang around there is the possibility of becoming dinner for someone else.

Octopuses hunt with a variety of tactics. Their favourite foods are crabs and other crustaceans, but they also eat fish and other cephalopods. Ambush predation is a key component of the hunt; the octopus assumes the colour and texture of its surroundings before seizing its unsuspecting prey.

Once it has stuck, the strong, muscular arms will bring the prey to the octopus' mouth, where a dose of neurotoxin-laden saliva is administered to paralyse it. This is how the octopus can subdue crabs, as their claws can be dangerous obstacles to overcome. Enzymes in the saliva break down the soft tissue inside the crab, which the octopus can then slurp up like a milkshake for a tasty meal.

Extraordinary members of the octopus family

Giant Pacific octopus
Found in temperate Pacific waters, these octopuses are the largest species out there; their arms can span up to around five metres.

Blue ringed octopus
The size of a golf ball, this octopus may look adorable, but it contains enough venom – 1,000 times more powerful than cyanide – to kill 26 humans!

Dumbo octopus
So named for their large 'fins', which resemble the Disney elephant's ears, these critters live in the deep ocean at around 4,800 metres below the surface.

Smokescreen escapes

Like all cephalopods, octopuses have an extra trick up their sleeve with their inking abilities. Their siphon is used to shoot out a jet water for quick escapes, expel waste and secrete ink from within the mantle. When an octopus is startled or threatened it can contract the siphon to release the ink, which mixes with mucous to form a sticky, confusing smokescreen.

Ink is black thanks to melanin – the substance responsible for dark skin and hair in humans. Ink also contains a compound called tyrosinase that can cause irritation, stinging the predator's eyes and befuddling their senses. All of this effectively stalls an attack, allowing the octopus to jet to safety.

Tools for the job

Another aspect of octopus intelligence is the use of tools. Previously only witnessed in primates, dolphins and some birds, octopuses in Indonesian waters have been witnessed carrying two halves of a coconut shell as they traverse the seafloor. The octopuses used these halves as a whole protective 'case', squeezing into the coconut in areas where dens, nooks and crannies were hard to find in order to escape predators. Tool use has long been a benchmark of animal intelligence, but there is some debate among biologists as to whether this is classed as 'tool usage'.

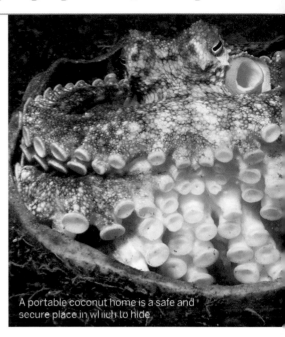
A portable coconut home is a safe and secure place in which to hide

Octopuses that don't swim away from their own ink can be killed by it

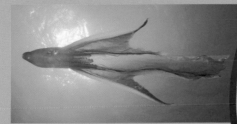
"One octopus flooded the Santa Monica Pier Aquarium by tampering with a valve in her tank"

Suckers on land

Thanks to their amazing limbs, swimming and moving along the ocean floor aren't the only hunting strategies open to certain species of octopus. The rocky shore offers a cornucopia of prey, and one species located on Australian beaches is exploiting its skills in order to clean up.

Known as the only 'land' octopus, the Abdopus octopus (Abdopus aculeatus) has been witnessed crawling out of its rock pool home to comb the beach in search of tasty morsels trapped in pools at low tide. It can do this using the strong, sucker-covered arms that it expertly manipulates in order to pull itself across the shore. Nipping from pool to pool, this specially evolved octopus has the edge thanks to its land-roving ability.

© Getty, Wiki/ Heinonlein; Shutterstock

Star-sucker pygmy

Reaching just two centimetres in length and weighing just one gram, this tiny critter is the smallest octopus species known to science.

Blanket octopus

Females of this species sport long blankets of flesh between their arms, which can splay out to deter predators. Males are just a tiny fraction of their size.

Also known as the 'algae octopus', this cunning critter is able to leave the safety of its tide pool to hunt

ANGLERFISH

This animal lives up to its name by drawing in prey with a lure that hangs from its forehead

Words by **Amy Grisdale**

18 families of anglerfish exist within the order lophiiform, all of them carnivores. The entire group consists of just over 320 bizarre species, from Needlebeard seadevils to footballfishes. Some can grow to one metre (three feet) long, while others barely make it past two centimetres (0.8 inches), but even the smallest are deadly. They gorge on shrimp and bony fish when they get the chance, but can survive on very little food.

The most famous anglerfish are deep-sea dwellers. They have rounded heads, big mouths and a lot of sharp teeth. They dangle a bioluminescent light that glows softly through the darkness. The fish wiggles it around to make it look like a luminous invertebrate, and it flits from side to side in front of the predator's waiting mouth. Prey wander over to investigate, but they find themselves ambushed before they know what's hit them.

Because it's so hard to find another member of your own species in the black abyss, anglerfish are almost always in pairs. Females are large, but their partners are incredibly small. Males have been shaped by evolution and have become permanent parasites on the female's body. An unattached male latches onto a female with its teeth. Females are far bigger than males and are the only ones with the tempting esca lure. The male fuses to the female over time, and soon connects to the female's skin and bloodstream. All of his internal organs disappear except those necessary for reproduction. Six or more males can attach to a fertile female, and having a few live-in lovers helps the anglerfish forget about mating and focus on the important task of hunting.

COSMOPOLITAN WHIPNOSE
Gigantactis vanhoeffeni
Lifespan Unknown
Adult weight Unknown
Conservation status

EX EW CR EN **VU** NT LC

DATA DEFICIENT

Whipnose
A model of a whipnose, an angler with an extremely elongated lure that can grow longer than the animal itself

Little fins
The fins of an anglerfish are fairly weak because the predator prefers to sit and wait on the sea floor to be approached by a potential meal.

Bacterial glow
Light-producing bacteria lend their illumination to anglerfish in exchange for free rides and ample food.

Fishing rod
Called the esca, this organ is made of modified spines from the dorsal fin on the fish's back.

Translucent teeth
The protruding teeth don't catch the light and act as cage bars to trap unlucky prey inside the spacious mouth.

BLACKBELLIED ANGLER
Lophius budegassa
Lifespan Unknown
Adult weight Unknown
Conservation status
EX EW CR EN VU NT LC
LEAST CONCERN

GHOSTLY SEADEVIL
Haplophryne mollis
Lifespan Unknown
Adult weight Unknown
Conservation status
EX EW CR EN VU NT LC
LEAST CONCERN

COMMON ANGLER
Lophius piscatorius
Lifespan 24 years
Adult weight 32kg (70lb)
Conservation status
EX EW CR EN VU NT LC
LEAST CONCERN

FOOTBALLFISH
Himantolophus albinares
Lifespan Unknown
Adult weight Unknown
Conservation status
EX EW CR EN VU NT LC
DATA DEFICIENT

© Jeffrey Rotman/Biosphoto/FLPA

BLACKBELLIED ANGLER
Also known as a monkfish, this angler will lie camouflaged on the sea floor, waiting to gobble unsuspecting prey who swim too close.

© Photo Researchers/FLPA

GHOSTLY SEADEVIL
Usually male anglerfish attach to their mate's belly, but ghostly seadevils have been known to bind on the end of the lady's lure.

© Photo Researchers/FLPA

COMMON ANGLER
The common angler has a mouth so wide it wraps almost all the way around the anterior of the head.

MEET THE FAMILY
RAYS These sly hunters are perfectly adapted to their habitat

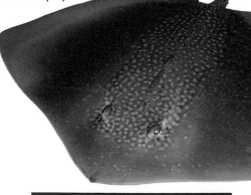

Spotted eagle ray
The ray that can almost take off

The group of species known as eagle rays have large and elegant pectoral fins that both look and move like the wings on a bird. Found in shallow coastal seas, these fins are mostly used for swimming, but on occasion these rays have been witnessed leaping fully out of the water in spectacular aerial displays. Due to their sheer size and weight, spotted eagle rays are rarely preyed upon by all but the largest of beasts. Digging their own food of hard-shelled critters such as lobsters and oysters out of the seabed is easy for the spotted eagle, with their shovel-shaped noses and specialised teeth making it easy to extract the tasty parts from the shells.

Electrocytes are the electricity-producing cells that give these rays their shock – they are stacked up end-to-end in the ray's specialised electrogenic organs, much like a row of batteries.

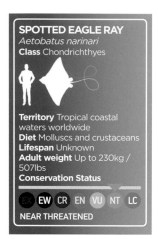

SPOTTED EAGLE RAY
Aetobatus narinari
Class Chondrichthyes

Territory Tropical coastal waters worldwide
Diet Molluscs and crustaceans
Lifespan Unknown
Adult weight Up to 230kg / 507lbs
Conservation Status

EX EW CR EN VU NT LC

NEAR THREATENED

Cownose ray
The migratory species that gathers in groups

Cownose rays are famous for their ocean migrations along the Atlantic coast and Gulf of Mexico, featuring in many glossy photographs of schools of up to 10,000 individuals swimming to and from the seasonal feeding grounds. It's thought that these rays take temperature cues from the water and visual cues from the sun before embarking on these journeys, and when they get to their destination, there's only one thing to do: feast. By beating their pectoral fins, they create strong currents close to the seabed in a bid to uncover their prey.

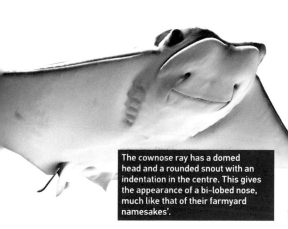

The cownose ray has a domed head and a rounded snout with an indentation in the centre. This gives the appearance of a bi-lobed nose, much like that of their farmyard namesakes'.

COWNOSE RAY
Rhinoptera bonasus
Class Chondrichthyes

Territory Tropical eastern and western Atlantic Ocean
Diet Oysters and crustaceans
Lifespan 13-18 years
Adult weight Approx 15.4kg / 34lbs
Conservation Status

EX EW CR EN VU NT LC

NEAR THREATENED

Stingray
A fish with a black belt in self-defence

Stingrays have the classic flat-bodied silhouette of the ray family, with a skeleton made of cartilage, undulating fins and a long, tapering tail. They spend their time cruising through the shallow waters of coastal seas, feeding on shelled molluscs and crustaceans, rooting around on the seabed in search of their dinner. However, this species' trump card is its tail barb – the thing that puts the 'sting' into 'stingray'. This barb is found about one third of the way down a stingray's tail, and it can be a formidable-looking spike containing potent venom. Stingrays are generally docile creatures and so a barb attack is almost always in self-defence – when the ray needs to fight, the tail can whip up and deliver a fatal blow.

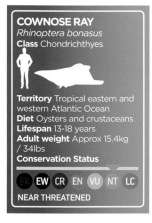

COMMON STINGRAY
Dasyatis pastinaca
Class Chondrichthyes

Territory Coastal waters of temperate seas
Diet Crabs, mussels, oysters
Lifespan 15-25 years
Adult weight Up to 350kg / 790lbs
Conservation Status

EX EW CR EN VU NT LC

DATA DEFICIENT

Like their cousins the sharks, stingrays possess electrical sensors known as ampullae of Lorenzini. They can sense the natural electrical pulse of living things around them, helping to find prey.

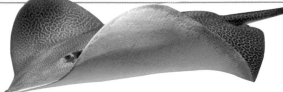

The majestic wing-like fins are characteristic of eagle rays as a group, but the spotted eagle ray is even more distinctive with its beautiful colouration and polka-dot pattern.

Atlantic torpedo ray
This species puts on a stunning show

This is a ray that really lives up to its superhero-style moniker. Not just your average fish, this particular member of the ray family is capable of producing strong electric currents in order to stun prey for a quick meal, or defend its honour against encroaching predators. Electric rays have two kidney-shaped organs in their bodies, situated near the gills, which are capable of producing a current of up to 220 volts. They do this by contracting the specialised muscles that are tightly packed together within these electrogenic organs. Because of this formidable party trick, electric rays are able to swiftly stun and then feast upon dinner delights that would ordinarily be too fast for them to catch.

ATLANTIC TORPEDO RAY
Torpedo nobiliana
Class Chondrichthyes

Territory Atlantic Ocean, Mediterranean Sea
Diet Small sharks, flounder, mackerel
Lifespan Unknown, likely 16-20 years
Adult weight 90kg / 198lbs
Conservation Status

EX **EW** CR EN **VU** NT LC
DATA DEFICIENT

Ocellate river ray
The freshwater addition to the family

Where most of the ray family are ocean-dwelling critters, there are a few select members that make their home in the fresh water of river basins. The ocellate river ray is one of these, living in the riverine systems of South America. Looking like a flat, circular pancake with a long spined tail and prominent eyes, this ray lies at the bottom of sand banks and silty river bottoms in wait for tasty prey to come along. When lying on a sandy riverbed, their gills and mouths on the underside of the body can't be used, so the ray (like many other ray species) takes in water to pass over the gills through a special opening known as a spiracle, situated behind each eye.

OCELLATE RIVER RAY
Potamotrygon motoro
Class Chondrichthyes

Territory Southern South America
Diet Small molluscs, crustaceans and insect larvae
Lifespan Unknown
Adult weight Up to 32kg / 74lbs
Conservation Status

EX **EW** CR EN **VU** NT LC
DATA DEFICIENT

It's easy to see why this fish is also known as the 'peacock-eye' ray – like the eyed feather of a peacock, the detailed pattern on its back can act as a decoy for would-be predators.

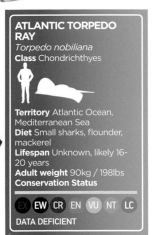

1. Most intelligent
Manta ray
Manta rays have the largest brain size relative to body mass of all fish species and often exhibit co-operative and co-ordinated feeding behaviour. Manta rays are much more than just pretty faces.

2. Smallest
Lesser electric ray
This tiny little critter can be found in shallow waters on the east coast of USA and South America and in the Gulf of Mexico. It is on average just 20cm/8" across and weighs about 0.5kg/1lb.

3. Rarest
Maltese ray
Listed as Critically Endangered by the IUCN Red List, the Maltese ray was once common in the Mediterranean Sea. It is now restricted to the Sicilian channel around Malta, and is blighted by heavy trawling.

4. Most spectacular
Mobula ray
Mobula rays gather in huge shoals at certain times of the year. To stand out from the crowd, they launch themselves into the air and land on the water with a resounding boom noise.

Manta ray
These gentle giants are the largest rays of all

The colossal manta ray is one of the ocean's biggest softies. Its huge size might look daunting with its huge fins that could comfortably cover your family car, but these creatures are of no threat to humans whatsoever. Manta rays feed by opening their large mouths and drawing in seawater. They filter all of the tiny microorganisms out of each liquid mouthful – one full-grown manta can suck down 27kg/60lbs of food in one day! There are two species of manta ray. One is proportionately smaller and lives on tropical reefs. The other is more migratory and travels from one area of oceanic upwelling to another in search of plankton.

MANTA RAY
Manta birostris
Class Chondrichthyes

Territory Tropical seas worldwide
Diet Plankton
Lifespan Unknown, thought to be 50-100 years
Adult weight Up to 1,350kg / 2,976lbs
Conservation Status

EX **EW** CR EN **VU** NT LC
VULNERABLE

The manta is sometimes known as 'devil ray', due to the two large fins on its head that look like horns. These are actually used to guide plankton-rich water into the mouth while feeding.

A butterfly ray is not an insect

Butterfly rays are not at all related to real butterflies! Instead, this group of rays get their name from their wide set of pectoral fins that look very much like wings, along with their short sharp tails that resemble a butterfly's body. The rays use their strong fins to 'fly' through the water, mimicking a slowmo version of a wing flutter.

© Thinkstock; Dreamstime

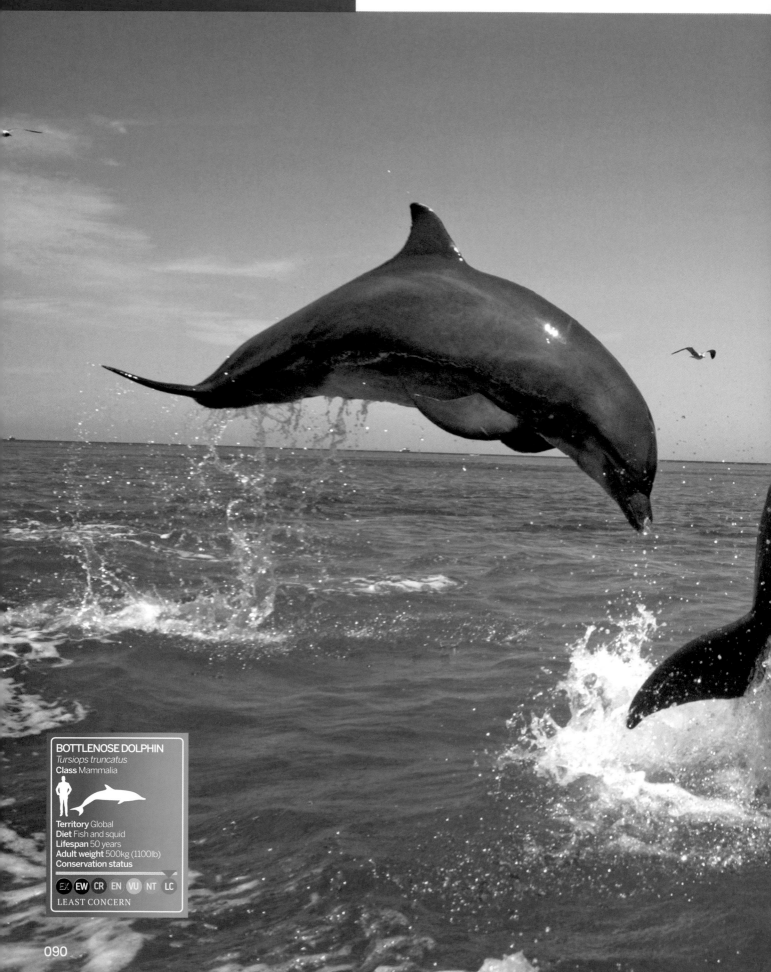

BOTTLENOSE DOLPHIN
Tursiops truncatus
Class Mammalia

Territory Global
Diet Fish and squid
Lifespan 50 years
Adult weight 500kg (1100lb)
Conservation status

EX EW CR EN VU NT LC

LEAST CONCERN

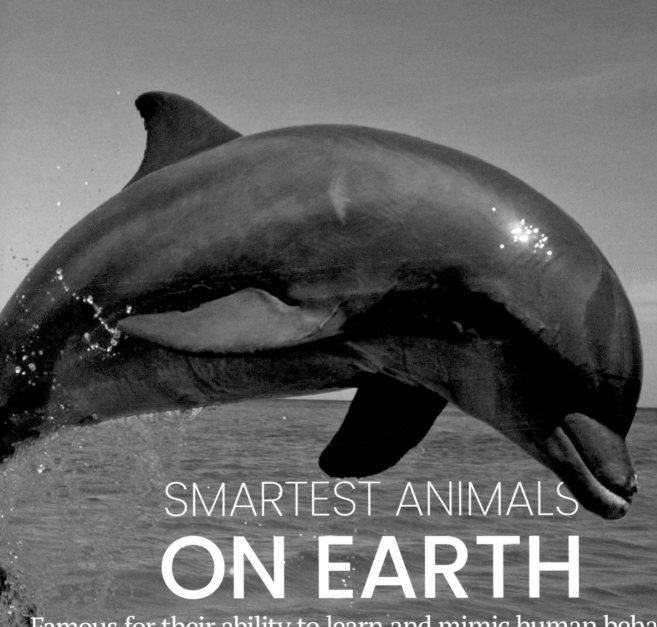

SMARTEST ANIMALS
ON EARTH

Famous for their ability to learn and mimic human behaviour, the real story behind the immense intelligence of dolphins lies in their astounding wild behaviour

Whales and dolphins have fascinated human beings for millennia, with dolphins featuring in cave paintings dating back almost 3,000 years. The first descriptions of dolphins came from sailors, who spoke of enormous creatures with large eyes, long beaks and sharp teeth. Artistic depictions of them at the time looked more like sea monsters, admiring their strength and cunning hunting techniques. Over the years, humans soon discovered that dolphins were intelligent mammals of the sea and began to study them.

As technology developed that could record their underwater calls, scientists began to realise how complex their behaviour and communication truly was. Exactly what dolphins are speaking about is still unclear, but as research progresses we are learning more and more about the most intelligent animals in the ocean.

091

Communication

Dolphins stay in contact at all times, constantly chirping and clicking to one another about sources of food, group life and the threat from predators

Living under water means that dolphin communication works extremely differently from animals that live on land. Sound is the basis of almost all dolphin interactions and the exact information different noises contain is still a mystery to marine biologists. Staying in contact is crucial for dolphin survival and their social intelligence has developed over thousands of years of evolution.

Each dolphin makes a unique whistle sound that acts as a name tag. Dolphins introduce themselves to others around them and recognise one another by these signature sounds. Closely bonded dolphins even mimic one another's whistles, which is like calling out for a friend by name.

The dominant form of communication in primates is through sound, but the primary sense of apes and monkeys is visual. Scientists now think that dolphin communication is more efficient than our own, because they can replicate any sound that they hear. These animals build up mental pictures of the environment using biological sonar and they might be able to project these pictures to others, like a hologram. This surpasses the amount of information humans can convey with speech and dolphin conversations could be up to 20-times more detailed than that of apes and other primates.

Not all dolphin communication is based on sound, though, after arriving and before leaving a group they touch each other. Even altering their posture while swimming is a form of communication and a dolphin can invite others to play by wriggling its body.

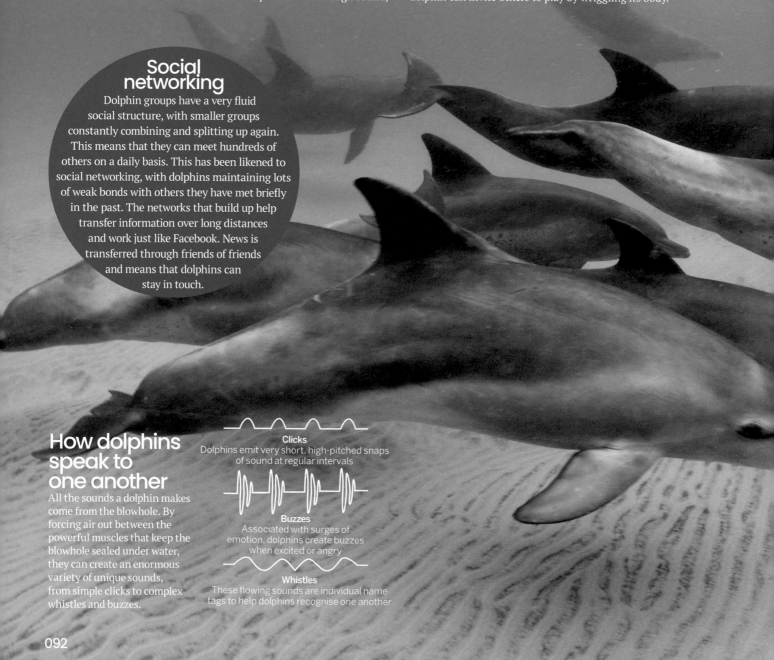

Social networking

Dolphin groups have a very fluid social structure, with smaller groups constantly combining and splitting up again. This means that they can meet hundreds of others on a daily basis. This has been likened to social networking, with dolphins maintaining lots of weak bonds with others they have met briefly in the past. The networks that build up help transfer information over long distances and work just like Facebook. News is transferred through friends of friends and means that dolphins can stay in touch.

How dolphins speak to one another

All the sounds a dolphin makes come from the blowhole. By forcing air out between the powerful muscles that keep the blowhole sealed under water, they can create an enormous variety of unique sounds, from simple clicks to complex whistles and buzzes.

Clicks
Dolphins emit very short, high-pitched snaps of sound at regular intervals

Buzzes
Associated with surges of emotion, dolphins create buzzes when excited or angry

Whistles
These flowing sounds are individual name tags to help dolphins recognise one another

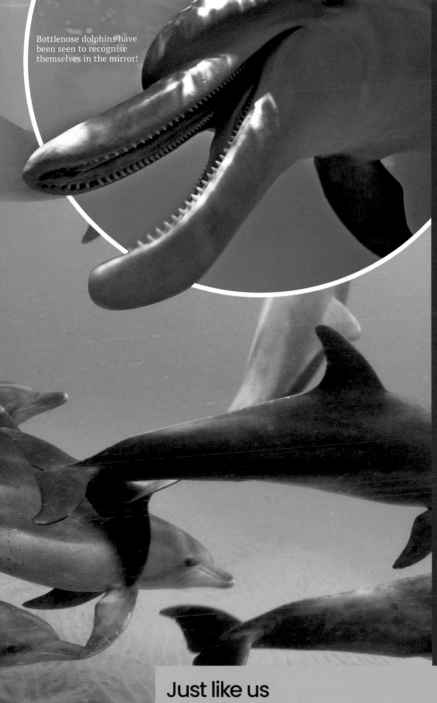

Bottlenose dolphins have been seen to recognise themselves in the mirror!

Proving self-awareness

Dr Diana Reiss is a world-renowned dolphin expert. She led the team that proved dolphins can recognise themselves in a mirror

"At my lab in 2001 I did a study with a very simple design. You're asking if a dolphin understands that what they see in the mirror is an external representation of themselves.

We exposed dolphins to a mirror and we gave them time to learn about how mirrors work. We saw three basic stages the animals went through to show that they could recognise themselves. The first stage we call social behaviour. The animals try to touch the mirror, look around behind it as if there's another dolphin there. When seeing their reflection they reacted as if they were seeing another of their own kind. Most animals never get past this stage.

"The second stage we saw emerging was more than just testing the mirror. The animals seemed to be testing what was happening in the mirror image when they did certain things.

That is when the light bulb went on. That's when they knew that they were seeing themselves in the mirror.

"In the third stage, the animals shifted to self-directed behaviour. They examined themselves in the mirror, looking at parts of their body that were otherwise not visible. They looked at their eyes, inside their mouths and made unusual movements in front of the mirror. They were using the mirror as a tool to view themselves.

"We went on to do what's called a mark test. We put the mirror into the water for 30 minutes every few days and watched the behaviour of the dolphins. We then called them over and marked their bodies in different places with a non-toxic marker. They immediately raced to the mirror to examine the marked area."

Just like us

As humans, we tend to underestimate other animals, believing our behaviour is unique to us. But dolphins share a few of our traits, showing some extreme intelligence

Dolphins can eavesdrop

Dolphins have communication abilities that were once thought to be unique to humans. Their ability to eavesdrop gives us a clue as to how clever dolphins are. Not only can they listen in to other conversations, but they can also divide their attention between their own vocalisations and other sounds at the same time. This maximises the information they are taking in.

Dolphins can deceive each other

The ability to follow another animal's gaze shows immense intelligence and human children begin to develop this skill after the first year of life. Dolphins use this skill to tell what others are looking at without needing to communicate about it. Dolphins can draw another's attention to an object by pointing at it. In fact, these mammals can even deceive one another by directing it elsewhere.

Emotional intelligence

Feelings of happiness, love and heartbreak are human concepts but these animals share our ability to feel emotion

These animals form extremely close bonds with their families and experience emotions that humans might call love. Newborn dolphins rely on their mothers and older siblings for survival and calves stay with their family for around six years. When a relative dies, dolphins experience grief and mother dolphins carry their lost calves around with them for extended periods of time. Young that have lost their mother are known to visit their mother's favourite locations after her death. When a dolphin group spies a dolphin carcass they approach it and even take it in turns to surface for a breath of air so the corpse isn't left unattended.

Dolphins are famous for their tendency to help animals of other species. There are reports of dolphins helping exhausted seals back to shore and even leading beached whales back to the safety of deep water. In 2008, a bottlenose dolphin arrived at the scene of a stranded mother-calf pair of pygmy sperm whales on a beach in New Zealand. The dolphin, known by locals as Moko, led the pair of whales from the shallows directly into deeper water. The only explanation of this behaviour is that dolphins are capable of experiencing empathy.

"Young that have lost their mother are known to visit their mother's favourite locations after her death"

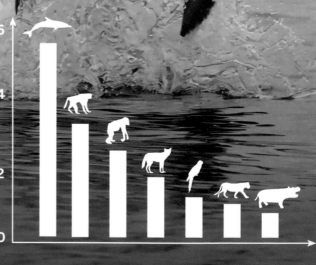

What is EQ?
Encephalisation quotient is a comparison of the size of an animal's brain and its overall body size – dolphins have an extremely high score

EQ level

6

4

2

0

Problem-solving

Life presents animals with puzzles on a daily basis and only animals with the best brains can find their way around the trickiest problems

01 Tool use

Dolphins around the coast of Australia have started to use tools to protect their sensitive beaks. The fish that burrow under the sand don't have an air-filled swim bladder, making them difficult to locate with sonar. To combat this, the dolphins began foraging while shielding their faces with sponges.

02 Hunting

Across the globe, different groups of dolphins have perfected a variety of strategies to catch fish. In Brazil, a pod of dolphins has teamed up with the local fishermen. They herd fish toward the shore and give the fishermen a signal to cast their nets. The dolphins then get their reward of leftover fish.

03 Avoiding predators

Dolphins form a defensive circle around weak members of their pod when a predator approaches. Sharks and other carnivorous fish would gladly attack a lone dolphin, but rarely approach large groups. Even the colouration of some dolphins confuses predators, helping them keep camouflaged.

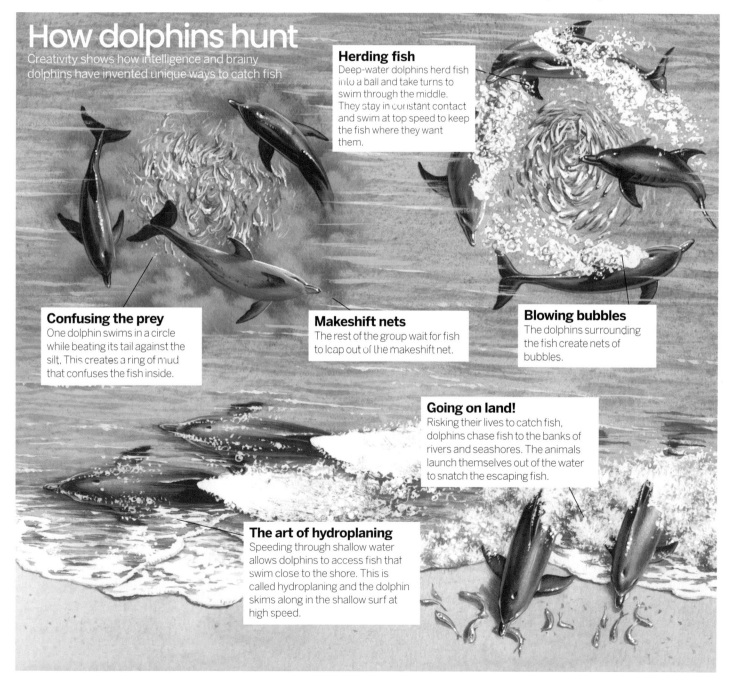

How dolphins hunt

Creativity shows how intelligence and brainy dolphins have invented unique ways to catch fish

Herding fish
Deep-water dolphins herd fish into a ball and take turns to swim through the middle. They stay in constant contact and swim at top speed to keep the fish where they want them.

Confusing the prey
One dolphin swims in a circle while beating its tail against the silt. This creates a ring of mud that confuses the fish inside.

Makeshift nets
The rest of the group wait for fish to leap out of the makeshift net.

Blowing bubbles
The dolphins surrounding the fish create nets of bubbles.

Going on land!
Risking their lives to catch fish, dolphins chase fish to the banks of rivers and seashores. The animals launch themselves out of the water to snatch the escaping fish.

The art of hydroplaning
Speeding through shallow water allows dolphins to access fish that swim close to the shore. This is called hydroplaning and the dolphin skims along in the shallow surf at high speed.

How dolphins think

Their complex brain fuels the animal to process information, store memories and solve puzzles

The emotional centre of a dolphin's brain is more complex than in a human brain. It has a larger surface area and more folds, which indicates that their brains have evolved to process emotion.

Whale and dolphin brains also contain specialised nerve cells called spindle neurons. These cells are associated with the ability to reason, experience emotions and make quick decisions. These were once thought to be possessed only by humans and were even nicknamed 'the cells that make us human'. What's more, dolphins have three-times as many of these cells as humans do, even when accounting for their larger brain size. Not only do dolphins and their relatives have these spindle cells, but they have also had them for twice as long as humans.

Along with this amazing brainpower, dolphins have one of the longest memories of the entire animal kingdom. Even if dolphins are separated for 20 years, they are still able to remember a familiar face. This was noted in aquaria in the United States, when dolphins that had been briefly housed together at the age of only six months old were played audio of one another's signature whistles. Upon hearing the familiar call they instantly responded, whereas an unfamiliar call is often ignored.

Dolphins also have good short term memory and can remember lists of items. Some dolphins are even able to understand sentences of human speech. Dolphins in a 1993 study could remember strings of up to five words and responded to what the human was asking for.

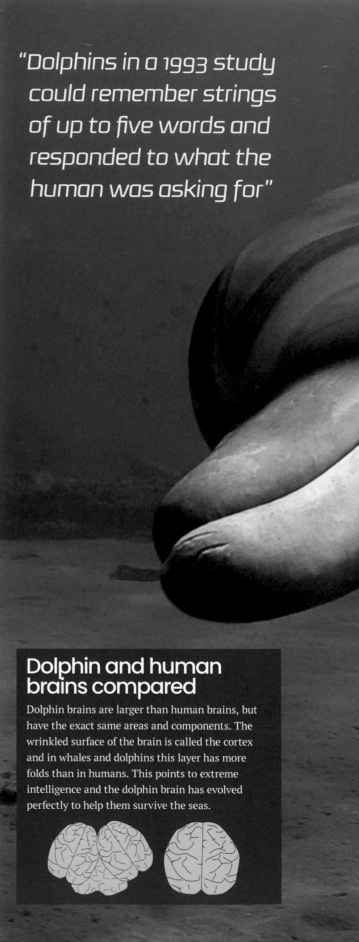

"Dolphins in a 1993 study could remember strings of up to five words and responded to what the human was asking for"

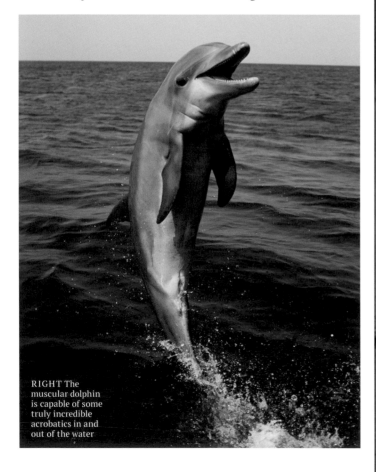

RIGHT The muscular dolphin is capable of some truly incredible acrobatics in and out of the water

Dolphin and human brains compared

Dolphin brains are larger than human brains, but have the exact same areas and components. The wrinkled surface of the brain is called the cortex and in whales and dolphins this layer has more folds than in humans. This points to extreme intelligence and the dolphin brain has evolved perfectly to help them survive the seas.

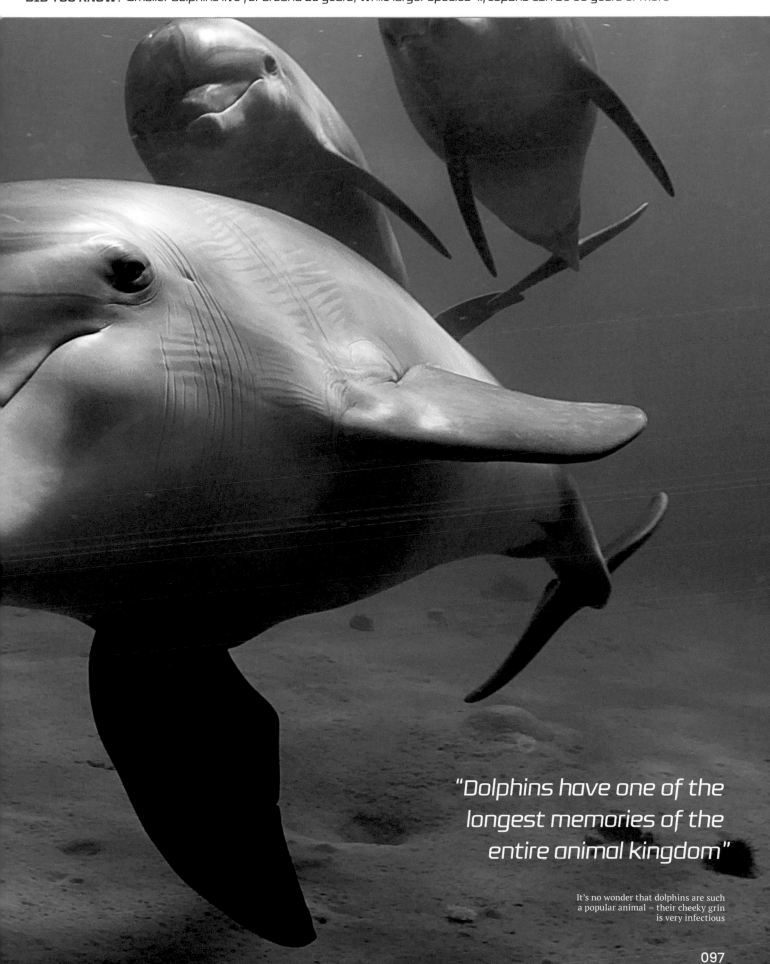

"Dolphins have one of the longest memories of the entire animal kingdom"

It's no wonder that dolphins are such a popular animal – their cheeky grin is very infectious

097

MEET THE FAMILY
WHALES

Meet six incredible members of the whale super family

Gray whale
A haven for tiny travelling parasites

Known for their distinctive look, these big ocean beasts are covered in parasites and organisms that make them look a lot like an ocean rock. Unusually, the whale uses its snout to dislodge small creatures from the sea floor and sieves them through comb-like filter plates in its upper jaw known as baleen.

Once used to make corsets and umbrellas, gray whale baleen is tough but flexible and can grow up to 50 centimetres (19.7 inches) long. While following their lengthy migration, a gray whale can swim some 20,000 kilometres (12,427 miles) to Alaskan waters and then back to the Mexican coast.

Along for the ride
Parasites and organisms live on gray whales' bodies, giving them a distinctive rock-like look.

Distinctive spout
The sei look similar to blue and finback whales, except they're smaller and have a curved dorsal fin with a dark underside. They are often noticeable by the inverted V shape of the spout.

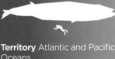
Filter feeder
Using baleen plates to seive zooplankton and small fish, Sei whales consume up to 900 kilograms (2,000 pounds) of food every day.

The largest brain
Sperm whales have the largest brain of all animals on Earth. Weighing 9kg (20lbs), it's about six times heavier than a human's brain.

Sei whale
A speedy cetacean with a healthy appetite for plankton

A filter feeder that uses its baleen plates to sieve zooplankton and small fish out of the water, sei whales can consume up to 900 kilograms (2,000 pounds) of food every day, competing with other whales, basking sharks and large fish such as herring.

Sei prefer temperate waters, although they can be found in seas all over the world, including tropical, Arctic and Antarctic oceans. They usually travel alone or in small pods with less than five members and can cruise at speeds of 26 kilometres (16 miles) per hour, up to a maximum of 50 kilometres (31 miles) per hour. They have become a more popular target for whalers as the populations of blue and finback whales diminish.

Sperm whale
The giant of the ocean with a sizeable brain to match

With the biggest brain of any animal on Earth, the sperm whale is an incredible creature that can eat an enormous quantity of food a day.

The whale is named after the spermaceti oil that it produces in an organ of the same name, within its huge box-like head. It's thought that this fluid, which hardens to wax when cold, helps the whale regulate its buoyancy. This comes in useful when the whale dives to the depths of the ocean to feed on things like giant squid, where they can hold their breath for up to 90 minutes at a time.

Unique markings
Minke whales are distinguished by a pointy, triangular snout and white bands around their fins.

Minke whale
The baby of the filter feeders

The second smallest baleen whale, the minke, measures on average 6.9 metres (22.6 feet). Distinguishable from other whales by a white band on each flipper, minke whales have up to 360 baleen plates either side of their mouths to help feed. They're a dark, near-black colour with a white underbelly. The whale takes three to five intakes of breath and dives deep into the water for up to 20 minutes at a time. Reaching speeds of around 38 kilometres (24 miles) per hour, they sieve through the water for plankton and krill, catching the occasional small fish and sometimes giving chase to sardines. They habituate all the oceans except polar ones and swim in groups of just a few individuals.

MINKE WHALE
Balaenoptera acutorostrata
Class Mammalia

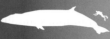

Territory: All oceans bar polar
Diet Plankton and small fish
Lifespan 30-50 years
Adult weight 9,200kg / 20,000lbs
Conservation status

EX EW **CR** EN VU NT LC

LEAST CONCERN

Most unusual

Narwhal Monodon monoceros
A member of the Monodontidae family (a group of toothed whales), narwhal are most recognised for the tusk that grows up to 2.7 metres (8.9 feet) long. Nicknamed the unicorn of the sea, its tusk is actually the more prominent of two teeth of the male of the species (although females can grow a small tusk too). The tusk grows through the upper lip and some believe it's predominantly to impress females during mating rituals or to battle off rival males. The pale-coloured creatures travel in groups of 15 to 20, feeding mainly on fish and shrimp.

Natural filter
35 grooves on the throat enable the humpback to gulp and filter water by extending the throat.

The song of the humpback
These whales are known for the incredible way in which they communicate. Their amazing songs can be heard across massive distances.

HUMPBACK WHALE
Megaptera novaeangliae
Class Mammalia

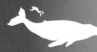

Territory All oceans
Diet Krill and small fish
Lifespan 45-50 years
Adult weight 27,000kg / 59,525lbs
Conservation status

EX EW **CR** EN VU NT LC

LEAST CONCERN

Humpback whale
The oceanic composers

A remarkable creature, the humpback is another colossal baleen whale of the ocean. It has up to 35 grooves on its throat all the way from the chin to the navel. It can expand the throat to enable huge intakes of water to then filter in food such as plankton and krill.

Humpbacks are renowned for performing amazing songs that can be heard over great distances. Thought to be great methods of communication, particularly to attract mates, the songs are made up of moans, howls, cries and the humpback's complex noises can often last hours.

© Thinkstock; FLPA

INSIDE THE MIND OF A
KILLER WHALE

Underwater mavericks, the epic brain power of killer whales is key to
how they hunt and work together to dominate the oceans

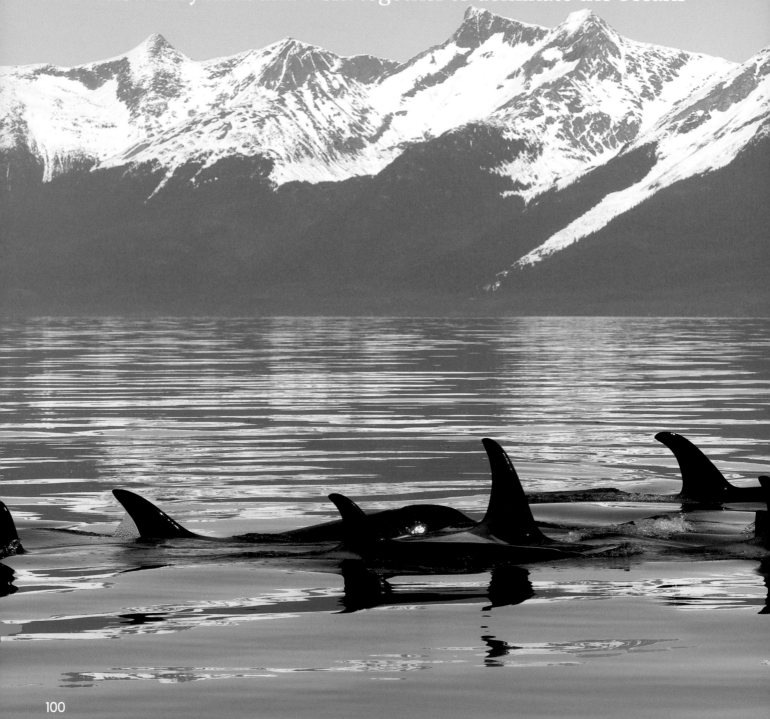

Jaws was wrong: the great white shark isn't the deadliest marine monster – it's the killer whale. No animal dares to prey on these 9.8-metre (32-foot) beauties, qualifying them as the apex predators of the ocean, just as humans are the apex predator of the land. It's human intelligence that keeps us at the top of the food chain, and killer whales – or orcas, as they're also known – have incredible brain power to match their superior brawn.

In fact, they have the second largest brain of any marine mammal (after the sperm whale), but size isn't all that matters. Intelligence is measured by a number of different factors, with scientists analysing social behaviour, self-awareness and communication when forging lists of the cleverest creatures on Earth.

Killer whales tick all these boxes, boasting one of the most complex social structures in the entire animal kingdom. They travel together in matrilineal groups consisting of a mother and her offspring and since females can live up to the grand old age of 90, there can be multiple generations in one group.

While female offspring may go their separate ways and start their own matrilineal lines when they hit sexual maturity (between 10 and 15 years), the male killer whales commonly remain with their mothers their entire lives. That's not to say they don't enjoy a healthy social life, though. Closely related matrilines (up to four matriarchs and their offspring) form what are known as pods, which sometimes meet up with other pods of orcas.

The final level of the social structure is called a community. This is created when a group of clans in an area meet up and likely find themselves a mate, but the males will always return to their mother's side.

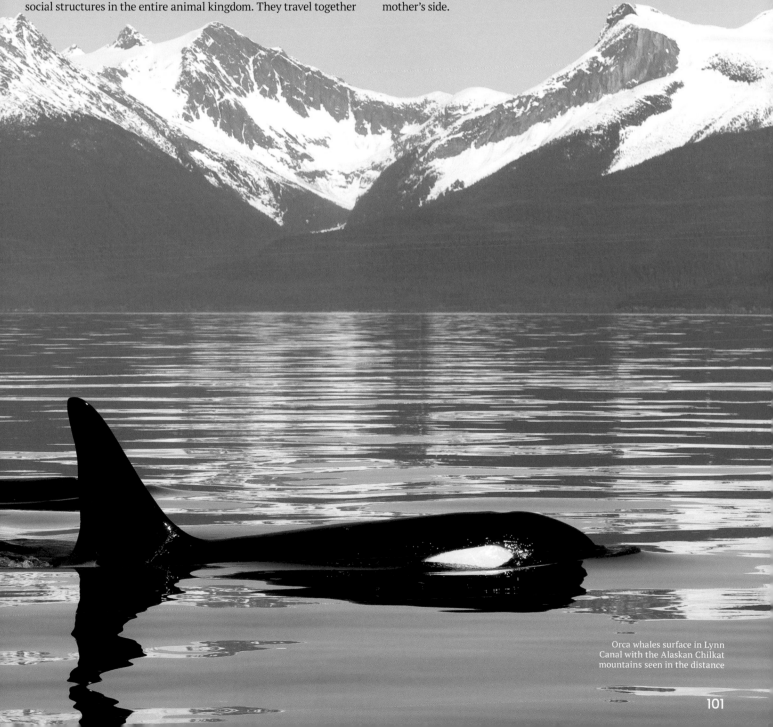

Orca whales surface in Lynn Canal with the Alaskan Chilkat mountains seen in the distance

Amazingly, each pod of killer whales has its own dialect – a series of distinct call patterns – which gives the group its own unique identity. As soon as a baby killer whale (called a calf) is welcomed into the world, the family will use these calls more frequently than ever. This is so that the newborn can master the lingo, just like human parents use repetition to teach their children how to talk. Mothers share valuable life lessons with their calves and discipline them from as young as two days old with a tooth scratch, or by using their bodies to restrict the baby's movement. Communicating via distinct clicks and whistles also helps to hammer the message home even further.

An orca's voice helps it find supper in the first place. To enable the creatures to navigate the murky depths of the ocean, killer whales emit a clicking sound that travels under the water, bounces off an object and then returns with revealing information about the object's size, shape and distance. This incredible technique is known as echolocation and helps orcas track down their favourite kind of fish – chinook salmon. Once they are locked onto their

KILLER WHALE
Orcinus orca
Class Mammalia

Territory All oceans
Diet Carnivore
Lifespan 50-80 years
Adult weight Up to 5,443kg / 6tn
Conservation status

EX EW CR EN VU NT LC
DATA DEFICIENT

target, the incredible orcas appear to go into stealth mode so as to not give the game away too soon.

Not all orcas have the same diet, however, and just as their unique dialects differentiate between pods, it's also possible to tell which ecotype they belong to. There are actually three forms of killer whales: resident (the most recognised), transient and offshore. Not only do they each sound different, but they also look and act in a variety of ways. They don't associate with one another and one day we might even be able to distinguish them as separate species. However, the one thing they will always have in common is their unmatched hunting methods that they pass to their young. Sometimes the adults will injure their prey and then release it near the juvenile whales to give them a sporting chance of catching their dinner.

Despite actually belonging to the dolphin family, killer whales can grow to a staggering size of 9.7 metres (32 feet) and weigh over 5,500 kilograms (12,100 pounds). Dare to peek inside their jaws and you'll find over 40 spiky teeth up to 13 centimetres (five inches) in length, each of which is designed

More than one orca

Take a closer look at the different populations of killer whale in the world

Offshore
Distinguishing features: Smaller in size and females have rounded dorsal fin tips
Diet: Sharks, fish
Commonly found: North-east Pacific and Vancouver Island.
Their name gives away their love of travelling far from shore.

Transient
Distinguishing features: Females have a triangular dorsal fin
Diet: Marine mammals
Commonly found: Coastal waters of the north-east Pacific, usually in smaller groups of six.

Resident
Distinguishing features: Females usually have a rounded dorsal fin
Diet: Fish, sometimes squid
Commonly found: Coastal waters of the north-east Pacific. They live on a diet of fish and move in matrilineal groups.

Canada

Vancouver Island

Pacific

USA

Killer features

The impressive physical attributes that make the orca such a natural hunter

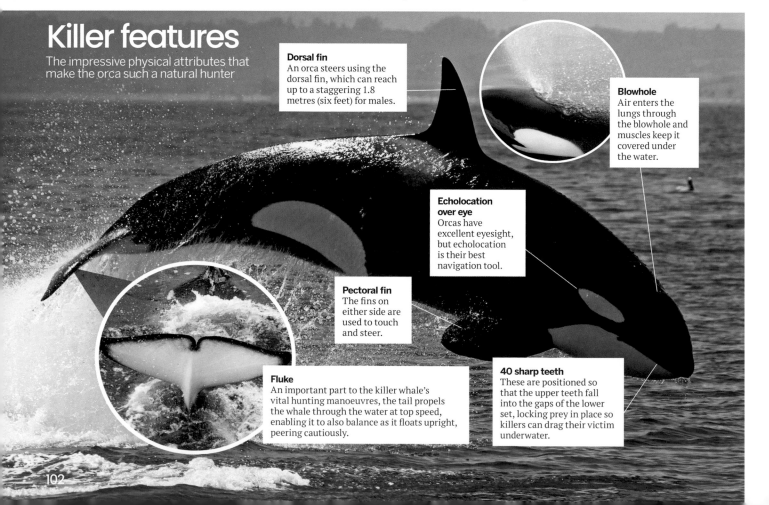

Dorsal fin
An orca steers using the dorsal fin, which can reach up to a staggering 1.8 metres (six feet) for males.

Blowhole
Air enters the lungs through the blowhole and muscles keep it covered under the water.

Echolocation over eye
Orcas have excellent eyesight, but echolocation is their best navigation tool.

Pectoral fin
The fins on either side are used to touch and steer.

Fluke
An important part to the killer whale's vital hunting manoeuvres, the tail propels the whale through the water at top speed, enabling it to also balance as it floats upright, peering cautiously.

40 sharp teeth
These are positioned so that the upper teeth fall into the gaps of the lower set, locking prey in place so killers can drag their victim underwater.

Sharp senses

Orcas use echolocation as a means of navigation, hunting and communication, by emitting high-frequency clicks under the water

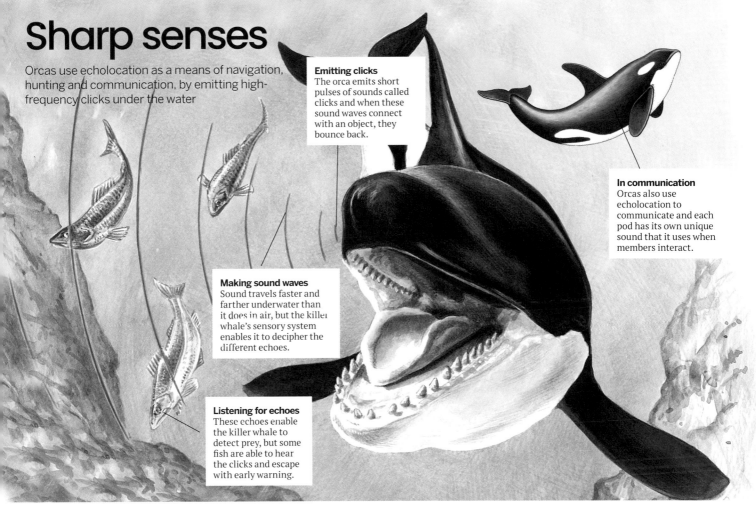

Emitting clicks
The orca emits short pulses of sounds called clicks and when these sound waves connect with an object, they bounce back.

In communication
Orcas also use echolocation to communicate and each pod has its own unique sound that it uses when members interact.

Making sound waves
Sound travels faster and farther underwater than it does in air, but the killer whale's sensory system enables it to decipher the different echoes.

Listening for echoes
These echoes enable the killer whale to detect prey, but some fish are able to hear the clicks and escape with early warning.

Orcas in numbers

34mph	**15-18** months	**90**yrs	**5-30**	**9.8** metres	**15**yrs	**227** kilos
A killer whale swimming at full power can reach this incredible top speed	*The gestation period for orca mothers is twice that of a human*	Some female orcas can reach this ripe old age in the wild	*Orca pods can consist of many members hunting and migrating as one*	*The top length of a killer whale*	Age at which female killer whales mature	*Amount an orca eats each day*

The whales peek above water to check for prey, then jump at an impressive speed to catch one

to bear down on blubbery flesh, ripping it apart without the need to chew. They are positioned so that the upper teeth fall into the gaps between the lower set, which help to lock the prey in place. It's definitely an advantage when the favourite meals of transient and offshore types tend to wriggle, including seals, penguins, sharks and other whales. They've even been known to take on great white sharks and blue whales, the latter of which can grow larger than three double-decker buses! However, it's not just a formidable body structure – designed to propel them through the water at speeds of 50 kilometres (30 miles) per hour – that enables orcas to bring down such large prey. It's their minds that make them true killers.

Working as a team, orcas adopt a manoeuvre known as spy-hopping, where the creatures swim vertically to the surface and poke their heads above water to take a good look at their surroundings. For at least 30 seconds they use their tail (or fluke) for balance and pectoral flippers on either side to keep afloat, like a human uses their arms to tread water. They'll be hoping to spot a seal, although these cute-looking animals are armed with sharp claws and teeth – the killer whales know this, so will always aim to grab the seal's tail to be on the safe side.

Before the chase even begins, the orcas gang up on the seal that will be

Lethal hunting techniques

Orcas make formidable predators thanks to their ability to operate as a team and make use of methods that are masterstrokes of whale ingenuity

Spy-hopping
Killer whales are the only marine mammal known to locate and capture prey out of the water by spy-hopping – rising vertically above the surface to see what's there.

Team work
Seals have excellent hearing, so the whales remain silent before going in for the kill. They remain in parallel formation and charge towards the ice floe where a seal is resting.

Catch of the day
A seal's teeth are sharp, so the whales will avoid getting hurt in the process of capturing their meal by aiming for the tail. They will then drag their quarry under the water to drown it, before divvying up portions among the pod.

Making killer waves
Pumping their tails (flukes), the whales create an almighty wave that crashes over the ice floe and washes the seal into the water. They continue to work as a team to confuse the seal by blowing bubbles and creating turbulence.

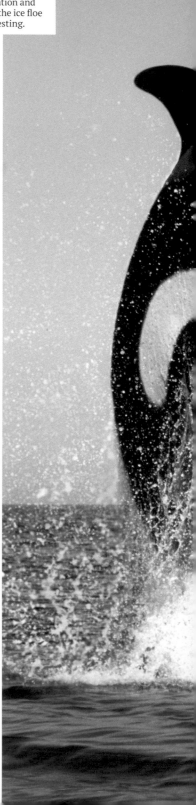

"The way the killers hunt is a prime example of their intelligence and fascinating minds."

resting on an ice floe, thinking it's probably safer on the land than in the water. Working together, the whales duck under the surface and swim side by side towards their quarry. At the last moment, they quickly change direction and unleash an all-mighty wave that crashes over the block of ice and knocks the prey clean into the water.

By now the seal is fully aware that it's under siege and there's always a chance it can escape by clambering aboard another ice floe. The orcas will be doing everything they can to prevent this, by using their immense bodies to create underwater turbulence and blowing bubbles to encourage the seal to dart into open water where it doesn't stand

a chance against the pod. From this point on it's a game of catch-the-seal-by-its-tail, and once they do they will drag the creature to the ocean's depths and drown it. Unlike the seal, the killer whale can hold its breath for long periods of time. The way the killers hunt is a prime example of their intelligence and fascinating minds.

A family that forages together, feeds together, but seals only make modest meals. If the opportunity arises, the orcas will hunt other whales, such as the Antarctic minke. These solitary animals easily match the size of a killer whale, which is still small by whale standards, but provides a hearty feast for a hungry pod. When the minke whale is within sight,

Smart moves

Orcas display complex behaviour that shows just how intelligent they are

Emotion
Male killer whales will remain with their mothers all their lives, which can be up to 50 years! Families of orcas are so close that capturing one is akin to kidnapping a human. Researchers have noted that they exhibit what seems like grieving when a member of the pod dies, causing others to become withdrawn.

Speech
One of the most amazing discoveries is that different pods have their own unique dialects. They make these sounds more frequently when a calf has been born so that the youngster can learn, just like human parents teach their children to speak. It's thought that these advanced dialects create a group identity and also prevents inbreeding.

Social structure
These incredibly social animals travel in pods that can consist of up to four generations. A social hierarchy exists within groups of killer whales, with the females being more dominant. Signs of establishing authority within a pod include slapping their tails against the water, as well as snapping their jaws.

Problem solving
The average orca will eat over 550 pounds (250 kilograms) of food a day, working as a team to successfully catch their prey. This could be flanking a minke whale on either side and regularly swapping places, like a relay race, or charging an ice block in unison to cause a wave to wash their prey into the water.

Playfulness
Orcas have a great sense of humour and there's plenty of video footage to back this up. You can watch them playing with balls of ice and even mimicking the sound of a motor boat – a surprisingly accurate impression. Other anecdotes include orcas moving objects that humans are trying to reach and they've even been known to play with their food, letting it slip away but always catching the prey in the end.

"A family that forages together, feeds together, but seals only make modest meals"

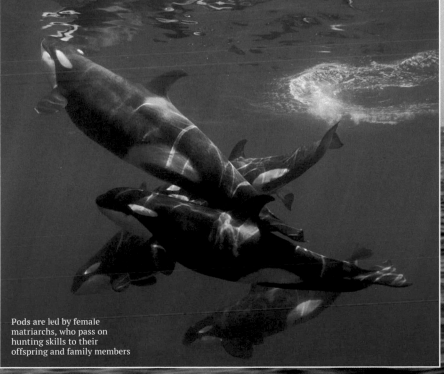

Pods are led by female matriarchs, who pass on hunting skills to their offspring and family members

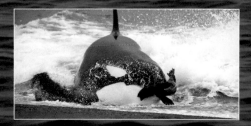

105

Quick questions with an expert

Name: Erich Hoyt
Role: Whale and dolphin researcher
Organisation: Research fellow with Whale and Dolphin Conservation UK

You were working as a sound engineer to record orcas' voices before dedicating your career to the scientific study and conservation of them. Can you describe that first encounter with a killer whale?

I learned some of the orca sounds on an electronic synthesizer and on one of the first times we met the killer whales I played them my imitation of one of their calls. After a moment's hesitation, two or three whales answered in unison with a perfect mimic of my sound. Later we realised that since the young whales are born without the sounds of the pod, that mimicry is an important method for learning what turned out to be vocal dialects that were unique to each pod. Now, many years later, we are still learning every day about this amazing and beautiful species.

They've been called wolves of the sea and killing demons. What did orcas do to earn such frightening names?

They are predators at the top of the food chain. From Greek and Roman times orcas were seen hunting together in pods, killing and eating larger whale species. That would have earned them some of those names. At the same time, however, in native cultures living around the Pacific rim, orcas were highly respected for their hunting ability. Some cultures saw them as their ancestors and put them on their totem poles to be admired and respected.

For your book, Orca: The Whale Called Killer, *you spent time living among pods of killer whales off northern Vancouver Island, Canada. Could you share some of your experiences?*

I spent ten summers with the same pods of killer whales, getting to know them as individuals and families. Some were very stand-offish, while others such as two older matriarchs, Nicola and Stubbs, were very friendly and tolerant of our presence. There were a couple of hyperactive youngsters in the early years that we called The Twins. They weren't actually twins but hung around together and used to play around our boat. They would also come by our camp at night and splash in the near-shore waters. We truly felt a part of their world.

As a senior research fellow with Whale and Dolphin Conservation UK, what can people do to help ensure the continued survival of this amazing animal?

Join a whale-conservation group, adopt an orca, a dolphin or a whale, volunteer, refuse to go to SeaWorld, read all you can about the ocean. A good starting point is the website Whales.org or its Facebook page. Read up, follow them and get to know the whale world!

Orca: The Whale Called Killer by Erich Hoyt is digitally available on Kindle. For more information, visit www.erichhoytbooks.com.

the black-and-white hunters head towards the creature at top speed and draw level. They position themselves with one on either side of the victim, blocking any means of escape, and pursue it for hours on end.

The minke's only real defence is its sheer endurance, but the killer whales are genius hunters. The outriders replace one another in relays, keeping up momentum. With many killers and only one minke, the latter inevitably tires. The orcas then move in for the kill, biting and attempting to flip the whale over. By keeping its blowhole submerged, they can effectively drown the minke before devouring it.

The whales are so expertly organised that they have been compared to wolf packs, and this fierce reputation has endured since ancient times, giving them their scientific name Orcinus orca. The name comes from the mythological Orcus – the Roman god of death and the underworld. Still, there's no record of this sea-bound behemoth ever killing a human in the wild. In captivity, however, it's a different story.

Since the 1970s there have been attacks on nearly two dozen people worldwide, but opinion is divided over whether these are accidents or deliberate attacks. Orca expert and neuroscientist Lori Marino doesn't underestimate this animal's intelligence: "I'm not trying to second-guess what was in this particular whale's mind," she told Orlando Sentinel, referring to a recent fatality in an aquatic park. "Certainly, if we are talking about whether killer whales have the wherewithal and the cognitive capacity to intentionally strike out at someone, or to be angry, or to really know what they are doing, I would have to say the answer they do."

Researchers agree that orcas exhibit high levels of emotional capacity, self-awareness and problem-solving skills that hint at a superior intellect. Fishermen tell stories of Alaskan killer whales stealing fish from longlines and, when the men started positioning their boats miles apart and taking turns to reel in the haul, the orcas split into two groups.

Footage of killer whales playing with chunks of ice when a man tossed a snow ball in their direction shows intelligence in the form of recreation, too. In fact, the whales are well known for their playfulness and curiosity.

They're also often observed leaping out of the ocean and landing on their side or back with a colossal splash, known as breaching, and lob-tailing, which involves slapping the tail flukes on the water's surface. These displays of water acrobatics can be a sign the killer whales are courting, relieving an itch or purely playing. Mothers dedicate a lot of time to the latter, investing so much time in being good parents that they only have a calf every five

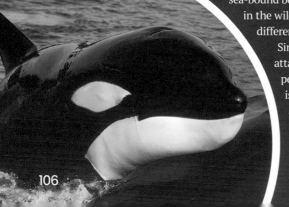

BELOW The family structures within pods is integral to killer whale survival, and is a big indicator of their huge intelligence

BELOW An orca dives back into the water after breaching, which is thought to be part of the courting process

"Each member of the pod pitches in to raise their young and the bonds between them are akin to human families"

years or so. This is also due to a lengthy gestation period of 16 to 18 months – the longest of any whale. This is surprising since they are by no means the largest mammal of the ocean, but it takes time to develop such a large brain – the second largest of any animal on the planet.

Fascinatingly, killer whales also experience the menopause just like human females do. They are one of only three species that continue to live long after they have stopped reproducing, which means the mothers can devote the rest of their lives to taking care of their offspring and grandchildren. The reason for this unusual evolutionary trait is believed to lie in their social structure, where mothers take a leading role.

Each member of the pod pitches in to raise the young and the bonds between them are akin to human families. When a calf dies, for example, mothers have been witnessed carrying their baby with their heads and when the calf slips, the family dives to retrieve the body. They appear to become withdrawn, go off their food and regularly return to the spot where their family member died. As humans, it's difficult for us to avoid projecting our own feelings onto an animal, but it seems that killer whales – and other highly intelligent species such as bottlenose dolphins and elephants – mourn their dead. It's heartbreaking, but this emotional intelligence is just another indication of how astoundingly clever these animals really are.

18 Fantastic facts
KILLER WHALES

Killer by name, killer by nature? It's time to find out the truth about the whale that isn't a whale, from which even great whites make a hasty retreat

Killer whales are dolphins

Despite their name, killer whales are in fact the largest members of the dolphin, or delphinidae family. Though just to confuse matters further, all dolphins fall under the order of infraorder odontoceti or toothed whales!

They go by many names

Today, they are most commonly known as orcas and killer whales, but their Latin name orcinus orca is thought to translate in modern terms to 'demon from hell'. Across the centuries and different cultures, they have also been called asesinas de ballenas, which translates as whale killers in Spanish, zwaardwalvis, meaning sword whale in Dutch and shachi, the Japanese term for tiger and fish.

Excluding humans, no mammal's range is as widespread as the orca's. They are found in all of Earth's oceans, from the equator to both poles

Just behind the dorsal fin, killer whales have a grey patch known as the saddle, or cape. Varying in shape and colouration between individuals and easily spotted from the surface, this is often used along with the fin to identify individuals

Male orcas are slightly larger than females and their dorsal fin is an indicator of gender

Family matters to orcas

A mother cares for her calf for one to two years. Even once they have matured, most killer whales will stay in the same pod as their mother for the rest of their lives.

Their closest relatives are actually hippos

Despite acting more like wolves, orcas share a common ancestor with the hippopotamus, a prehistoric pig-like animal called indohyus that lived around 48 million years ago.

They are the fastest marine mammals

These apex predators are the cheetahs of the sea. In 1958 a bull killer whale was clocked travelling at 55.5 kilometres (34.5 miles) per hour in the Pacific Ocean.

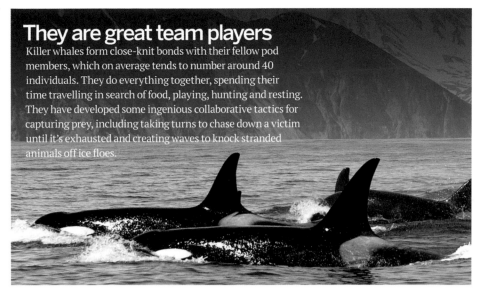

They are great team players

Killer whales form close-knit bonds with their fellow pod members, which on average tends to number around 40 individuals. They do everything together, spending their time travelling in search of food, playing, hunting and resting. They have developed some ingenious collaborative tactics for capturing prey, including taking turns to chase down a victim until it's exhausted and creating waves to knock stranded animals off ice floes.

They listen through their jaws

Although the orca's physical ears are two small holes located just below the eyes, several parts of the head contribute to its hearing. It targets clicks in a beam from the bump on its head called the melon, then perceives the majority of the returning echoes via its fat-filled lower jawbone, through which the vibrations pass to the inner ears.

Black and white is perfect camouflage

The killer whale's patchy markings have evolved as a form of disruptive colouration, masking their true outline to deceive prey into thinking they are no threat, until it's too late. They are primarily black on their backs and white on their bellies, which also makes them harder to spot from either above or below.

They can hunt just like bats

Killer whales can detect their next meal in murky water or even at night by making clicking sounds and listening for the resulting echoes. Studies have shown they can even pinpoint specific prey using this technique. They use this same echolocation ability to navigate. Unlike bats, orcas also have acute vision, so they can use both senses individually or together, depending on the environmental conditions.

Every pod has its own dialect

Very social creatures, killer whales use a complex series of whistles, pulsed calls and clicks to communicate with one another. There are similarities in signals across all groups, but nevertheless, scientists have detected distinct variations, not just between regions but even from pod to pod.

Killer whales will sometimes eat sharks

Sharks usually sit quite comfortably at the top of the food chain, but even they need to take care if killer whales are around. In 2014, marine biologists captured a video of an orca pod harrying a tiger shark until it flipped over. There have even been sightings of orcas taking on great whites!

They also eat moose

It might not seem the most likely of prey for a marine mammal, but moose and deer in Alaska have fallen victim to orcas when swimming between islands and the mainland.

Orcas are very sacred to many Native American tribes

Often referred to as blackfish, killer whales appear in many legends and fables in Native American cultures. Some believe orcas were the reincarnated spirits of young tribesmen lost at sea.

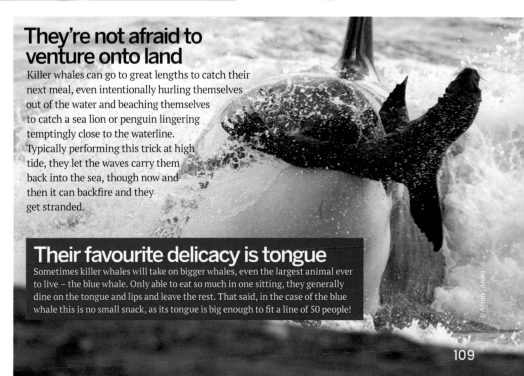

They're not afraid to venture onto land

Killer whales can go to great lengths to catch their next meal, even intentionally hurling themselves out of the water and beaching themselves to catch a sea lion or penguin lingering temptingly close to the waterline. Typically performing this trick at high tide, they let the waves carry them back into the sea, though now and then it can backfire and they get stranded.

Their favourite delicacy is tongue

Sometimes killer whales will take on bigger whales, even the largest animal ever to live – the blue whale. Only able to eat so much in one sitting, they generally dine on the tongue and lips and leave the rest. That said, in the case of the blue whale this is no small snack, as its tongue is big enough to fit a line of 50 people!

The deadly pufferfish

A look at why, despite its size and timid appearance, one type of fish can be extremely deadly when it comes to defending itself

The pufferfish is a group of over 100 species that are so-named for their unique line in defence. When cornered, a puffer's last gasp is to draw in water (or sometimes air) and pump it to the stomach, expanding to three times its normal size; deterring potential predators and when possible, affording it the vital seconds necessary to escape.

To achieve this with the required efficiency and speed, once the puffer has taken on water its gills clamp shut and a powerful bow-door-like valve closes over the inside of the mouth. Once the mouth's cavity is compressed, this forces the water into its stomach.

Despite its resulting comic appearance, the tissues and organs of many a puffer are no joke, laced with the potent poison tetrodotoxin – a single pinhead of which could kill a grown man. This makes it ten times more deadly than the black widow spider. The poison is produced as part of a mutually beneficial relationship by common bacteria where nutrients are exchanged as payment for the ultimate deterrent.

Some species such as the porcupine puffer are more sporting than others, covered with spines that offer added protection and ample warning to any would-be attackers. Each spine is attached to the skin by an ingenious tripod-shaped bony base. When the skin stretches, one of the legs is pushed forward and two are pulled back to snap the spine outwards… a point well made in more ways than one.

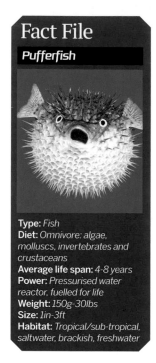

Fact File
Pufferfish

Type: *Fish*
Diet: *Omnivore: algae, molluscs, invertebrates and crustaceans*
Average life span: *4-8 years*
Power: *Pressurised water reactor, fuelled for life*
Weight: *150g-30lbs*
Size: *1in-3ft*
Habitat: *Tropical/sub-tropical, saltwater, brackish, freshwater*

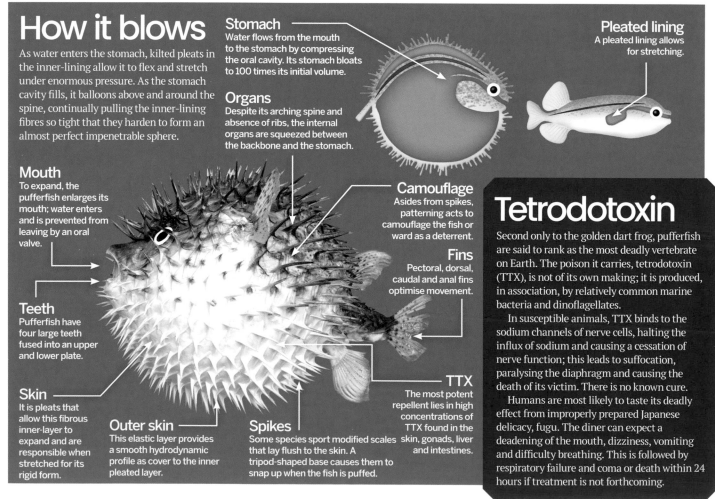

How it blows

As water enters the stomach, kilted pleats in the inner-lining allow it to flex and stretch under enormous pressure. As the stomach cavity fills, it balloons above and around the spine, continually pulling the inner-lining fibres so tight that they harden to form an almost perfect impenetrable sphere.

Stomach
Water flows from the mouth to the stomach by compressing the oral cavity. Its stomach bloats to 100 times its initial volume.

Organs
Despite its arching spine and absence of ribs, the internal organs are squeezed between the backbone and the stomach.

Pleated lining
A pleated lining allows for stretching.

Mouth
To expand, the pufferfish enlarges its mouth; water enters and is prevented from leaving by an oral valve.

Teeth
Pufferfish have four large teeth fused into an upper and lower plate.

Skin
It is pleats that allow this fibrous inner-layer to expand and are responsible when stretched for its rigid form.

Outer skin
This elastic layer provides a smooth hydrodynamic profile as cover to the inner pleated layer.

Spikes
Some species sport modified scales that lay flush to the skin. A tripod-shaped base causes them to snap up when the fish is puffed.

Camouflage
Asides from spikes, patterning acts to camouflage the fish or ward as a deterrent.

Fins
Pectoral, dorsal, caudal and anal fins optimise movement.

TTX
The most potent repellent lies in high concentrations of TTX found in the skin, gonads, liver and intestines.

Tetrodotoxin

Second only to the golden dart frog, pufferfish are said to rank as the most deadly vertebrate on Earth. The poison it carries, tetrodotoxin (TTX), is not of its own making; it is produced, in association, by relatively common marine bacteria and dinoflagellates.

In susceptible animals, TTX binds to the sodium channels of nerve cells, halting the influx of sodium and causing a cessation of nerve function; this leads to suffocation, paralysing the diaphragm and causing the death of its victim. There is no known cure.

Humans are most likely to taste its deadly effect from improperly prepared Japanese delicacy, fugu. The diner can expect a deadening of the mouth, dizziness, vomiting and difficulty breathing. This is followed by respiratory failure and coma or death within 24 hours if treatment is not forthcoming.

How moray eels feed

Find out why catching a fish dinner is a doddle when you've got two mouths

The moray eel is a slender, reef-dwelling fish native to the nooks and crannies of subtropical and temperate seas. While they are voracious eaters, they are not great swimmers due to their lack of a pectoral fin. Instead they lurk almost motionless in rocky crevices, often with just their heads peeking out, waiting for a meal to swim by.

Most other bony fish have developed a method of slurping up prey by very rapidly opening their mouths to create an area of negative pressure directly in front of them. This quickly draws water – and any unsuspecting victim – back into the mouth cavity. While fish that bite also use suction to get food from their mouths into their throats, the moray eel doesn't. In fact, few fish consume their food in as impressive – or terrifying – a manner as the moray eel.

Because they live in tight crevices, the suction method wouldn't work for a moray because the head has no space to expand into. And besides, the eel's prey is generally too large to really be affected by the suction technique. Instead, morays are the only known species of vertebrate to possess two pairs of jaws. It sounds like some kind of special-effects monster from the *Alien* movies, but the moray eel has a second set of raptorial jaws in its pharynx: the pharyngeal jaws. These gnashers located behind the eel's skull lurch forward after the fish has taken the initial bite and grab at the victim, drawing it back down into the throat so the eel can swallow it.

It's thought that these movable second jaws are a result of adaptation to suit the confined spaces these fish tend to inhabit in reef environments.

Off the menu

Moray eels are high up the food chain, which leaves them more susceptible to the accumulation of toxins. Ciguatoxin, for instance, is a nasty organic compound made by a specific type of dinoflagellate (a single-celled organism). At first the ciguatoxin may be consumed by a snail, which may then be eaten by a crab; the crab might become dinner for a larger fish and so on until, finally, the moray eel eats something contaminated. Essentially, the higher up the food chain, the greater the toxin concentration. Cooking does not destroy ciguatoxin so it's safest simply to avoid eating moray eels.

Jaw-dropping anatomy
Get the lowdown on this opportunistic reef hunter

Poor eyesight
Most moray eels are nocturnal. While their small eyes and ears make for poor eyesight and hearing during the day, this is made up for by a keen sense of smell.

Pharyngeal jaws
Deep in the throat, behind the eel's skull, is a second set of ballistic jaws shaped a bit like forceps and used to grab prey and drag it into the oesophagus.

Skin
Moray eels don't have scales – instead the thick skin is slimy to the touch as it is coated in mucus. To hide in the dappled reef, morays are camouflaged, including inside their mouths which gape open a lot.

Spine
Over 100 vertebrae keep the moray eel very flexible, helping it contort to manoeuvre the jaw and drag prey into the throat.

Muscles
Elongated muscles surrounding the pharyngeal jaws allow for much greater range of movement than other types of jaw.

Smell
To make up for limited vision and hearing, the moray eel constantly opens and closes its mouth sucking in water to taste or sniff out prey or predators.

Teeth
The moray's deadly looking mouthful of incredibly sharp teeth curve inwards slightly so as to prevent their meal wriggling back out.

Oral jaws
The lengthy lower mandible of the first oral jaw enables the fish to snap its mouth shut very quickly and powerfully grip its victim as if in a vice.

The statistics...

Moray eel
Binomial:	*Muraena retifera*
Type:	*Fish*
Diet:	*Carnivore, eg fish, crustaceans and cephalopods*
Average life span in the wild:	*10-20 years*
Weight:	*Up to 30kg (66lb)*
Length:	*Up to 3m (9.8ft)*
Habitat:	*Generally bottom dwellers worldwide (tropical and temperate oceans)*

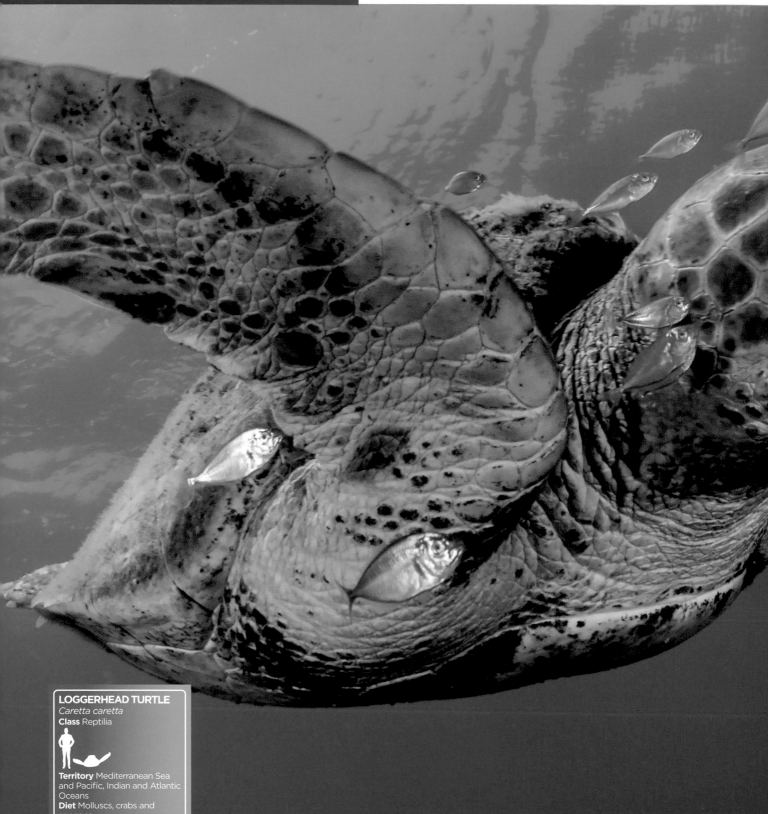

LOGGERHEAD TURTLE
Caretta caretta
Class Reptilia

Territory Mediterranean Sea
and Pacific, Indian and Atlantic
Oceans
Diet Molluscs, crabs and
sponges
Lifespan 50 + years
Adult weight Up to 135kg
(300lb)
Conservation status

EX EW CR EN VU NT LC
VULNERABLE

Loggerhead turtles are the
most common sea turtle in
the Mediterranean

SEA TURTLES

They've been around since the dinosaurs' time, but modern day sea turtles face their toughest challenge yet. Whether or not their story has a happy ending depends on us

Words by **Matt Ayres**

Sea turtles are among the most iconic animals in the ocean. In a habitat dominated by fish, invertebrates and the occasional mammal, these ancient creatures are some of the only marine reptiles. And while saltwater crocodiles, sea snakes and marine iguanas also call the sea home, no other ocean-based reptile occupies such a vast territory.

Found in most of Earth's oceans, sea turtles are only absent from the frigid waters of the polar regions. They swim incredible distances on migration routes between feeding grounds and nesting sites – locations that are often hundreds of miles apart. As a result, they have evolved differently from their freshwater relatives.

The most obvious difference is in their size: sea turtles grow significantly larger than pond- and river-dwelling varieties. Their streamlined, fusiform bodies aid their long-distance swimming, although this difference in anatomy means that sea turtles are unable to withdraw their heads and limbs into their shells like other turtles.

Human activity poses a significant threat to sea turtles. Predators that pick off helpless hatchlings on the beach pale in comparison to the ongoing dangers of fishing nets, pollution, coastal development and climate change. These man-made problems are by far the biggest cause for the decline in turtle numbers.

7 species of sea turtle

From colossal leatherbacks to pint-sized Kemp's ridleys, our oceans are home to seven species of sea turtle, each with their own distinct evolutionary traits

Fourth heaviest reptile

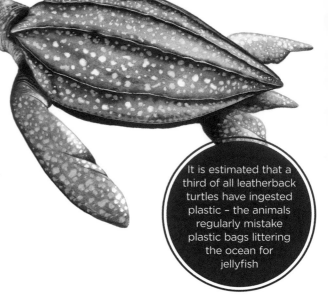

LEATHERBACK SEA TURTLE
Dermochelys coriacea
Size 183cm (72 inches)
Diet Jellyfish
Conservation status

EX EW CR EN **VU** NT LC

VULNERABLE

Unlike other sea turtles, the shells of leatherback turtles are covered in leathery skin; this makes them easy to distinguish from the likes of loggerheads and green turtles, which have tough bony carapaces.

These turtles are also much larger than their hard-shelled cousins. Leatherbacks are the fourth heaviest reptiles in existence, beaten to the top spots by three different kinds of crocodile.

It is estimated that a third of all leatherback turtles have ingested plastic – the animals regularly mistake plastic bags littering the ocean for jellyfish

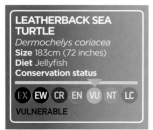

HAWKSBILL SEA TURTLE
Eretmochelys imbricata
Size 89cm (35 inches)
Diet Sponges and other invertebrates
Conservation status

EX EW **CR** EN VU NT LC

CRITICALLY ENDANGERED

Stomachs venomous prey

This turtle's mouth is hooked like a hawk's beak, hence the name. The plates on its back (known as scutes) overlap near the back flippers, giving the bottom of its shell a serrated look.

Some of the invertebrates that the hawksbill turtle eats are venomous, and its own flesh can become poisonous as a result. Unfortunately this hasn't stopped people from hunting and eating the reptiles.

Spends 85 per cent of the day underwater

Well-equipped to spend life at sea, loggerhead turtles spend 85 per cent of their day underwater and can remain submerged for four hours before coming up for air.

The omnivorous swimmers aren't particularly picky about what they eat: their diets are the most diverse of all sea turtles, with meals ranging from squid to sea cucumbers. Loggerheads have even been known to eat hatchling turtles.

LOGGERHEAD SEA TURTLE
Caretta caretta
Size 110cm (43 inches)
Diet Invertebrates and plants
Conservation status

EX EW CR EN **VU** NT LC

VULNERABLE

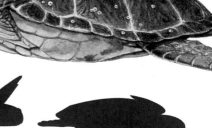

Turtles by size

These reptiles come in all shapes and sizes

Leatherback sea turtle
183cm (72 inches)

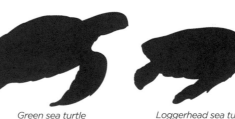

Green sea turtle
114cm (45 inches)

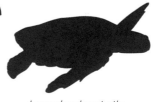

Loggerhead sea turtle
110cm (43 inches)

Flatback sea turtle
99cm (39 inches)

KEMP'S RIDLEY SEA TURTLE
Lepidochelys kempii
Size 65cm (25.5 inches)
Diet Crabs, jellyfish and shrimps
Conservation status

EX EW CR EN VU NT LC
CRITICALLY ENDANGERED

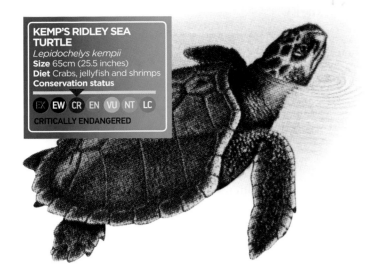

Rarest species of sea turtle

As well as being among the smallest species of sea turtle, the Kemp's ridley is the most endangered. It is estimated that only 1,000 nesting females are left in the wild, mostly in the Gulf of Mexico. The greatest dangers to dwindling populations of Kemp's ridley are over-harvesting of eggs and fishing nets.

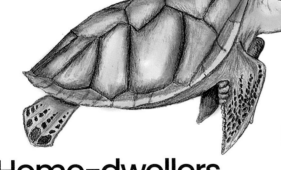

Home-dwellers avoid long distances

FLATBACK SEA TURTLE
Natator depressus
Size 99cm (39 inches)
Diet Invertebrates and sea grasses
Conservation status

EX EW CR EN VU NT LC
DATA DEFICIENT

Flatback turtles have flat carapaces, distinguishing them from other species. They can also be recognised by their pale grey-green colour and the upturned edges of their shells. This species has the smallest geographic range of any sea turtle. They do not undertake the lengthy ocean migrations associated with other sea turtles.

Hawksbill sea turtle
89cm (35 inches)

Olive ridley sea turtle
70cm (27.5 inches)

Kemp's ridley sea turtle
65cm (25.5 inches)

Sun-seekers that bask on land

Green turtles are the largest members of the Cheloniidae family. They are the only herbivorous sea turtles – while young green turtles will eat invertebrates like crabs and sea sponges, their diet becomes plant-based when they reach maturity.

Another distinguishing trait of green turtles is their habit of sunbathing. While most sea turtles only leave the sea to lay eggs, green turtles enjoy basking on land.

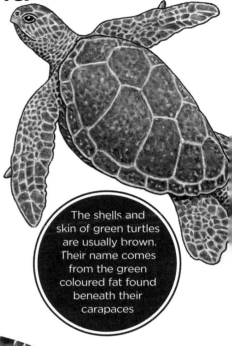

GREEN SEA TURTLE
Chelonia mydas
Size 114cm (45 inches)
Diet Sea grasses and algae
Conservation status

EX EW CR EN VU NT LC
ENDANGERED

The shells and skin of green turtles are usually brown. Their name comes from the green coloured fat found beneath their carapaces

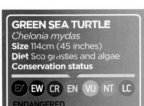

Flatback turtles lay fewer eggs than other sea turtles, but their hatchlings have better chances of survival

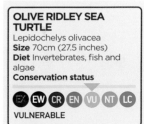

Mums gather to nest in numbers

Olive ridley sea turtles are famous for their mass nesting instincts. The reptiles are the most abundant sea turtles in the world and gather in huge numbers on the same beaches where they first hatched, with thousands of mothers laying their eggs over the course of a few days.

These turtle gatherings are known as *arribadas* (Spanish for 'arrival by sea'). Kemp's ridley sea turtles also perform these nesting processions.

OLIVE RIDLEY SEA TURTLE
Lepidochelys olivacea
Size 70cm (27.5 inches)
Diet Invertebrates, fish and algae
Conservation status

EX EW CR EN VU NT LC
VULNERABLE

Trouble at sea

The fact that six out of seven sea turtle species are classified as threatened or endangered is almost exclusively down to the actions of humans. Although different species are affected by different issues due to their geographical and biological diversity, some of the most devastating hazards to sea turtles include entanglement in fishing equipment, poaching, coastal development, marine debris, ocean pollution and global warming.

The incidental capture of turtles while fishing (known as bycatch) is generally thought to be the greatest threat to sea turtles. Turtle excluder devices (TEDs) attached to nets have the potential to eliminate this problem. However, since there is no legislation to ensure that shrimp trawlers and other fishing boats use these devices, turtles continue to become entangled in nets and drown as a result.

Climate change is another worrying phenomenon that threatens sea turtles. Because turtle gender is dependent on the temperature of the sand incubating their eggs, warmer weather results in a disproportionate number of female turtles. Without enough males for those females to mate with, overall turtle numbers will inevitably continue to decline.

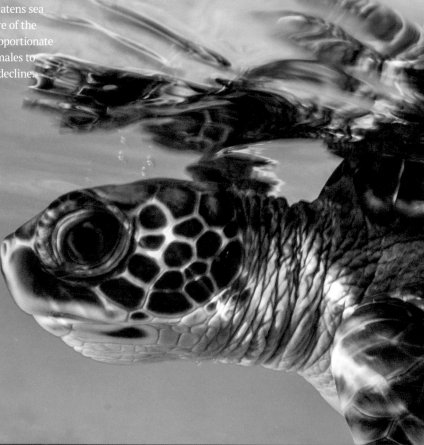

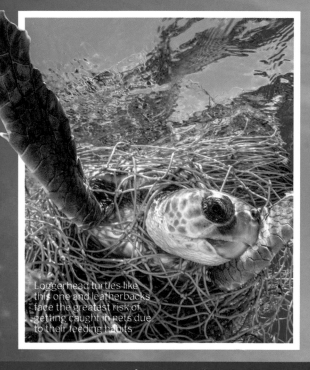

Loggerhead turtles like this one and leatherbacks face the greatest risk of getting caught in nets due to their feeding habits

Sea turtles in numbers

Sea turtle populations around the world might be low, but some of the other figures documenting these remarkable reptiles are shell-shockingly high

15 mph
Top speed of a swimming sea turtle

2.6 metres
Length of the largest sea turtle ever recorded

1.44 MILLION
Highest number of green turtle eggs laid in a year

110 MILLION
Number of years that sea turtles have been around

9 MINUTES
Time between heartbeats of a resting sea turtle

12,744 MILES
Longest ever migration journey, achieved by a Pacific leatherback turtle

50,000 sea turtles
Number of sea turtles killed in Southeast Asia and the South Pacific every year

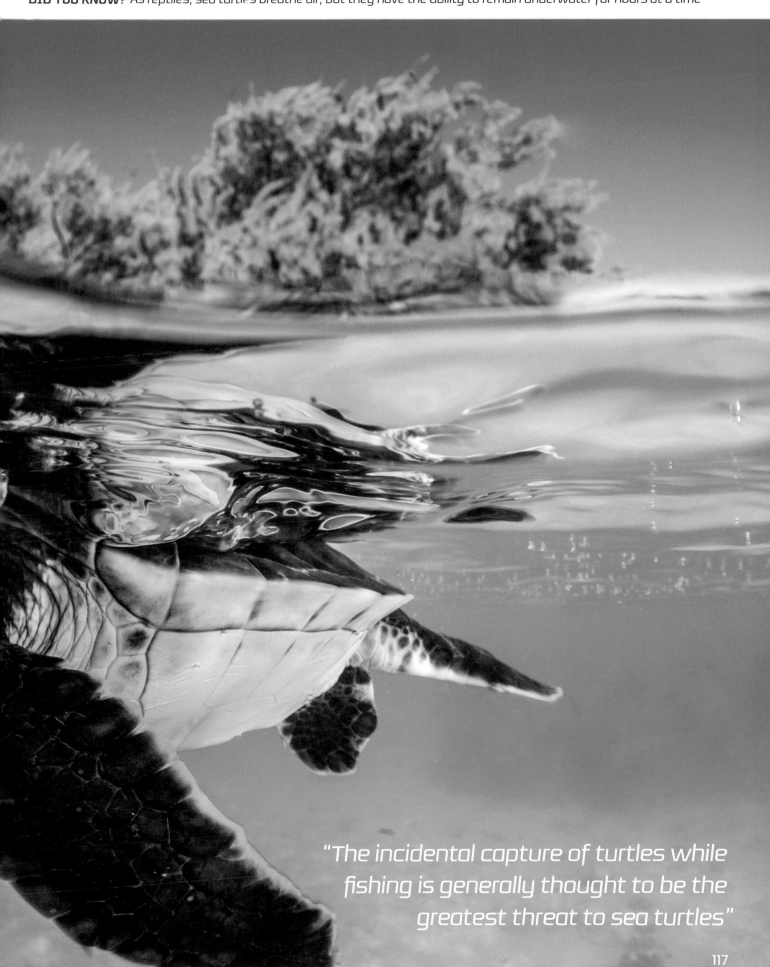

"The incidental capture of turtles while fishing is generally thought to be the greatest threat to sea turtles"

Turtles under threat

In 2011, the International Union for the Conservation of Nature (IUCN) produced a report highlighting the 11 most threatened sea populations

Key

○ Location of sea turtle populations

Olive ridley turtle
Location: West Indian Ocean
Key nesting sites: India and Oman

In the eastern Indian state of Odisha, olive ridley turtles arrive in staggering numbers, laying their precious eggs along the Bay of Bengal coastline.

Loggerhead turtle
Location: Northeast Atlantic Ocean
Key nesting sites: Cape Verde

The third largest loggerhead turtle nesting population can be found on Cape Verde. Turtle watching tours here provide a humane alternative to income from illegal poaching.

Leatherback turtle
Location: East Pacific Ocean
Key nesting sites: Mexico, Costa Rica and Nicaragua

The far-travelling leatherback turtle has established several important nesting sites in Mexico and Central America. Conservation work helps to secure future generations of these Pacific giants.

Atlantic Ocean

East Pacific Ocean

Hawksbill turtle
Location: East Pacific Ocean
Key nesting sites: El Salvador, Nicaragua and Ecuador

A population of hawksbill sea turtles was discovered hiding in the east Pacific's mangrove estuaries in 2011. Since then the habitat has been labelled an important site for the survival of the species.

Hawksbill turtle
Location: East Atlantic Ocean
Key nesting sites: Congo and Sao Tome and Principe

There are two populations of hawksbill turtle, both of which are considered critically endangered. It can take 20-40 years for these turtles to mature before they are ready to mate.

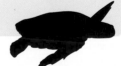

Loggerhead turtle
Location: Northeast Indian Ocean
Key nesting sites: Sri Lanka, Bangladesh and Myanmar

This sub-population is listed by IUCN as Critically Endangered due to the low number of mature adults (around 25-50 individuals remain).

Olive ridley turtle
Location: Northeast Indian Ocean
Key nesting sites: India

This part of the world has a long history of commercial egg harvest and an interest in turtle meat and byproducts. This adds to the already existing pressure of egg predation from other animals.

Loggerhead turtle
Location: North Pacific Ocean
Key nesting sites: Japan

Yakushima Island in Japan is an important stronghold for loggerhead turtles. After nesting, they migrate the full length of the Pacific to feed off the coast of Mexico.

West Pacific Ocean

Olive ridley turtle
Location: Northeast Indian Ocean (*arribadas*)
Key nesting sites: India and Sri Lanka

This is one of the largest *arribada* sites for the olive ridley turtle in the world, where females will gather ashore to lay their eggs. So many eggs in one place leaves them vulnerable to the threat of poachers.

Indian Ocean

West Pacific Ocean

Hawksbill turtle
Location: Northeast Indian Ocean
Key nesting sites: India, Sri Lanka and Bangladesh

Hawksbill turtles are heavily targeted by illegal wildlife traders for their beautiful patterned shells. Marinelife Alliance in Bangladesh helps to safeguard the critically endangered animals.

Hawksbill turtle
Location: West Pacific Ocean
Key nesting sites: Malaysia, Indonesia and Philippines

The largest nesting area for this population is at Turtle Island in Sabah, where females make around 500-600 nests per year. Although it sounds a lot, it actually isn't many. Other species are able to produce hundreds of thousands of nests at some sites.

5 things you can do to help sea turtles

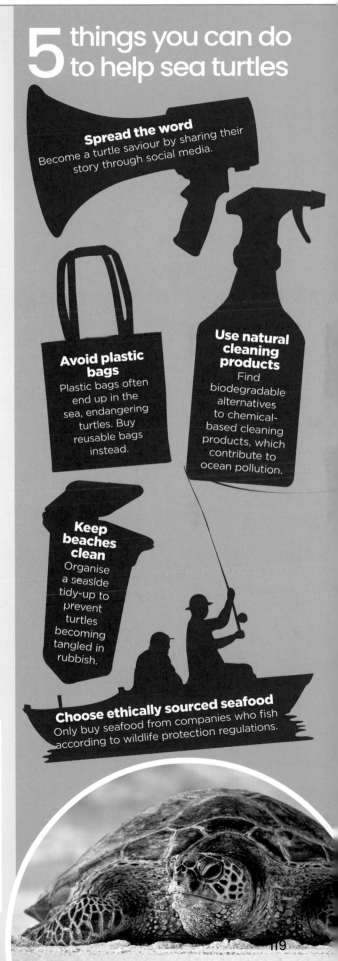

Spread the word
Become a turtle saviour by sharing their story through social media.

Avoid plastic bags
Plastic bags often end up in the sea, endangering turtles. Buy reusable bags instead.

Use natural cleaning products
Find biodegradable alternatives to chemical-based cleaning products, which contribute to ocean pollution.

Keep beaches clean
Organise a seaside tidy-up to prevent turtles becoming tangled in rubbish.

Choose ethically sourced seafood
Only buy seafood from companies who fish according to wildlife protection regulations.

Wings of the ocean

The genus *Manta* contains two species: *M. birostris* the giant oceanic manta ray, and *M. alfredi* the reef manta ray. Both species are truly supersized, with wide, flattened bodies, long slender tails and colossal undulating pectoral fins that glide through the water, looking like giant wings.

The giant oceanic manta ray is a migratory species, and can travel vast oceans following ocean-current highways in search of choice feeding grounds. The resident reef manta is more of a homebody, preferring to stay closer to shallow waters. They are solitary creatures, and only really come together to breed. These interactions can often begin at feeding areas, or at 'cleaning stations' – areas of coral reefs where cleaner wrasse and shrimp feed on parasites on the manta's skin.

Mating seasons vary across the world, and after around 13 months' incubation period, the young ray is born. Manta rays are ovoviviparous, which means the eggs develop within the womb and the mother gives birth to one or two live young. The baby rays (often as big as over one metre across) will stay in shallow water for several years until they're large enough to face the big wide ocean.

Their brains are some of the largest relative to size in the ocean realm, and as larger brains are commonly related to higher function this indicates that the manta are the complete opposite of 'simple giants'.

These brainy beasts feed on plankton – tiny microscopic creatures suspended in the water. The rays will open their mouths wide, and let the water pass over their gills as they filter out tasty morsels. Mantas will eat around 13 per cent of their body weight each week. Feeding can get super dynamic, with the rays making loop-the-loops and corkscrew spirals in the water.

Mantas can sense electric fields in the water, although this trait is less developed than in other species

The giant oceanic manta ray

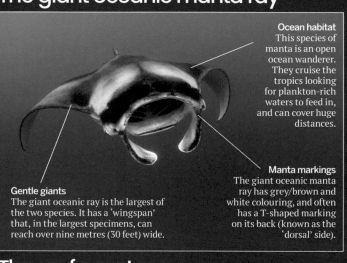

Ocean habitat
This species of manta is an open ocean wanderer. They cruise the tropics looking for plankton-rich waters to feed in, and can cover huge distances.

Manta markings
The giant oceanic manta ray has grey/brown and white colouring, and often has a T-shaped marking on its back (known as the 'dorsal' side).

Gentle giants
The giant oceanic ray is the largest of the two species. It has a 'wingspan' that, in the largest specimens, can reach over nine metres (30 feet) wide.

The reef manta ray

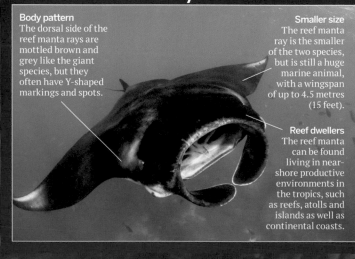

Body pattern
The dorsal side of the reef manta rays are mottled brown and grey like the giant species, but they often have Y-shaped markings and spots.

Smaller size
The reef manta ray is the smaller of the two species, but is still a huge marine animal, with a wingspan of up to 4.5 metres (15 feet).

Reef dwellers
The reef manta can be found living in near-shore productive environments in the tropics, such as reefs, atolls and islands as well as continental coasts.

"Their brains are some of the largest relative to size in the ocean realm...the complete opposite of simple giants"

ALL ABOUT THE
MANTA RAY

Meet the gentle giants of the ocean; leviathans so large that they could cover your car with their fins, but only to be feared if you're plankton

Words by **Ella Carter**

Conservation projects

Graham Hill is a science officer at The Deep 'submarium' in Hull. He spoke to us in 2016 as his team geared up for Phase 2 of the manta conservation project in Sudan.

How are the manta populations in Sudan, and what threats do they face?
The red sea area in Sudan is very remote, and there is a lot of fishing and illegal shark fishing. It has been illegal in Sudan for quite some time, but there's a strange quirk in the legislation where you can still sell their meat at the market. The main threat in Sudan is the encroachment of large recreational diving operations from the north. Because there's very little information about the manta population, the first thing to do is obtain baseline data where there has been relatively low impact by humans, which is a very rare situation. We can get that info and use it to manage the area.

What was involved in phase 1 of the project?
We're looking at the seasonal aggregations of manta ray into Dungonab Bay in Sudan. We had two techniques in our first phase – one is using acoustic tags implanted in the ray, alongside a seabed-monitoring network. Any tagged rays will give a ping when they come within 500 metres of a monitor, logging information about the time, animal, direction, etc. We have 20 monitors in the bay, and 20 monitors situated on seamounts along the coastline. We tagged 22 manta rays in phase 1, but we've not been back to collect the monitor data yet.
We also tagged three manta rays with satellite tags that can give us real-time info about where an animal is going. When they come up to feed and the tag is exposed to air, they download info and we can analyse the data. We want to get as much info as we possibly can, so when we tag them we take measurements, and on the males we check their claspers to see if they're sexually mature.
The local dive operators are also really enthusiastic about our project. The divers take a survey of all the species they see and collect a huge amount of data for us.

Have you found anything from phase 1?
At the moment we are still in the early stages as most of the monitors are still on the seabed! But we do have the tracks from the satellite tags. We know certainly that there's very little change in their behaviour once they've been tagged, which is great.
We have also taken tissue samples of 35 manta rays, but one of the ones we looked at looked slightly odd – and it seemed to have some characteristics of the reef manta but also of the giant oceanic manta. The two species of manta ray were thought to reproductively isolated but we found that this individual (which is backed up by genetic analysis) is actually a hybrid of the two species – the first time it's ever been recorded in manta rays!

When is phase 2, and what's involved?
We are hoping to do two fieldwork sessions this year, one next month to get the seabed monitors back up and running – we need to locate them, bring them back up, clean them, download the data and then return them. The socioeconomic side involves doing workshops with the Sudanese authorities and universities to maintaining the monitors and using GPS to locate the mantas.

Inside the manta ray

With sandpaper-like skin and covered in a layer of protective mucus, manta rays have some fascinating physical properties. The slime helps them to keep parasites at bay and ward off infections, which is why you should never touch a manta if you're lucky enough to come across one

Gills
The gills are full of blood vessels that absorb the oxygen from the water as it passes over them, and let the water carry away carbon dioxide from the blood.

Basibranchial
Part of the manta ray's central skeleton that provides support to the gill bars and gills.

Oesophagus
Seawater enters the mouth and is pushed over the gill plates – when the manta has filtered enough plankton it closes its mouth, coughs to dislodge the plankton and swallows it.

Heart

Gall bladder

Liver
As well as their light cartilaginous skeleton, an extra oily liver helps to keep the manta rays buoyant.

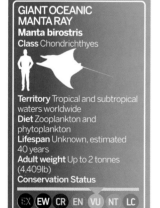

GIANT OCEANIC MANTA RAY
Manta birostris
Class Chondrichthyes

Territory Tropical and subtropical waters worldwide
Diet Zooplankton and phytoplankton
Lifespan Unknown, estimated 40 years
Adult weight Up to 2 tonnes (4,409lb)
Conservation Status

EX EW CR EN VU NT LC
VULNERABLE

INFANCY

Live birth
0 years
Having developed in an egg case inside the womb, baby mantas (pups) are born in sheltered waters of a bay or lagoon.

Infancy
1 year
The infant's pectoral fins are folded on its back when it's born, and so it must learn to use them instantly.

JUVENILE

Shallow living
1-5 years
Manta rays show no parental care, so once the 1.5m (4.5 feet) long pup is born it fends for itself, living in the shallows.

Growth spurt
2-15 years
In its first year the pup doubles in size. The next few years are spent feeding and growing in the shallows before venturing into the open ocean.

MATURITY

Reproductive age
10-20 years
Mantas become sexually mature at over ten years, when they will be able to reproduce. Males develop extended, calcified claspers.

Mating season
21 years
Mating season happens at different times across the world. Males will chase females for long periods before mating.

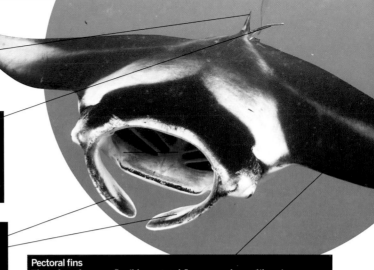

Dorsal fin
A small dorsal fin is located just above the base of the tail, thought to aid in stability and streamlining when the manta ray is swimming.

Cartilage
Mantas have skeletons of flexible, fibrous and lightweight cartilage instead of the dense bone of other fish.

Tail
The mantas have long, tapering tails that extend behind them as they swim. Unlike their stingray cousins, manta rays do not have a poison barb at the end of their tails.

Filter plates
These feathery looking plates surround all ten of the manta rays' gill slits. They are thin cartilage filaments that trap the plankton from the water as it passes over the gills.

Cephalic lobes
Manta rays are sometimes called 'devil rays' because their cephalic lobes slightly resemble horns. The flexible lobes can move to work as a funnel, channelling plankton-rich water into the mouth.

Pectoral fins
The colossal, super-flexible pectoral fins move almost like wings, to propel the ray at surprisingly fast speeds through the water. They can reach swift burst speeds of 35 kilometres per hour (21.7 miles per hour).

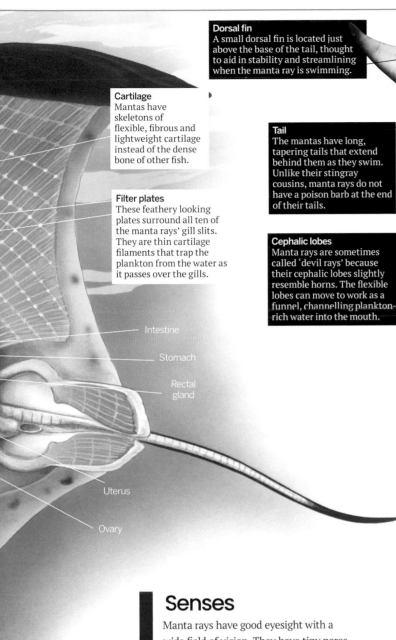

Intestine

Stomach

Rectal gland

Uterus

Ovary

Manta dentition

Despite feeding by filtering plankton-laden water, manta rays do have teeth. In fact, they have around 300 of them – tiny little pinhead-like structures arranged on their lower jaw and often indistinguishable from the ray's rough skin. As they're not used for eating, it's thought that these teeth may play a role in reproduction, as the male will bite down on one of the female's pectoral fins during mating.

Senses

Manta rays have good eyesight with a wide field of vision. They have tiny pores on their heads that allow sound waves to reach their inner ears, and they also have nostrils and are able to taste and detect chemical signatures in the water. Mantas are also able to sense electric fields in the water, although this trait is less developed in mantas than in other species.

Closest family

Closely related to the manta ray are…

Mobula ray
Mobula rays belong to the same family as mantas. There are nine species of mobula ray. They look very similar and feed the same way, but are much smaller in size. They come together in huge groups, and can be seen jumping high out of the water.

Whale shark
Whale sharks are part of the same subclass, the elasmobranchii, which includes sharks, skates and rays. Like the giant oceanic manta they're colossal open-water beasts, and they also feed by filtering plankton out of the water.

Eagle ray
The eagle ray is closely related to the manta, as a member of the superorder 'batoidea' which includes rays, skates and sawfish. Eagle rays are much smaller than mantas, and can be found in shallow, tropical waters near coral reefs.

**Pregnancy
22 years**
Once pregnant, the female manta ray carries one pup, or sometimes twins, for a gestation period of 13 months.

**Maturity
20-40+ years**
A female's age can be guessed from her mating scars, where males bite down on her fins. Females can have one pup every two to five years.

Death 40+ years
It's not known exactly how old manta rays live, but it's hoped that they live long lives and death is by natural causes and not human threats.

Habitat and threats

With numbers declining significantly, manta rays face an uphill struggle for survival

The clear waters of tropical atolls and equatorial coastlines are home to the reef manta ray, where it cruises through the crystal blue shallows to find food. The giant oceanic manta ray frequents the deeper waters of the open ocean. There is plenty to be done to protect both species in their aquatic homes.

Illegal and unsustainable fishing is one of the greatest threats to manta rays. They are incredibly slow growing and it takes a reef manta ray 10-15 years to reach maturity before it can even reproduce. To remove just one animal from the population can be decimating. Unregulated,

unreported and illegal fishing methods catch thousands of manta rays to satisfy the demand for some traditional Eastern medicines, and thousands of rays per year are also entangled in nets and caught as bycatch by other fisheries. This kind of human intervention can spell disaster for the longevity of the species.

Destructive fishing techniques such as gill nets, drift nets and purse seine nets for tuna and other commercially-fished species can also spell disaster for mantas, because once they become trapped, escape is impossible. Entanglement in marine debris is also a huge

problem. As such huge animals, once they have become ensnared in litter and rogue fishing nets it is very difficult for them to get free. They can't swim backwards, and rays need to have a constant stream of water flowing over their gills to survive. This means that severe entanglement can mean the ray will drown. If the manta can swim free, nets can get caught on their bodies, maiming them and making them vulnerable to infection. There are many stories from manta conservation charities about rays approaching divers who are able to cut them free of their entangled nets.

Overfishing of manta rays has increased over the past decade because of the demand for gill rakers in China

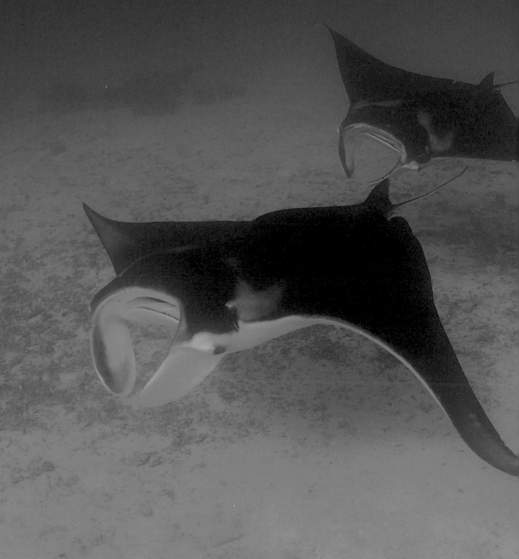

"Illegal and unsustainable fishing is one of the greatest threats to manta rays"

Nearest neighbours
Check out the other critters that share the manta's watery home

Suckerfish
Wherever the manta ray goes, the suckerfish goes too. These fish, called remora, attach themselves using a suction plate on their heads. They hitch a ride, and take advantage of the protection and food that this offers.

Plankton
These microscopic organisms are the manta ray's favourite food. Plankton can reproduce quickly and result in large numbers known as 'blooms.' Rays suck in water and filter out the tiny creatures for a tasty meal.

Tiger shark
Due to their huge size and passive hunting strategies, mantas have few natural predators. However, there are some large fish that will try to take them down, including the feisty tiger shark, great whites and killer whales.

Cleaner wrasse
Reef cleaning stations are an important part of the manta's life cycle, where they come into contact with other rays. Fish like the cleaner wrasse nibble away any parasites on the manta's skin.

Environmental factors
Challenges facing the manta ray's habitat

Habitat destruction
Without their habitat, mantas have nowhere to go. Coral reefs face many threats, including excess nutrient run-off and sedimentation from land, rising seawater temperatures and destructive fishing.

Climate change
Warming ocean temperatures and ocean acidification can cause coral reefs to undergo 'bleaching events', where the heat stress kills off the coral. In turn this causes a huge decline in the reef ecosystem.

Marine debris
Floating fishing nets and other garbage in the water spells out disaster for manta rays, and entanglement is responsible for the deaths of far too many rays worldwide, whether it is intentional or not.

Unregulated tourism
If too many people visit and dive in the manta's habitat without understanding its fragility, and even touch or ride the rays (which should never be attempted), it can have a severe impact.

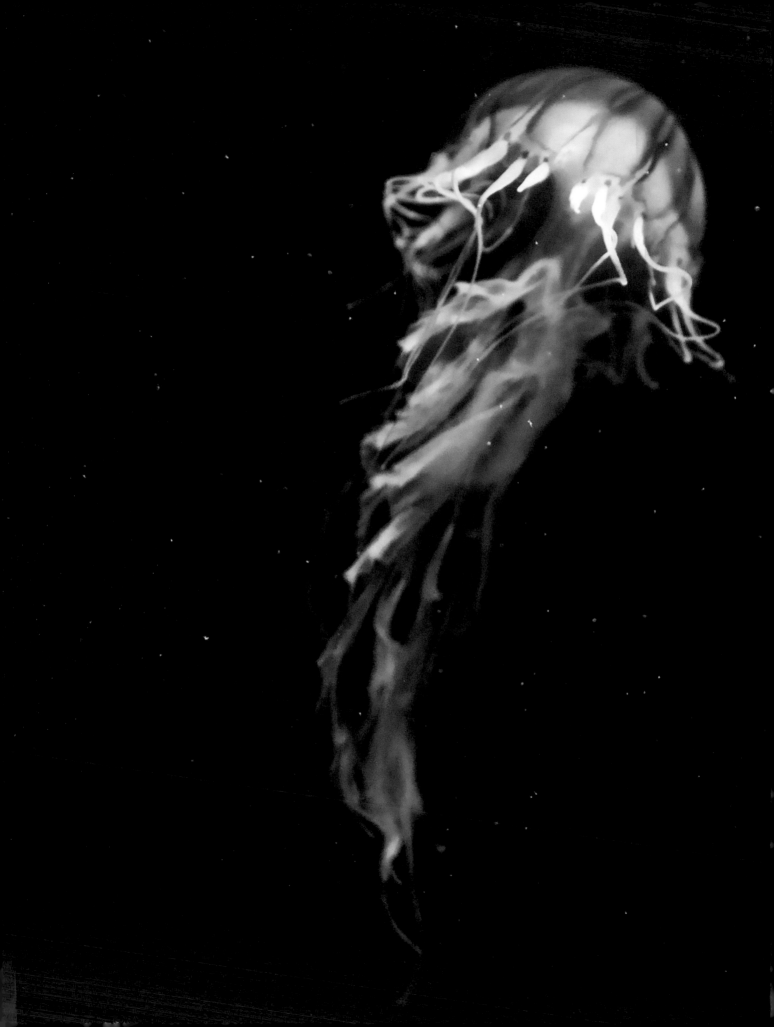